Pioneering Spirits

The Lives and Times of Remarkable Women Artists
in Western History

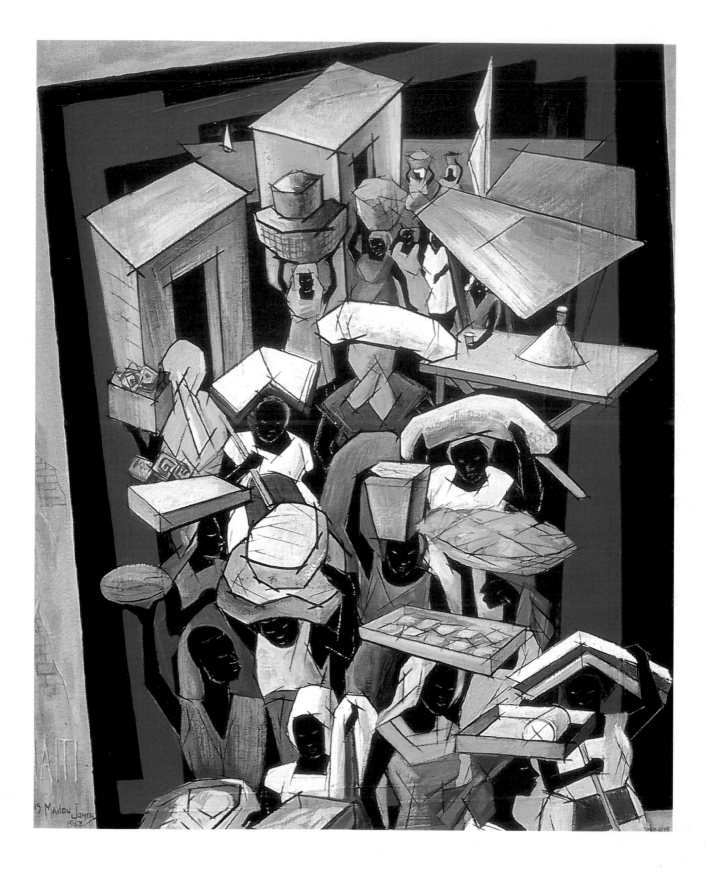

Pioneering Spirits

The Lives and Times of Remarkable Women Artists in Western History

Abby Remer

Davis Publications, Inc. Worcester, Massachusetts

Printed in Italy
Library of Congress Catalog Card
Number: 96-085574
ISBN: 87192-317-3
10 9 8 7 6 5 4 3 2 1

Publisher:
Wyatt Wade

Editorial Director:
Helen Ronan

Production Editor:
Nancy Wood Bedau

Assistant Production Editor:
Carol Harley

Editorial Assistance:
Jane Boland
Stacie Moffat

Manufacturing Coordinator:
Steven Vogelsang

Copyeditor:
Deborah Sosin

Design and Electronic Page Makeup:
Douglass Scott
Tong-Mei Chan

Front cover: *Lilla Cabot Perry.* Mother and Child, *c. 1890s, oil on canvas, 40 1/4" x 30". Collection of Hirschl & Adler Galleries, Inc.*

Back cover: *Sofonisba Anguissola.* Double Portrait of a Boy and Girl of the Attavanti Family, *date unknown, oil on panel. Allen Memorial Art Museum, Oberlin College, Ohio; Kress Study Collection, 1969.*

Title page: *Lois Mailou Jones.* Marché, Haiti, *1963, polymer. Courtesy of the artist.*

Acknowledgments

I would gratefully like to thank all those who supported me in this joyous journey. I am especially grateful to Helen Ronan, Jane Boland, Deborah Sosin, Nancy Bedau, Michael Remer, Dr. Jesse Stoff, Natalie Jones, and, of course, special thanks to Allen, Rilla, and Murray for their steadfast company and assistance.

About the Author

Abby Remer has written extensively about arts and culture, including her recent book *Discovering Native American Art.* She is also the founder and president of A. R. Arts & Cultural Programs, Inc., a company that provides innovative arts and cultural educational services to organizations nationwide. Along with her degree in art history from Oberlin College and a masters in museum education from Bank Street College of Education, Ms. Remer spent her early career working in the education departments of numerous New York City museums. Currently, among her other projects, she teaches graduate courses at New York University.

Table of Contents

Preface

*This absence of any sense of our tradition as women
seemed to cripple us psychologically. I wanted to change that,
and I wanted to do it through art.*

—Judy Chicago, discussing *The Dinner Party*,
a huge table installation and a seminal feminist
artwork of the 1970s, containing elaborately
decorated place settings that commemorate the
achievements of women throughout history.

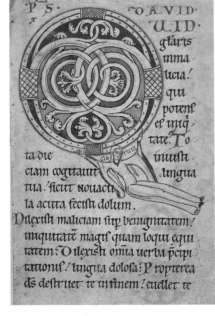

Fig. 1-18 Detail.

Claricia. Claricia and Initial Q,
St. Memin Psalter, *c. 1200, Germany.
Detail, The Walters Art Gallery,
Baltimore.* See page 15.

History is almost always told by those in power. Because men have dominated most Western societies throughout the ages, it is not surprising that much of women's remarkable achievements have gone largely unnoted until recent times.

Pioneering Spirits is not meant to, nor could it ever, delineate the entire scope of female artistic accomplishments. I have chosen to concentrate primarily on Western traditions to limit a clearly unwieldy topic. Some readers may not be familiar with works by numerous women artists. In the last few decades, however, dedicated writers, scholars, curators, and students have brought many of these artists' names and creations to a broader public.

Women did not achieve artistic success in a vacuum; therefore, I have devoted considerable attention to the social and historical environment in which they lived and worked. I hope that this background will illuminate the expansive nature of women's achievements as both artists and individuals.

This book merely hints at the wealth of information available. Choosing which artists to include was a challenging task. For every female mentioned, many others necessarily were omitted. Those profiled either exemplify larger trends or are particularly unique in their endeavors. A selected bibliography at the end lists further resources for those who wish to delve more deeply into the subject. Ultimately, I hope *Pioneering Spirits* will offer readers an inkling of the dynamic range, accomplishments, traditions, and capabilities of the many inventive female artists over the centuries.

Abby Remer
New York City, 1996

Introduction

Why don't the names of female artists throughout Western history come trippingly off the tongue, or at least pop immediately to mind? Why are so few women artists as well-known as their male counterparts?

Until recently, females fought nearly insurmountable obstacles in their attempts to achieve widespread recognition. The duties of mother, wife, and daughter required an enormous commitment of time and energy. Eventually, well-to-do ladies were educated in the arts, but only as amateurs. Their creative abilities, no matter how substantial, were viewed as alluring qualities first to attract and then hold a man. Those who pursued their passion were scorned by society for their "unfeminine" conduct. As professionals, men typically denied women training by making it almost impossible for them to enter either a master's studio or an academy, traditional paths for aspiring artists. Without access to the prescribed curriculum, women could not acquire the skills necessary for tackling the large-scale figurative works that were most highly regarded by the art establishment.

Female artists persevered nonetheless. Many, particularly before the twentieth century, were daughters, sisters, or wives of male creators. Some cultivated their charms to be accepted by society. Others thrived as eccentrics whose independence and success flew in the face of proper, ladylike behavior. Even those fortunate enough to have family connections, money, and emotional support often faced public ridicule and ostracism.

A significant number of women did achieve acclaim. Ancient Roman texts note their names, and, later, numerous female illuminators penned sumptuous medieval manuscripts. Churches, royalty, and the wealthy middle class commissioned women artists from the Renaissance until the modern age. As art changed, so too did female artists. Their styles sometimes fell within, and in other instances stood apart from, mainstream trends. Still other women helped advance and invent new aesthetics. Moreover, thousands of anonymous female hands fashioned beautiful items that added color and creativity to the home. Their art, termed craft, however, gained a secondary status within the academic hierarchy because it was so closely associated with the domestic realm.

The women's liberation movement of the 1970s prompted many females to use their art for political intent. Currently, women's growing self-awareness and breadth of expression has initiated a fresher, more inclusive version of art history. Females from all races and ethnic backgrounds are mining both ancient and more recent role models, seeking inspiration and confirmation of their creative heritage. Bringing these pioneering spirits to light will construct a rich and exciting present and lay a firm foundation for an even more dynamic future.

Chapter 1

From Prehistory to the Middle Ages:
Scarcity, Anonymity, and Tenacity

Women Artists Prior to Recorded History: The Earliest Pioneers

Who made the very first creative expressions? Ancient myths from many cultures and surviving visual evidence demonstrate that women have been artists since the dawn of humankind. (Fig. 1-1)

Tools found in female gravesites from the seventh millennium BC, during the Neolithic period, indicate that women skillfully fashioned baskets, pottery, and *textiles* (woven or knit cloth) during the first 20,000 years of human life.

Women also probably made string skirts, believed to be symbols of female fertility, similar to those carved on the small, voluptuous figurines that date from about 25,000 BC. (Fig. 1-2) The earliest remaining string, possibly used in these types of skirts, is a 17,000-year-old fossilized example discovered in the painted caves of France. And some 9,000 years ago, another female artisan seems to have left us the oldest existing cloth, a linen piece from Turkey.

Fig. 1-1 "It's never occurred to you, I suppose, that they might have been done by a cave-woman." *New Yorker*, 23 July 1973.

Drawing by Leslie Starke; © 1973. The New Yorker *Magazine, Inc.*

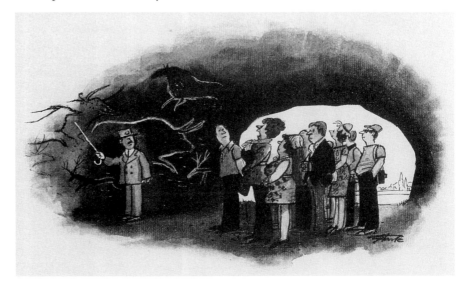

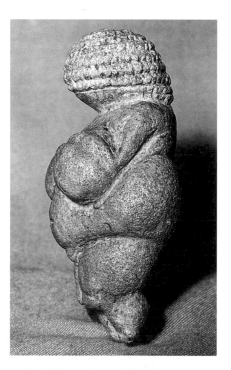

Fig. 1-2 While we will never know the gender of the artist who created this strong, fertile female figure, the discovery of similar small sculptures across Ice Age Europe, from Siberia to Spain, demonstrates how women were honored for their role as life giver in prehistoric times. Some historians feel that these figurines, possibly representing Mother Earth, suggest the widespread worship of a mother goddess to ensure fertility.

Venus of Willendorf, *c.* 25,000 BC, *limestone. Naturhistorisches Museum, Vienna.*

Fig. 1-3 Clothing may make the man, but who made the clothing? Some 1,300 years ago, a Huari woman in the Andean highlands, in what is now Peru, wove this sleeveless man's shirt.

Female Peruvian weavers used narrow backstrap looms to produce some of the finest weavings in the world during the 2,000 years before the Spanish conquest. In northern Peru, beautifully designed textiles have been found dating from as early as 2500 BC.

Pre-Columbian Poncho, 600–800 AD, *Peru, alpaca wool. Philip Morris Companies Inc.*

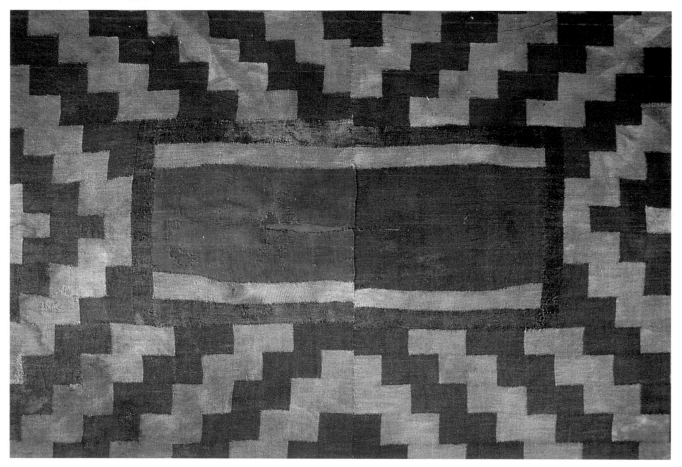

Fig. 1-4 When a Zuni woman decorated this pot, she was performing as her ancestors had, a sacred act similar to a man's offering of prayer. Women deliberately inserted breaks into their ceramic patterns to allow the design's spirit to enter and exit the work. What substance do you think this jar held? The water, an important element in the desert climate, is considered the very life of the vessel.

Zuni Pueblo, New Mexico. Rainbird Jar, c. 1880, clay and pigments. Courtesy of The Montclair Art Museum, Montclair, NJ.

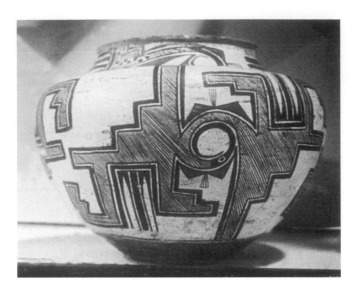

Evidence from African, Peruvian (Fig. 1-3), Inuit, and Native American cultures also suggest that women were active artists. They created primarily utilitarian objects with simple but elegant designs, seemingly inspired by the surrounding environment. As indicated by later tribal societies, females probably decorated items both to enhance their beauty and to honor the spiritual forces that were believed to inhabit the natural materials. (Fig. 1-4)

Female Artists of Antiquity

Why were men usually responsible for producing the grand palaces, temples, sculptures, and wall paintings in the Sumerian, Egyptian, Assyrian, Persian, Greek, and Roman civilizations? Women in these ancient societies generally were limited to domestic activities. They had little opportunity to obtain artistic training, with the exception of spinning and weaving, which were regarded as female occupations and handed down from mother to daughter.

Women in Ancient Egypt: The Land of Linen

Females in ancient Egypt generally fared better than those in Mesopotamia, Greece, or Rome. They had legal rights and could manage their own property, which would not automatically transfer to their husbands once they married. If they divorced, wives could claim part of their spouse's assets to support themselves and their children.

Women held few jobs in government because most were never taught to read or write, although on occasion a scribe's daughter inherited her father's position. However, some, particularly ladies of royal families, served as part-time priestesses in temples. Royal women also could act

The Origins of Women's Work
Perhaps the oldest arts of weaving, basket making, and pottery were female tasks because these activities were compatible with aspects of child rearing. Women produced textiles, tended gardens, and prepared food, while keeping an eye on their youngsters at home.

Language and Women's Art
The connection between creating life and spinning thread is illustrated in the term "life span." The word *span* comes from a verb meaning "to spin," which originally implied "to draw out or stretch long."

as regents. For instance, history indicates that Queen Ahhotep ruled on behalf of her young son Ahmose and even led troops into battle.

Egyptian paintings and small figurine models frequently portray females at their most essential jobs of spinning and weaving. (Fig. 1-6) By around 2000 BC, Egyptian women primarily produced linen, while their Mesopotamian sisters largely worked with wool. Perhaps the difference stems from the fact that Egyptian sheep were hairy rather than woolly, and that the people considered the animal's fleece ritually unclean. Moreover, linen, which is cool and absorbent, was practical for the hot, dusty climate of the Nile Valley.

Egyptian women not only fashioned garments from linen but towels, bed sheets, and blankets as well. They also used small pieces similar to today's tissue paper to wrap objects and cut larger sections into bandages to wrap the dead.

Mesopotamian Females: The Ancient Near East

Mesopotamian women enjoyed fewer rights than their Egyptian counterparts. Upon marriage, wives became their husbands' property, and daughters from poor families could be sold into marriage or slavery to improve a family's financial situation. A husband also could legally sell or pawn off his spouse or children to pay debts.

As elsewhere, women's main labor was running a home, including conducting the time-consuming process of making cloth. With the exception of female artisans and slaves, who had to work for others, the majority of well-off wives in the ancient Far East practiced the textile arts

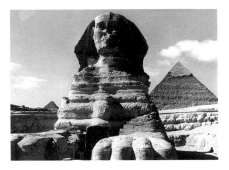

Fig. 1-5 Overall, women in ancient Egypt fared better than those in Mesopotamia, Greece, or Rome. They held some legal rights, and a few royal females themselves ruled the land or governed through their sons.

Pyramid of Cheops and Great Sphinx, *c.* 2530 BC, *Gizeh, Egypt.*

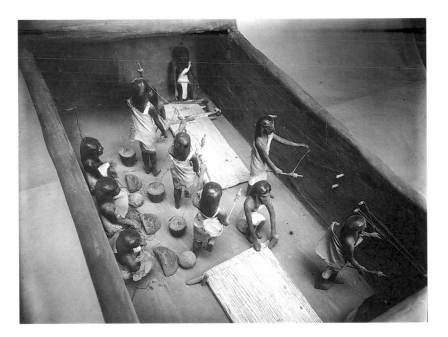

Fig. 1-6 Women often staffed and supervised textile production, which, along with agriculture and perfume manufacturing, was central to Egypt's economy. Females were responsible for every stage of making cloth. The women situated against the left-hand wall, dressed in simple white garments hanging over one shoulder, first spin the flax fibers into thread. Next, the figures near the opposite wall refine the materials before the weavers at the horizontal looms fashion them into finished cloth.

Wooden Model of Middle Kingdom Egyptian Weaving Shop, *from the Tomb of Meket-Re, Eleventh Dynasty, c.* 2000 BC. *All Rights Reserved, The Metropolitan Museum of Art. Photograph by Egyptian Expedition, 1919–20.*

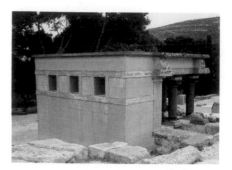

Fig. 1-7 Knossos was one of several Minoan cultural centers on the island of Crete. The complex consisted of multistoried painted buildings with many rooms, running water, a sewage system, theater, storage chambers, and terraces. Minoan women most likely made much of the earthenware found at the site.

Knossos, c. 1800–1600 BC. Knossos, Crete. Photograph by Michael Remer.

solely as a household chore. Yet not every woman was wholly satisfied staying confined to the domestic front. Records exist showing that some upper-class women went into business themselves, selling their home-spun goods abroad in exchange for gold and silver. Surviving Assyrian clay tablets document letters and accounts of wives, daughters, and sisters who operated weaving workshops and shipped off material to their husbands or other family members on trading expeditions, which flourished in Mesopotamia around the second millennium BC.

Creative Women of Crete: An Island Oasis in the Aegean

Females living in about the third millennium BC on the island of Crete held a relatively enviable position in this sunny and secure agricultural society. A queen-priestess ruled Minoan civilization, and women practiced all professions, including manufacturing the island's famous pottery, which was distributed throughout the ancient world.

In addition to creating ceramics, females fashioned beautiful cloth. They were the first in the region to use wool, which, unlike fibers from flax plants, was easy to dye and already came in various shades according to the pigmentation of particular sheep.

Minoan culture declined sometime between 1500 and 1400 BC, but oral tradition carried tales of the women's famous weavings down through the centuries. Many scholars believe that the Greek poet Homer, who lived around 800 BC, used stories of Minoan Crete to describe the island where Odysseus' ship was wrecked. Homer offered a glimpse of the Cretan women's daily lives in *The Land of Phaiakians*:

> *And fifty serving women belong to the house,*
> *some of whom grind on the millstone the ruddy grain*
> *while others weave at the looms and twirl their spindles*
> *as they sit, restless as the leaves of the lofty poplar,*
> *and the liquid olive oil runs down from the linen warps.*
> *By how much the Phaiakian men are expert above all other*
> *men in*
> *propelling a swift ship on the sea, by thus much their women*
> *are skilled at the loom for Athena has given to them beyond*
> *all others*
> *a knowledge of beautiful craftwork and noble intellects.*

Greece

Women, Weaving, and Mythology The connection between women and weaving abounds in early Greek mythology. Tales from the period suggest a relationship between spinning thread and creating life. This association may have evolved because many women spent their time weaving

while waiting to attend to an expectant mother during childbirth. The goddess Athena presents another connection between weaving and birth. She was the patron of weaving and brought fertility to the crops.

An early Greek myth about Athena's power tells of a girl named Arachne, who unwisely boasted to Athena that she easily could outweave her. The goddess challenged Arachne to a contest. While the girl crafted a rather indecent cloth depicting scandalous love affairs of the gods, Athena embroidered cautionary tales of mortals who dared to compete with the gods and depicted their resulting punishments. When the great goddess saw Arachne's handiwork, she became enraged and turned the girl into a spider, leaving her to spin complex webs in dark corners for all eternity.

Homer also honored Athena's weaving by associating the craft with human cunning in his epic poem the *Odyssey*. He described Athena continually helping the hero Odysseus out of difficult situations. When the two conspire on yet another plot, they cry out, "Come, let us weave a plan."

Greek Women and Textiles As in other areas of the ancient world, Greek females of all classes were responsible for manufacturing textiles. (Fig. 1-9) Wealthy women labored with their slaves at home, and poorer females earned income as wool workers in commercial enterprises.

Athenian women lost their equality with the dawning of the Classical Greek age, around 500 BC. Similar to their Mesopotamian sisters, those in the upper classes were held in haremlike seclusion and rarely allowed out except for major celebrations. At home, they were responsible for creating all the cloth for household needs.

The importance of weaving in Greek society is demonstrated by the selection of two Athenian noble girls every four years to help spin the yarn used in the robe for the life-size cult statue of Athena. It took the young ladies and two priestesses nine months to weave the elaborate garment, which portrayed the horrific battle between the gods and giants in sea-purple and saffron-colored threads. The robe honored Athena's powers for having saved the city when she led the gods to victory.

Making Athena's ritual clothes was one of the few occasions when women in the ancient world received recognition for their artwork. By about the middle of the second millennium BC, new technologies, generated in response to increasing market demand, changed how textiles were made. As a result, women were excluded from what grew to be lucrative businesses outside the home, because they were consumed by pregnancies and domestic responsibilities.

Sappho:
An Ancient Artist of Letters

Sappho, born approximately 600 BC, was one of the great early Greek lyric poets; Plato called her the tenth muse. She was an aristocrat who wrote poetry and produced several books, of which only fragments exist. One poem is titled "Thank You, My Dear."

> **Thank you, my dear**
> **You came and you did**
> **well to come: I needed**
> **you. You have made**
> **love blaze up in**
> **my breast—bless you!**
>
> **Bless you as often as the**
> **hours have been endless to**
> **me which you were gone.**

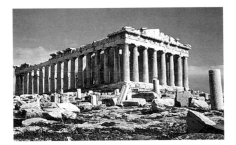

Fig. 1-8 The ruins of temples and statues on the Acropolis still cap the sacred hill above Athens. The elegant structures represent the height of classical Greek culture. The central building on the Acropolis is the Parthenon, a temple dedicated to the goddess Athena, after whom the city is named.

Iktinus and Kallikrates, The Parthenon, *448–432 BC, Athens, Greece.*

Fig. 1-9 This black-figure painting on Greek pottery shows women manufacturing cloth. The central image depicts two females weaving on a loom. How is this mechanism different from the one seen in the Egyptian model? (Fig. 1-6) Would you prefer to spend hours a day weaving on a horizontal or a standing loom, the latter of which is still used in parts of Greece today?

The vase is called a *lekythos*, a nearly cylindrical ancient Greek oil flask, tapered at the bottom, with a long, narrow neck and a small mouth. Women typically stored oils and perfumes in these vessels.

Lekythos. Attributed to the Amasis painter. Women Working Wool on a Loom, c. 560 BC. Said to have been found in Attica. The Metropolitan Museum of Art, Fletcher Fund, 1931. All Rights Reserved, The Metropolitan Museum of Art.

Women and Art in Greek Literature

Homer alluded to the significance of weaving in upper-class Greek women's lives in his narrative poems the *Iliad* and the *Odyssey*. He wrote of Penelope, the wife of Odysseus, spending her days weaving a shroud for Odysseus' father, Laertes, only to unravel it each night. For twenty years, Penelope kept her suitors at bay until her husband returned, by promising that she would pick a new lover only when her labor was complete.

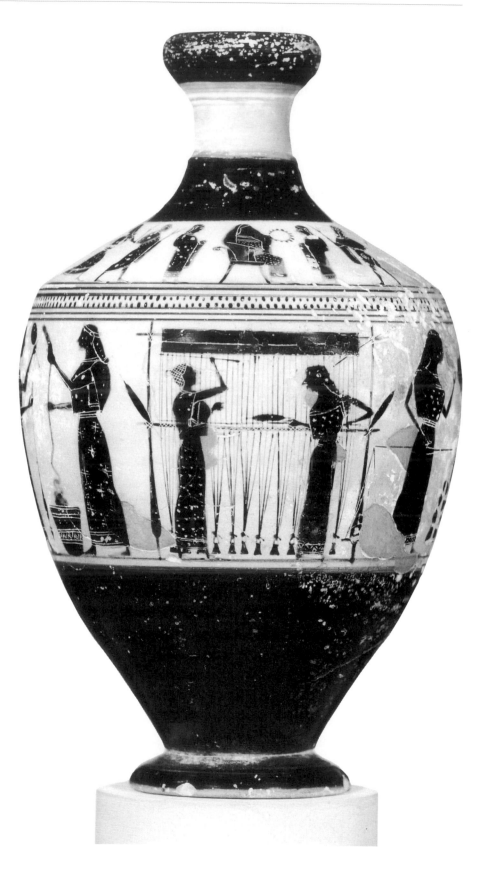

Early Greek Female Painters Ancient Greek mythology attributes the invention of painting to a woman. According to legend, the young maiden KORA, who lived in Corinth during the mid-seventh century BC, sketched the outline of her lover's shadow on the wall before he went off to war. Kora's father, the potter Butades, is said to have then filled in the drawing, building it into a relief sculpture.

The earliest surviving records of any female artist come from ancient Greece—a period when some artists began to sign their works. A handful of women's names remain, but relatively little is known about these individuals, and few works can be specifically attributed to any particular female. During the fourth to first centuries BC, wealthy Greek women began to receive a rudimentary education, which increased their ability to participate in cultural life. One of the most celebrated fourth-century women artists was HELENA. She is credited with having painted the original battle scene of Alexander the Great defeating Darius, which served as the basis for the famous mosaic in Pompeii. (Fig. 1-10)

Most of the information about female Greek artists comes from the Roman historian Pliny, writing in the early part of the first century AD. In his text on the history of art, he stated:

> *Women, too, have been painters:* TIMARETE, *the daughter of Mikon, painted an Artemis at Epheso in a picture of a very archaic style.* EIRENE, *the daughter and pupil of the painter Kratinos, painted a maiden at Eleusis;* KALYPSO *painted portraits of an old man, of the juggler Theodoros and of the dancer Alkisthenes;* ARISTARETE, *the daughter and pupil of Nearchos, painted an Asklepios....* OLYMPIAS *was also a painter; of her we know only that Autoboulos was her pupil.*

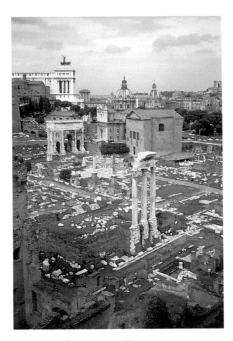

Fig. 1-11 The Roman Forum was constructed over many centuries, starting at the end of Julius Caesar's life. Today you can still see the ruins of the temples, state buildings, open spaces, basilicas, and monuments where Roman men, but not women, bantered about politics, trade, weather, battles, history, art, and gossip.

Forum Romanum, *Rome, Italy.*

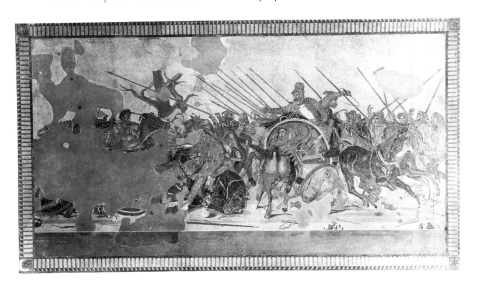

Fig. 1-10 The female Greek artist Helena is believed to have rendered the original painting on which this later Roman mosaic is based. This is one of the earliest surviving examples of women tackling a large-scale historical subject.

The Battle of Issus, *about* 100 BC. *Detail of Alexander, marble mosaic from the House of Faun, Pompeii, based on a fourth-century (c.* 315 BC) *Greek painting by Helena. Museo Nazionale di San Martino. Photograph courtesy of Soprintendenza Archeolgica delle Province di Napoli e Caserta, Naples.*

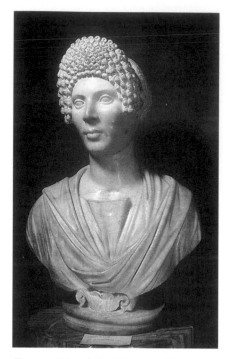

Fig. 1-12 How did artists record images of people many centuries before cameras were invented? Wealthy families commissioned Roman sculptors to create exact likenesses of themselves in marble. This woman's hairstyle and dress give us a good indication of how a well-to-do Roman lady might have appeared in ancient times.

Funerary Bust of a Woman, 120–130 AD, marble. The Nelson-Atkins Museum of Art, Kansas City, Missouri (Purchase: Nelson Trust).

Roman Marriages
For Rome's upper classes, marriage was a social and economic alliance rather than one of the heart. Families negotiated marriages and fathers sometimes chose a husband who was twice his daughter's age.

Pliny's observations reveal certain recurring historical patterns relating to female artists. For instance, women often learned their trade from their fathers; the art of portraiture was common; and female artists, even at this early time, served as teachers, with their own pupils.

Although relatively few names of artists of either gender exist from antiquity, women constitute a particularly small percentage. Powerful cultural elements contributed to this fact. First, far fewer women than men composed the population at large. The Greeks practiced female infanticide, and those young girls who did survive were fed an inferior diet compared with young boys; hence, the girls had a poorer chance for a long life. Females also married at an earlier age—between twelve and fifteen years old—and quickly became absorbed with household concerns. Furthermore, many women did not live beyond the childbearing years because death during pregnancy was common. With a life expectancy from five to ten years shorter than a man's, and their energies devoted to the family and home, it is no wonder that only a minute fraction of the female population were able to pursue any profession, including the arts.

Female Artists in Ancient Rome

Roman women were even less involved in public life than those in Greece. Works by male Roman artists show that women typically were restricted to conventional roles of obedient daughter, faithful wife, and caring mother. (Fig. 1-12) The name of only one female Roman artist has survived, IAIA OF KYZIKOS, active around 90 BC. Pliny praised Iaia in his writings and said that Emperor Augustus exhibited two of her works in his residence. Pliny remarked on Iaia's talents, stating that "no artist worked more rapidly than she did and her pictures had such merit that they sold for higher prices than those of Sopolis and Dionysios, well-known contemporary painters whose works fill our galleries." Pliny also described a self-portrait that Iaia painted with the help of a mirror, possibly the first easel self-portrait ever recorded. Because he noted that Iaia remained unmarried throughout her life, perhaps the artist's single status was not only unusual but also crucial to her professional success.

Few accounts of female painters from antiquity exist, but it is likely that the accomplishments of others have been lost over the centuries. Unfortunately, despite changes in women's artisitc involvement in the upcoming medieval era, documentation remains sparse.

European Middle Ages:
The Expanded Sphere of Female Creativity

Women's Lives in Medieval Europe

Why didn't Europe's Middle Ages offer more significant artistic opportunities for women? The scarcity of female artists from about 500 AD to the late fourteenth century is directly related to their position within larger Western society.

On the one hand, compared with women from earlier eras, those from the upper class, such as queens, princesses, and noble ladies, exerted far more power and influence than ever before. They often controlled large estates or royal courts while men went off to battle or were away on business, and many females became great patrons of the arts.

Most women rarely had careers outside the home. Whether accomplishing the work themselves or overseeing servants who did, females from all classes remained confined to the duties of family and hearth. During the early Middle Ages, the majority of women toiled alongside men in the fields; raised livestock; prepared meals; made bread, cheese, butter, beer, and candles; preserved meats, vegetables, and fruits; and produced both the raw materials and finished garments to outfit their families.

These duties were time-consuming, but they provided females with a degree of influence and independence. Their situation deteriorated, however, after the thirteenth century, when men shifted the production of many basic supplies away from the home to organized, urban enterprises. By the fifteenth century, male-dominated *guilds* (a union of people specializing in specific trade) began to exclude women deliberately to protect the economic status of their male members. Women remained active only in cloth and related crafts industries such as embroidery and dress and ribbon making, which historically had been female domains.

Artistic Training in Convents: Art in the Sacred Realm

As compared to the past, women found the largest opportunity for creative expression in the sacred rather than the secular realm. Many females produced art in medieval religious institutions. In western Europe, the Christian Church was the dominant social and political force, and convents, like monasteries, became great cultural centers. These powerful institutions provided superior working conditions, artistic training, and quality materials for artists to create objects that glorified the Christian God and the church. At convent schools, women were taught to weave tapestries, embroider wall hangings and vestments, and

European Guilds
People originally formed guilds to promote and protect the highly prized skills of their members. Although these organizations reached their height during the Middle Ages, some exist in various forms today.

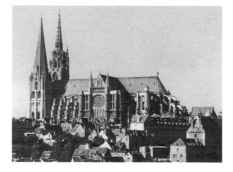

Fig. 1-13 From afar, the twelfth-century Chartres Cathedral and the city's old quarters do not look so different today from how they probably appeared in the Middle Ages.

Chartres Cathedral, *c.* 1142, *Chartres, France. Courtesy of the French Government Tourist Office.*

Wool Tapestries

Woven wall hangings were not unknown in ancient times, but during the European Middle Ages they became a popular and convenient method of adding color and warmth to large, drafty, damp stone buildings.

Fig. 1-14 Female needleworkers almost certainly stitched portions of the 230-foot-long Bayeux Tapestry, which depicts William the Conqueror's invasion of England in 1066. Imagine worshipping in the Bayeux Cathedral during the Middle Ages, with this intricate narrative tale decorating the walls.

Bayeux Tapestry (detail), c. 1073–83, wool embroidery on linen. Courtesy of the French Government Tourist Office.

finely decorate pages of religious texts. These opportunities were available only to females from wealthy families, because a large *dowry* was required to join the convent.

Notably, convents not only were a means for upper-class women to pursue artistic endeavors but also served as one of the few socially acceptable alternatives for those who did not wish to marry and raise a family.

Embroidery As already noted, females made textiles long before recorded history. In the early Middle Ages, before the development of town economies in the twelfth and thirteenth centuries, noblewomen executed *embroidery* (decoration of textiles with needlework) primarily in convents and at home. They learned the art as part of their convent education. Unlike today, embroidery was not considered a casual pastime; it was a serious undertaking and appreciated as an important art form. (Fig. 1-14) Men in monasteries and secular workshops also were embroiderers, but only females from the upper classes had the leisure and education to pursue this time-consuming activity.

England was the most famous center for the needle arts, which were known collectively as *opus Anglicanum*, or "English work." (Fig. 1-15) The term refers to the country's expressive embroideries

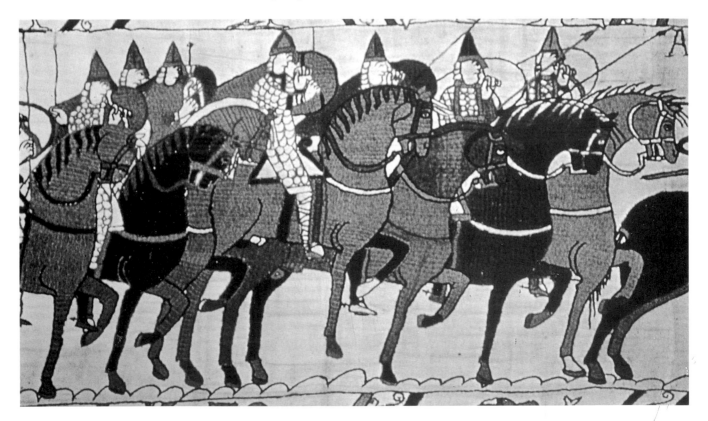

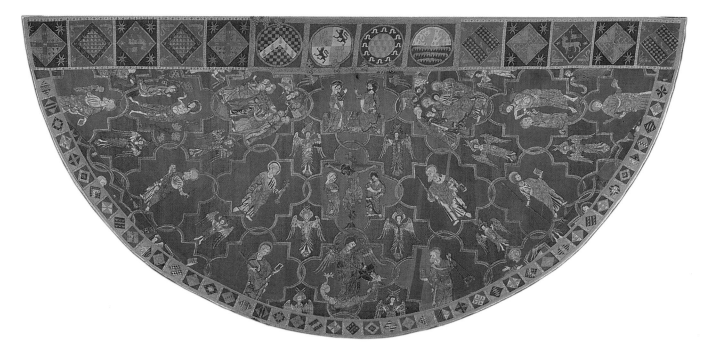

encrusted with pearls, jewels, and luminous gold, silver, and colored silk threads sewn onto velvet or linen. Artists typically depicted biblical scenes and those from the everyday world. Royalty, clerics, and wealthy persons throughout Europe greatly desired these elaborate, shimmering masterpieces, which were fashioned into wall hangings, curtains, banners, altar covers, tapestries, carpets, religious vestments, and ceremonial garments.

After the mid-thirteenth century, the demand for examples of *opus Anglicanum* grew so large that men shifted production away from convents or individuals in scattered residences to organized, commercial industries in town. As with manuscript illumination, they instituted protective laws that gradually relegated women to the most menial aspects of the process. In the fourteenth century, a tapestry guild forbade pregnant or menstruating women from working on large tapestry looms. Furthermore, in the fifteenth century, workshops of male embroiderers traveled in teams, thus further excluding women, whose ties were attached firmly to the home.

Manuscript Illumination Prior to the invention of the printing press, writing and painting were closely linked, and scribes typically were responsible for drawing the images on their pages. Copying and illustrating sacred text were considered acts of religious devotion because their very execution was believed to inform the mind and raise one's soul to God. (Fig. 1-16)

Fig. 1-15 How do the images in this delicate embroidery indicate the textile's initial function? The cope, a long church vestment, originally belonged to the Bridgettine Nuns of the Syon Convent, located outside London. Its *quatrefoils* (stylized floral images with four petals) are filled with scenes from the life of Christ and the Virgin, St. Michael slaying the dragon, and the twelve apostles.

The Syon Cope, 1300–20, *linen embroidered with colored silks, silver-gilt, and silver thread. Victoria and Albert Museum, London. Photograph © Trustees of the Victoria and Albert Museum, London.*

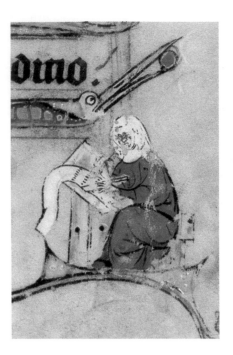

Fig. 1-16 Before the invention of the printing press, scribes, as seen with this laywoman, typically transcribed the written text and added their own imaginative illuminations. Consider the time and care it took to create this delicate and lively image.

Flemish(?). Book of Hours MS B.11.22 Fol. 100 e, *c. 1300, watercolor on tempera, miniature. Master and Fellows, Trinity College Library, Cambridge, England.*

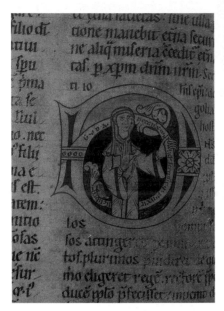

Fig. 1-17 A woman called Guda not only signed her name to this twelfth-century homily of St. Bartholomew, but also included a self-portrait, firmly grasping the large initial letter D. The words around her body proclaim: "Guda, a sinner, wrote and painted this book."

Guda. Self-portrait in Letter D (from manuscript Ms. Barth.42, fol.110vb.), *twelfth century. Stadt- und Universitätsbibliothek, Frankfurt am Main.*

Medieval artists of both genders customarily did not sign their work; thus, only a few examples by women have been identified. The earliest known female illuminator is ENDE, who lived in Spain around 975 AD. She contributed to a remarkable manuscript that describes the visions of St. John the Divine in the Book of Revelations, a popular topic in the tenth century. Within her imaginative, nearly hallucinatory illustrations, the artist refers to herself as *"Ende pintrix et dei aiutrix"* (Ende, woman painter and servant of god).

Artists sometimes inserted small self-portraits within illustrated manuscripts as a way to "sign" their works. GUDA, a twelfth-century nun from Westphalia, included her self-portrait in a *homily* (a moralizing lecture or written work about a specific topic) on St. Bartholomew, along with the words "a sinner wrote and painted this book." (Fig. 1-17)

Another illuminator, CLARICIA, probably was a laywoman working in a convent's *scriptorium* (copying workshop) in Augsburg. She painted her body joyously swinging outward as the tail of the letter Q in an early-thirteenth-century south German *psalter* (a collection of Psalms—sacred songs or poems used in worship). Claricia encircled her head with the letters of her name as if it were a halo, an appropriate association for the sacred text. (Fig. 1-18)

Other famous female illuminators include the nuns ST. GISELE VON KERSSENBROEK (Fig. 1-19), ADAHLHARD, ST. RATHRUDE, and DIEMUD, whose name, according to her biographer, became a byword for productivity because she produced some forty-five manuscripts that "exceeded what could be done by several men."

Fig. 1-19 Gisele von Kerssenbroek wrote and illuminated this manuscript, referred to as *Codex Gisele*. Can you detect all the minute nuances in the images within the capital P? The nun Gisele signed the very edge of the Virgin's coverlet and beneath portrays her community holding a sacred book. This intricate miniature is just one of fifty-two that Gisele completed in the text.

St. Gisele von Kerssenbroek. Codex Gisele, Initial P, 1300, parchment. Courtesy of Bischofliches Generalvikariat, Osnabruck.

Fig. 1-18 The scribe Claricia includes a rambunctious image of herself exercising on the letter Q. Her clothing suggests that she was probably a laywoman working in a convent's illumination workshop. Notice how the thin green lines in Claricia's wide sleeves echo the same color within the initial.

Claricia. Claricia and Initial Q, St. Memin Psalter, c. 1200, Germany. The Walters Art Gallery, Baltimore.

Artistic Penmanship: Medieval Scribes

During the Middle Ages, scribes typically worked within monasteries in rooms called scriptoria. These scribes fulfilled the increasing demand for copies of classic and religious texts. A single book could take years to transcribe. The texts were valuable for both the information they contained and their lavish decorations. Because of their great value, owners often chained manuscripts to desks to prevent theft.

Numerous influential abbesses who ran convents also were important to the development of manuscript illumination. These capable female administrators and educators sometimes worked on the books themselves or closely supervised those who did. A sampling includes AELFLAED, Abbess of Whitby; AETHELTHRITH, Abbess of Ely; CHRISTINA of Mergate; EUSTADIOLA of Bourges; HITDA of Meschede; AGENES of Quedlinburg; ADA, sister of Charlemange; and UTA, Abbess of Regensburg.

The twelfth century Abbess of Hohenburg (Alsace), HERRAD OF LANDSBERG, earned special renown. Between 1160 and 1170, she wrote and illuminated a massive text designed to educate her nuns in none other than "the history of the world, from the Creation to the Last Days." She introduced herself in *Hortus Delicarum* (The Garden of Delights), writing:

> *Herrade, who through the grace of God is abbess of the church on the Hohenburg, here addresses the sweet maidens of Christ.... I was thinking of our happiness when like a bee guided by the inspiring God I drew from many flowers of sacred and philosophic writing this book called* The Garden of Delights.

Fig. 1-20 Can you see how St. Hildegard's commentary matches her illustration? "And it happened in the year 1141 of Christ's incarnation, when I was forty-two years and seven months old, that a fiery light of great brilliancy streaming down from heaven entirely flooded my brain, my heart and my breast, like a flame that flickers not but gives glowing warmth, as the sun warms that on which he sheds his rays."

St. Hildegard von Bingen. Illustration from Scivias *(plate 13 321), 1165. Hessische Landesbibliothek, Wiesbaden. Photograph courtesy of Rheinisches Bildarchiv.*

Hortus Delicarum contains 636 *miniatures* (very small paintings), and unlike most medieval manuscripts, the images dominate the written text. The book, with its allegorical figures, illustrations of biblical scenes, apocalyptic visions, gardening hints, and scenes from contemporary life, serves as a medieval pictorial encyclopedia or almanac.

St. Hildegard of Bingen (1098–1179), the abbess of a convent in Germany, was regarded as one of the great mystics of the Middle Ages. She was involved in natural science, medicine, political and religious debates, music, and language reform, and even invented her own secret language. Beginning in 1142, St. Hildegard oversaw the production of a richly illuminated manuscript, *Scivias* (Know the Way of the Lord), which describes thirty-five of her personal revelations regarding the history of salvation. (Fig. 1-20) Along with Ende's earlier paintings, *Scivias* appears to be one of the first medieval manuscripts in which line and color depict scenes of supernatural contemplation.

St. Hildegard and Herrade, along with other abbesses of the era, were pioneers of this form of visual autobiography, created either by their own hand or under their direction. This twelfth-century trend also demonstrates women's growing attraction to a more personal form of spirituality. The shift was prompted largely by the erosion of women's ability to maintain active leadership roles because of new social and church reforms. When barred from the intellectual life of cathedral schools and universities, females increasingly turned toward mysticism and the use of vivid imagery; they also inspired commentaries as an alternative means of spiritual discourse.

Turning of the Tide: Female Lay Artists

Prior to the late thirteenth century, sacred illumination had been produced almost exclusively in monasteries and convents. However, as the demand for professional secular scriptoria grew, men pushed women out of manuscript enterprises; thus, few female lay illuminators are known. One, however, was Anastaise, a favorite contemporary of the first professional feminist writer in Western history, Christine de Pisan. In 1405, Christine celebrated the artist in her book *Cité des Dames* (*The City of Women*):

> *I know a woman named Anastaise who is so skillful and experienced in painting the borders of manuscripts and the backgrounds of stories that no one can cite a craftsman in the city of Paris, the center of the best illuminators on earth, who in these endeavors surpasses her in any way.*

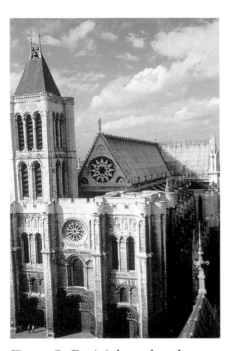

Fig. 1-21 St. Denis is located on the outskirts of Paris, one of the cities in which female lay artists, such as Anastaise, found employment. St. Denis' architecture marks the beginning of the second half of the medieval period. Its windows, stained glass, and enlarged apse let in a great deal of light, which symbolizes God's presence.

St. Denis, begun 1140, Paris, France. Courtesy of D. Thierry, French Government Tourist Office.

St. Hildegard's Vision

In her book *Scivias*, St. Hildegard described the impact of her visions:

It was in my forty-third year, when I was trembling in fearful anticipation of a celestial vision, that I beheld a great brightness through which a voice from heaven addressed me: "O fragile child of earth... express and write that which thou seest and hearest.... Not according to art but according to natural ability,...under the guidance of that which thou seest and hearest in God's heaven above."

Despite high praise, Anastaise apparently was confined to painting the secondary features of manuscripts, such as backgrounds and border patterns, rather than the more significant human figures.

Another important lay illustrator was BOURGOT, who, around 1353, helped her father, the painter Jean Le Noir, execute a Book of Hours for a wealthy patron from Flanders. The team's other distinguished clients, including King Charles V of France, are further testimony to the pair's artistic skills.

Only a limited number of female medieval painters have been linked confidently to specific works, and their illuminations were physically quite small. Undoubtedly many women's endeavors remained unsigned, and others were lost through the ages. However, creative women of the Middle Ages were the forerunners of later female Renaissance artists who would soon paint large and impressive canvases.

Sculpture

There is no concrete evidence of female sculptors in prehistory or antiquity. Their absence can be traced in part to the use of sculpture by men in early primal cultures for magical and spiritual functions. In later periods, and to some degree extending into the modern era, the manual labor of working in stone, wood, or metal was considered too physically demanding for women, who were perceived as the "weaker" sex.

Nonetheless, names of female sculptors from the late Middle Ages do occasionally appear in guild records. One such artist might have been SABINA VON STEINBACH (active early fourteenth century). Some scholars credit her with completing the figures on the south *portal* (the entranceway of a church) of the Strasbourg Cathedral, in France, which Sabina's father had left unfinished at his death in 1318. The apostle St. John the Baptist holds a scroll with words that carry conflicting evidence: *Gratia divinae pietatis adeto Savinae de petra dura per quam sum facta figura* ("Thanks be to the holy piety of this woman, Savina, who from this hard stone gave me form"). Some believe the lines credit Sabina as the artist, while others think they refer to her as the donor. An oil painting inside the cathedral, illustrating a young female sculptor kneeling before the archbishop to receive his blessing and a laurel wreath, further confuses the debate. Regardless of Sabina's authorship of these particular statues, guild records ultimately prove that at least some women sculptors did exist during this period.

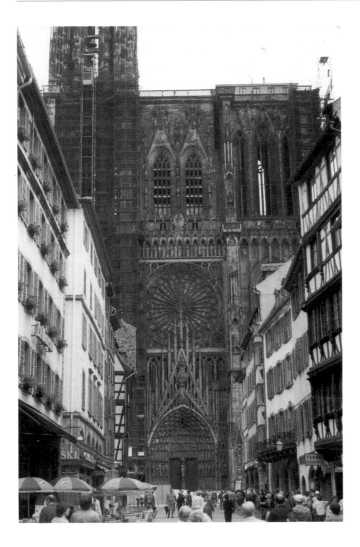

Fig. 1-22 Some credit Sabina von Steinbach for completing the sculptures on the south portal of the late-medieval Strasbourg Cathedral, still an imposing structure today.

Strasbourg Cathedral, *west facade begun 1277, Strasbourg, France. Photograph by Abby Remer.*

The Shifting Scene

Prior to antiquity, women primarily poured their creative energies into artistic endeavors related to the domestic realm. This continued in the ancient world. Early Greek and Roman historians did record the names of some notable female painters, but the majority doubtless remain unknown.

In the medieval period, anonymous women artists in convents, courts, and estates worked with brushes, pens, needles, and chisels. However, the Middle Ages also marked the beginning of the distinct division between men's involvement in the external world and women's confinement to the domestic realm. Later, the Renaissance and the Reformation would introduce a profound humanist spirit that emphasized individuality, particularly in the arts, but females would continue to encounter major obstacles to their creativity.

Nameless Through the Ages
In 1929, the British novelist and essayist Virginia Woolf made an interesting observation that applies as easily to women artists as female writers: "Indeed, I would venture to guess that Anon, who wrote so many poems without signing them, was often a woman."

Chapter 2

The 15th–17th Centuries in Southern Europe:
Setting Precedents

Renaissance Society

The European *Renaissance* (a French term meaning "rebirth") had far-reaching repercussions in Western culture, particularly in the arts. How did these changes impact women and their ability to become professional artists?

The Renaissance began in Italy around the fifteenth century, and its influence moved northward over the next 200 years. During this period, independent city-states and nations eroded the church's status as the dominant international, political, and religious leader. The emergence of Humanism powerfully shaped the new age.

Humanist philosophy developed as a reaction to the turmoil of the late fourteenth and early fifteenth centuries, an era marked by the Hundred Years' War, the Black Death, the eviction of the papacy from Rome, and the subsequent diminishing of faith in the church. The fall of Constantinople in 1454 also greatly affected Humanism. Numerous Christian refugees who fled to Italy brought with them an ancient Greek conception of man as the measure of all things, giving rise to the Renaissance emphasis on the importance of the individual in secular life.

Art in the Renaissance

How did the early-fifteenth-century art world react to the rise of an increasingly prosperous merchant class, whose power often equaled and at times even rivaled that of the church and landed nobility? Art acquired a middle-class, secular character. Previously, in the late Middle Ages, artists had begun working as members of commercial guilds rather than in convent or monastic workshops. Now, instead of acting as anonymous craftspeople, artists were gaining recognition for their creativity, fostered by the individualistic Renaissance philosophy. Artists no longer were considered merely craftsworkers, but gifted individuals who could mingle with political, religious, and intellectual leaders.

Was patronage affected by these changes? In addition to the church, affluent mercantile families, who could not claim status through birth, also initiated commissions of magnificent artworks that tangibly

The Birth of Artist as Genius
The idea of artists as exceptional individuals began, in part, during the early Renaissance. Italian citizens from various cities openly competed with one another by promoting the creative achievements of the men in their urban communities.

expressed their expanding political and economic power. Art in the Renaissance not only glorified the Christian God but also served as a visible symbol of personal and civic pride.

Within this context, a small number of female artists emerged. To comprehend women's relationship to art, it is important first to consider the nature of their lives within Renaissance culture as a whole.

Women in Renaissance Society

European Females of the Peasant and Lower Classes For women of the lower classes in rural communities, little had changed since European medieval times. They still contributed to the family economy, carrying out agricultural as well as domestic duties. Among the urban working class, females experienced increased limitations in guild-organized trades. What happened to women as men increasingly commercialized profitable craft enterprises? Beginning in the medieval era, these male-dominated institutions relegated female members to the least lucrative aspects of a particular craft, effectively prohibiting their ability to compete financially with men. Women remained active only in industries related to textiles, continuing their traditional association with spinning, weaving, and embroidery.

European Women of the Upper Ranks During the Renaissance, noble and royal females in courts and manors lost much of the power that they had wielded when men were away at war during the Middle Ages. They

From Panel to Canvas

Artists in Renaissance Italy were the first to favor the use of canvas over wood panels. By the seventeenth century, painters throughout western Europe relied on canvas. This shift in materials occurred in part because of the increased construction of ships for trade with the East. High-quality oak was hard to obtain because some 4,000 planks were needed to build just a single vessel, which would last for only one or two voyages before rotting. Canvas also had the advantage of being easily portable, allowing painters to carry their works as they traveled around Europe's art centers. Rembrandt commented that he didn't have to leave Amsterdam to see Italian pictures because so many passed through his northern city's ports.

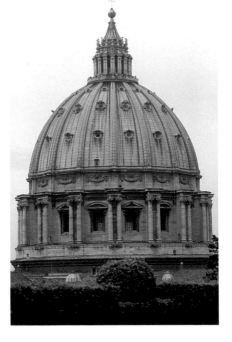

Fig. 2-1 The Italian High Renaissance artist Michelangelo designed the magnificent dome that tops St. Peter's in the Vatican, Rome. Sofonisba Anguissola's father sent an early drawing of hers to Michelangelo, seeking advice on how to advance his daughter's creative talent.

Michelangelo. St. Peter's Dome, *1546–64, Rome, Italy. Photograph by Oliver Radford.*

A Female Creative Profession
In the sixteenth century, women primarily participated in crafts associated with the textile industry. The term "spinster" derives from the fact that predominantly unmarried women who did not have to care for their families could afford to carry out the most tedious and low-paying job of spinning wool.

A Humanist's Viewpoint
The Humanist scholar Juan Luis Vives (1492–1540), hired by Queen Isabella of Spain to teach her four daughters, outlined the benefits of educating young females in his book *Instruction of a Christian Woman* of 1523: "The study of learning is such a thing that it occupieth one's mind wholly and lifteth it up into the knowledge of most goodly matters and plucketh it from the remembrance of such things as be foul." Vives was considered liberal in his day, but he ruled out teaching females grammar, logic, history, literature of romance and war, and the Greek and Latin poets. Instead, he preferred to instruct women about the holy books, works by Christian poets, and texts on moral philosophy that would "teach them to subdue passions and quiet the tempest of their minds."

now were even more narrowly confined to the role of wife and mother. Nonetheless, the advent of Humanism did alter women's lives to some extent and, by extension, their opportunity to become professional artists.

Humanism's Effect on Women: Increasing Educational Opportunities

Humanists recommended universal education and, by the sixteenth century, both upper- and middle-class females throughout much of Europe were taught by private tutors or in public schools. Women, unlike men, did not learn rhetoric, mathematics, or the sciences—subjects men perceived as too subtle and obscure for "female minds." Instead, women were instructed in religion, moral philosophy, and the classics, with the intent of protecting their innocence and encouraging prescribed feminine behavior.

The major goal of female education was for women to learn subjects and skills that would make them more interesting companions to men, prepare them for family life, and reinforce the concepts of female virtue—obedience to husbands, chastity before marriage, and fidelity ever after.

Although the impact of Humanist thinking primarily influenced men, the philosophy's regard for individuality did generate a climate in which a number of females were able to participate as artists. These women entered the profession through the back door, however, still functioning within the strict definition of suitable feminine conduct.

Humanist Education, the Arts, and Female Artists

The Humanists broke with the past conception of art as craft, promoting it instead as a noble educational pursuit. Now any well-born, properly educated young lady acquired at least passing knowledge of music, literature, and poetry, although she was schooled as an "amateur." Why would it typically have been inconceivable for upper-class women, or men for that matter, to join the ranks of professional artists? Society imposed a strong stigma upon artists because they shared representation with working-class craftspeople in the same guild associations. Therefore, only educated, but not aristocratic, individuals commonly became professional artists.

Females encountered obstacles beyond social constraints in their pursuit of creative careers. Humanist education had initiated a change in artistic training so that artists now were expected to possess a thorough

knowledge of science, mathematics, and perspective—the very subjects women were not taught. It was also often financially and socially impossible for them to work as an apprentice to a master—the requisite route for advancement. Even if females were willing to risk their "reputation" by working in the frequently unsavory male-apprentice community, society believed that their long years of training left them "too old" to wed, particularly in an era when marriage was women's primary means of economic security.

Were there any unifying factors among female Renaissance artists? For the most part, these women received training only as talented wives, daughters, or sisters of male artists. Even within this relatively nurturing artistic environment, women were not permitted to study from a male nude model because it was considered too scandalous. Without formal schooling in human anatomy, women gained few important commissions for the multifigure historical or religious compositions that were more highly prized art forms than portraiture or still lifes. Furthermore, because household duties prevented most females from traveling, they frequently remained unexposed to the most current artistic trends developing in western European art centers.

The Artists

The Decline of Art in Sacred Institutions

As in the Middle Ages, marriage and motherhood still were the expected female roles. Only women with money could choose an alternative lifestyle in a convent. Unfortunately, even these women were isolated from the new and sophisticated artistic knowledge circulating the temporal world.

Despite the growing secularization of European society during the early Renaissance, a number of nuns did gain recognition as artists. Examples include MARIA ORMANI, who in 1453 drew a self-portrait in a *breviary* (book of daily prayers and readings); ANTONIA UCCELLO from the Carmelite Order in Florence, the daughter of the renowned painter Paolo Uccello; and DONNA ANDRIOLA, a painter and mother superior. BARBARA RAGNONI was a fifteenth-century Italian nun who painted religious subjects in the Sienese convent of Santa Marta. MADDALENA CACCIA completed a mural that her father had started for the church in Moncalvo, after his death in 1625. PLAUTILLA NELLI, an early-sixteenth-century abbess, worked at the convent of St. Catherine in her native city of Siena. One of her numerous commissions was an ambitious fresco for Santa Maria Novella in Florence. Both she and PRUDENZA CAMBI reportedly trained other nuns as well.

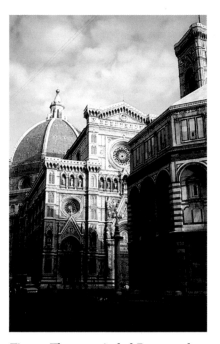

Fig. 2-2 Florence rivaled Rome as the cultural center of the Italian Renaissance, and artists often worked for patrons in both cities. Today the massive cathedral still captivates viewers with its marvelous, colorful marble that constantly changes shades with the shifting light.

Florence Cathedral. *Building designed by Arnolfo di Cambio in 1296 and the huge octagonal dome created by Filippo Brunelleschi, 1420–36, Florence, Italy.*

The Three-dimensional World: Renaissance Technical Advances

In fourteenth-century Italy, mathematics and art united to create one of the most significant technical advances in Western painting—the development of *linear perspective*. Linear perspective is a principal geometric technique used to generate the illusion of depth. Objects are drawn on straight lines that radiate out from a *horizon line*—the point at which the sky and earth appear to meet—and grow progressively smaller and closer together.

Art in the Veins: Sofonisba Anguissola's Creative Sisters

Sofonisba Anguissola's sisters also were accomplished artists, although they never achieved her acclaim.

ANNA MARIA (active 1568–85) Painted portraits and religious subjects

ELENA (active second half of sixteenth century) Studied with Bernardoni Campi, along with Sofonisba; entered the convent of San Vicenzo at Mantua in 1584

EUROPA (died c. 1578) Painted portraits and religious works

LUCIA (1540–65) Studied with Sofonisba

MINERVA (active second half of sixteenth century) Painter and Latin scholar who died quite young

Eventually, at the height of the Italian Renaissance in the sixteenth century, convents lost their autonomous status and funding. Along with the effects of the Reformation, this development hindered females living in sacred orders from continuing to make significant artistic contributions. Henceforth, virtually all renowned women artists came from the secular realm.

Sofonisba Anguissola: International Acclaim

SOFONISBA ANGUISSOLA (c. 1532–1625) was one of the first female Renaissance artists to achieve an international reputation, and her substantial body of work is well documented. Unlike her peers, Anguissola's father was not an artist. As a nobleman, however, he embraced Humanism's concept of the proper education for a cultured young lady. He provided all six of his daughters with an artistic education, which, in addition to painting and drawing, included poetry, literature, Latin, and music. Economics undoubtedly also played a role in Anguissola's father's decision to encourage his daughters' accomplishments—their achievements would make it easier for him to arrange for them to marry wealthy husbands.

It was unacceptable for females of Anguissola's social class to travel alone and study in Rome, then the cultural center of Italy. Therefore, she and her sister Elena apprenticed for three years with a local painter, Bernardino Campi, in their hometown of Cremona. Elena eventually abandoned painting to become a nun, but Sofonisba instructed her three younger sisters, one of whom later became an accomplished artist.

Ultimately, though, Sofonisba displayed the most exceptional talent in the family. Sofonisba's father promoted his daughter's career. In 1577, he corresponded with the Renaissance master Michelangelo and asked him to critique several of her drawings. In response to a composition of a smiling girl, Michelangelo replied that he admired the work but then challenged Anguissola to depict a more difficult subject of a crying boy. Anguissola's later art demonstrates her mastery at portraying a breadth of emotions, as seen in the loving relationship between the Attavanti siblings. (Fig. 2-3)

As a female, Anguissola was denied training in anatomy and therefore turned to portraiture rather than large historical or mythological figurative scenes. Her intimate representations conveyed a wide range of feelings and personalities in her subjects' faces. (Fig. 2-4) Anguissola's paintings greatly influenced her contemporaries' approach to conventional portraiture and anticipated the more passionate tenor of later Italian Baroque art.

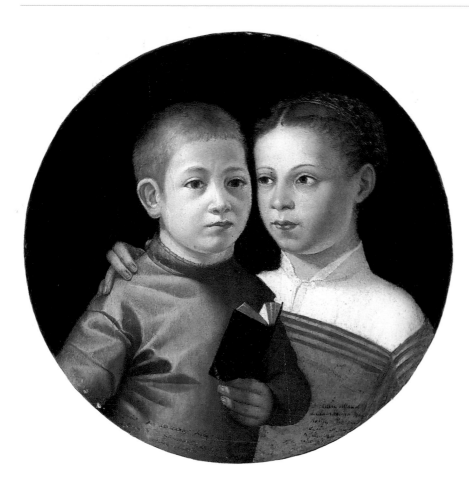

Fig. 2-3 What is the relationship between these two siblings from a wealthy Florentine family? In Sofonisba Anguissola's double portrait, the boy seemingly is absorbed in thoughts about his reading, demonstrating that even at such a tender age he is quite the educated young man. His sister is not engaged in intellectual pursuits, but rather one of emotion, as she tenderly embraces him. Perhaps it was she who taught her brother to read. As they grew older though, typically only the boy would be further schooled in academics, whereas the young lady would learn just those subjects necessary to run a household and entertain men.

Anguissola's radiant colors and subtle expressions support the claim that her pictures were "so lifelike that they lacked only speech."

Sofonisba Anguissola. Double Portrait of a Boy and Girl of the Attavanti Family, *date unknown, oil on panel. Allen Memorial Art Museum, Oberlin College, Ohio; Kress Study Collection, 1969.*

How did Anguissola's style reflect the Renaissance quest for realism? Her attention to precise details demonstrated society's desire to bring order to the observable world. Anguissola's devotion to artistic "truth," or realism, is illustrated in a letter she sent Pope Pius IV, which accompanied her portrait of the queen of Spain: "If the brush could repeat the beauties of the queen's soul to your eyes, they would be marvelous. However, I have used the utmost diligence to present what art can show, to tell your holiness the truth."

By 1559, Anguissola's reputation earned her an invitation to the Spanish court, where she received a generous annual pension, many gifts, and a substantial dowry when she married a rich nobleman and moved to Sicily in 1570. After his death four years later, Anguissola wed a ship's captain whom she met on her trip back to the mainland.

Anguissola was remarkable both because of her personal achievements and her ability to break new ground for future generations of female artists. The adulation, public recognition, and financial rewards she received provided keen incentive to her successors, who would nonetheless still encounter strong deterrents in their own careers.

Fig. 2-4 What are these young women doing? Sofonisba Anguissola depicts herself and her sisters engaged in a competitive intellectual contest. She pulls us into the scene through the figure that stares outward, acknowledging our presence. Anguissola's sophisticated composition, accurate details, and lively facial expressions demonstrate her confidence and sensitive artistic eye.

Sofonisba Anguissola. Three Sisters Playing Chess, 1555. *Muzeum Narodowe, Poznan, Poland.*

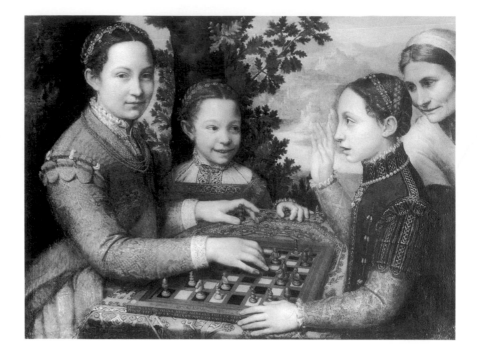

A Unique Mixture

According to some sources, ONORATA RODIANA (d. 1452) accomplished the unique feat of being both a successful fresco painter and a valiant soldier. Born in Castelleone, near Cremona, early in the fifteenth century, she became a reputable artist at an early age. One day, as Rodiana was working on a commission to decorate the palace of Gabrino Fondolo, a young nobleman attacked her. She stabbed him in the heart with a dagger, disguised herself in men's clothing, and fled to the mountains, where she became an officer of a fighting company. Fondolo eventually pardoned Rodiana so that she could return to finish his palace, but she remained a soldier and died defending her homeland against the Venetians.

Bologna: Center of the Women's Renaissance

Reports of Anguissola's success must have reached Bologna. But why would just this one Italian city produce as many as twenty-three women artists during the sixteenth and seventeenth centuries?

Bologna's university, founded in the Middle Ages, fostered the progressive intellectual atmosphere for this unusually high number of female artists. The school had educated women since the thirteenth century, although its female students were required to wear men's clothing. Women studied philosophy and law and became writers, educators, and publishers. In the fourteenth and fifteenth centuries, the university also supported the rise of a group of *miniaturists* (painters of very small portraits), which included female artists.

Women artists also benefited from Bologna's many civic and sacred commissions. The elegant Bolognese art of the era reflects the status of its fashionable patrons as well as the virtuous imperatives of the Counter-Reformation and society's attempt to amend the Catholic Church.

Finally, Bologna was blessed with its own female artist patron saint—CATHERINA DEI VIGRI (1413–63), who was canonized as St. Catherine of Bologna in the early 1700s. She was shy and uncomfortable with the Renaissance court life for which she was groomed, so dei Vigri entered a convent of the Poor Clares after her father's death in 1427. She become the abbess and gained distinction for her music, painting, and illuminations, although only a few works are now securely attributable to dei Vigri.

Genteel Female Artists of Bologna

*This excellent Painter, to say the truth, in every way prevails
above the condition of her sex.*
 —A patron of Lavinia Fontana, 1588.

Lavinia Fontana LAVINIA FONTANA (1552–1614) was raised in the midst
of Bologna's cultivated and learned society, although she was not of
noble birth. Her father was master of the influential guild to which the
city's painters belonged, and he routinely entertained prominent artists
and intellectuals in his home. Prospero Fontana's position protected his
daughter from any risk of scandal or slander about her profession, and
under his tutelage her creative talents blossomed. Prospero benefited in
turn from his daughter's achievements—he required Lavinia and her
rather untalented painter-husband to reside with him and pay him all
their earnings.

Lavinia Fontana undeniably was committed to her profession. Prior
to her marriage, Fontana declared that she would not take a husband
"unless he were willing to leave her the mistress of her first-beloved Art."

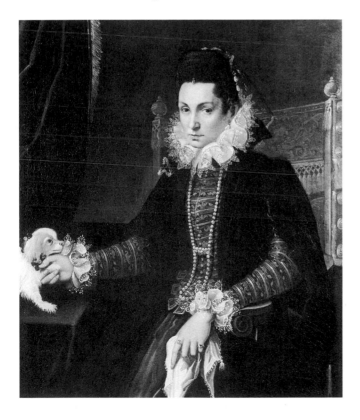

Fig. 2-5 How does Lavinia Fontana
immediately communicate this lady's
social and economic status? Fontana's
exquisite attention to details, such as
the lady's lace collar, silk jacket, and
penetrating gaze, made her particularly
popular with wealthy and elite patrons.
If Fontana were to portray you today,
what clothes and pose do you think she
might use to express your personality?

Lavinia Fontana. Portrait of a Lady
with a Lap Dog, *late 1590s, oil on canvas.
The Walters Art Gallery, Baltimore.*

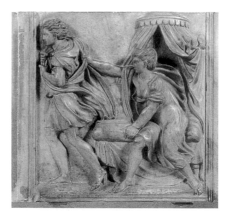

Fig. 2-6 How much real depth does Properzia di Rossi create in her sculpture of Potifar's wife grabbing hold of the Egyptian officer Joseph's cloak? Properzia develops a complex spatial scene on a fairly flat marble slab through her skillful understanding of anatomy and motion. Properzia competed with male artists to win her commission for some of the marble sculptures that now exist on the west facade of the Bolognese church of San Petronio.

Properzia di Rossi. Joseph and Potifar's Wife, c. 1570, marble bas-relief. Museo di San Petronio, Bologna, Italy.

Contrary to the norm, Fontana's husband did the typically less important "woman's" task of painting backgrounds and frames of her works and helping with the domestic chores.

People greatly praised Fontana's artistic style, which was characterized by broad areas of color that accentuated the sitter's features, sophisticated clothing, and ornate accessories. (Fig. 2-5) Popes, cardinals, ambassadors, and nobility sought her because of her portraiture skills. Fontana also expanded the range of subjects painted by women—she was the first female Bolognese artist to complete large public, religious, and mythological scenes. The Catholic Church in Rome offered her a position because of her immense fame.

Fontana produced approximately 135 documented paintings. She also gave birth to eleven children in eighteen years. Similar to other female artists of the day, she was one of the early "superwomen" who achieved professional success while simultaneously fulfilling the expected domestic role.

Properzia di Rossi: A Renaissance Sculptor Unlike Lavinia Fontana, PROPERZIA DI ROSSI (c. 1490–1530) was not shielded from male artists, whose accusations are believed to have contributed to her poor health and early death at age forty.

Properzia is the only known prominent female sculptor of the period. Giorgio Vassari, a contemporary biographer of the era, described her as the epitome of the Renaissance woman in his book *Lives of the Painters, Sculptors, and Architects*. He noted that Properzia was "a talented maiden both in household duties and in other things, so skilled in sciences that all men might envy her. She was beautiful in person and could sing and play better than any woman in the city."

Properzia gained her earliest acclaim for miniature carvings, made on apricot, peach, and cherrystones—one of which was said to have represented Christ's crucifixion, including tiny figures of the executioners, disciples, women, and soldiers. Properzia later excelled at large-scale works and won many competitions, including the commission for the facade sculptures of the San Petronio Church. Her exquisite relief of *Joseph and Potifar's Wife* (Fig. 2-6) demonstrates Renaissance art's concern for classical, idealized beauty of the human body. Notice the readily flowing clothes that accentuate the figures' movements, conveying the urgency with which the Egyptian officer's wife attempts to hold back Joseph by firmly gripping his garment. Despite Vasari's characterization of the work as "a lovely picture sculpted with womanly grace," its forceful composition is clearly equal to those created by her male peers.

A group of male artists who were appalled that Properzia had won the San Petronio commission deliberately set out to discredit her. They spread a malicious rumor that the biblical subject, although popular during the sixteenth century Counter-Reformation era, was actually an indiscreet metaphor for Properzia's unrequited love of a young nobleman who had rejected her for a woman of a higher class. As a result, the church's superintendents did not set her relief in place, and Properzia subsequently received pitifully low payments for her sculpture. Properzia became disheartened and soon took ill. Records of her being nursed at a hospital rather than at home, which was the norm, indicate that she died either poverty-stricken or friendless. One wonders what artwork Properzia might eventually have created had she lived to receive the pope's emissary, who arrived with news of an important new commission just a few days after her death.

Elizabeth Sirani ELIZABETH SIRANI's (1638–65) graceful paintings aptly represent the refined Bolognese style. Like Lavinia Fontana, Sirani created large-scale religious compositions. (Fig. 2-7) Although her penchant for scenes of the Virgin, Mary Magdalene, Salome, and *sibyls* (female prophets) reveals an inclination for triumphant, virtuous heroines, her choices might also have been limited because of women's restriction from studying live male models. (Fig. 2-8)

The public initially questioned the skill and speed with which Sirani worked because female artists were still rare and often considered

Fig. 2-7 Who is the most important person in Elizabeth Sirani's religious scene? How does she communicate that the Christ child is central to the picture's theme? All the figures actively revolve around this toddler, who himself twists as he stretches out his arm to bless the kneeling monk. Imagine how Sirani's sketch must have looked when she completed it in oil paints.

Elizabeth Sirani. Holy Family with a Kneeling Monastic Saint, *c. 1660, black chalk, pen and brown ink and brown wash on paper. Courtesy Christie's Images.*

Fig. 2-8 Elizabeth Sirani depicted a critical moment for Porcia in the story *Life of Brutus* by the ancient Greek biographer Plutarch. Porcia purposely cuts herself to try to convince her husband, Brutus, that he can share his terrible secret with her about Caesar's impending murder. Sirani instantly captures our attention by painting the moment just before the stabbing. Sirani probably chose this part of the story to convey women's courage, heroism, and equality to men. In Plutarch's text, Porcia explains to Brutus, "I was brought into thy house, not, like a mere concubine, to share thy bed...but to be a partner in thy troubles."

Elizabeth Sirani. Porcia Wounding Thigh, 1664. *Courtesy of Wildenstein and Co.*

Book of Judith 13:7–8
Compare how Gentileschi's powerful composition visually expresses Judith's emotions as described in the Bible: "And [Judith] approached his bed and took hold of the hairs of his head and said, Strengthen me, O Lord God of Israel, this day. And she smote twice upon his neck with all her might and she took away his head from him."

Fig. 2-9 How does Artemisia Gentileschi heighten the drama of this famous biblical scene? What has she done with the lighting and composition to express Judith's courage? In the story, the heroine used her charms to capture the fancy of Holofernes, the enemy of the Jewish people, before exacting her revenge. Gentileschi enhances Judith's bravery and determination by depicting the beheading in gory detail.

Artemisia Gentileschi. **Judith and Holofernes,** *c. 1618, oil on canvas. Uffizi, Florence. Scala/Art Resource, NY.*

freaks of nature. To disprove the gossip that her father was passing off his work as hers, Sirani grew accustomed to painting with gaping observers looking on. By the age of sixteen, she supported her entire family because her father's arthritis cut short his somewhat mediocre career. Sirani inspired many female students in the school that she ran, one of the earliest such institutions to enroll women who were not exclusively from noble or artistic families.

Sirani painted close to 190 artworks in her brief twenty-seven years. Her sudden death is believed to have been caused by bleeding ulcers resulting from chronic overwork. Sirani's passing was mourned publicly, and her fame was rivaled by only one other female artist in Italy, that of Artemisia Gentileschi, whose independent temperament defied the humanist ideal of refined feminine deportment.

Elsewhere in Italy

Artemisia Gentileschi ARTEMISIA GENTILESCHI (c. 1593–1652/53) contributed a great deal to the art world of her time. She helped initiate the Italian Baroque style, and her fervent brushwork and charged emotional content typified the flamboyant aesthetic and also echoed the intensity of her own life. Unlike the artists previously mentioned, who fit within the socially acceptable norm, Gentileschi's potent canvases, as well as the events of her life, disrupt the notion of correct female conduct.

Gentileschi's father, a follower of an Italian Baroque master, Caravaggio, originally taught his daughter to paint, but soon apprenticed her to learn perspective from a coworker of questionable reputation. Agostino Tassi was a violent man who had been convicted of arranging his wife's murder. Tassi molested the teenage Gentileschi while she was under his tutelage and then promised to marry her. However, during the five-month trial, Gentileschi was subjected to torture by thumbscrews, a seventeenth-century lie-detector device, in an attempt to confirm the validity of her claims. The case ultimately was dismissed and Gentileschi greatly scarred by the incident.

Gentileschi's father tried to avoid additional public attention in Rome by marrying her off to a Florentine. Historians often interpret Gentileschi's experiences as having motivated her poignant portrayals of women bravely battling male victimizers. Although most of Gentileschi's themes were common for the day, she did invest her heroines with an unusual, almost protofeminist mixture of determination and vulnerability. Gentileschi achieved an immediate and arresting impact in her art by embroiling such characters as Judith (Fig. 2-10), Susanna, Mary Magdalene, Lucretia, Esther, and Diana in dramatic and often violent situations.

A Woman's View

Artemisia Gentileschi's surviving letters reveal the conflict of being a professional female artist with her own independent determination to be treated fairly. In writing to a male patron in Messina, Italy, in 1649, Gentileschi remained steadfast in the price for her artwork despite his protests. At the same time, she softened her tone by adding, "I have the greatest sympathy for your lordship, because the name of a woman makes one doubtful until one has seen the work." In a later correspondence, she asserted, "As long as I live, I will have control over my being," but apologetically closed with, "I will not bore you any longer with this female chatter."

Gentileschi generated further tension in her compositions by using intense contrasts of dark and light, asymmetry, and depictions of theatrical moments, all of which helped to shape the Italian Baroque style.

Marietta Robusti Many female artists' fathers mentioned thus far enjoyed only moderate to successful artistic careers themselves. MARIETTA ROBUSTI (1560–90), however, was the daughter of an eminent painter known as Tintoretto. Tintoretto reportedly was so attached to his daughter that he dressed her in boys' clothing and took Robusti everywhere with him, instructing her along with his sons. Robusti's grand manner of portraiture was popular with the dignitaries who flocked to Venice. She was celebrated equally for her beauty and the musical accomplishments with which she entertained her sitters. When Robusti's fame spread to the courts of Spain and Austria, she was asked by the rulers to come to work for them. However, Tintoretto preferred to keep Robusti close to home and so found her a husband who agreed that the couple would live in his household until his death.

Fede Galizia By her late teens, FEDE GALIZIA (1578–1630) also had gained an international reputation for portraiture. Yet Galizia is most famous for her still lifes, making her one of the first Italian painters of this genre. The northern artists of Holland and Flanders eventually mastered this subject during the subsequent Baroque era.

Building a Base for the Future

During the Renaissance, wealthy females made strides as artists largely because Humanist philosophy permitted and promoted women's education. Cultural mores, however, limited "acceptable" female behavior and discouraged ladies from pursuing artistic careers independent of either their husbands or fathers. Men at the time feared economic competition and severely restricted women's access to artistic training. Nonetheless, increasing numbers of female artists overcame these obstacles and gained recognition and professional status. Amazingly, they competed for public commissions, sold art directly to wealthy individuals, and became court painters while often still tending to the domestic front. Ultimately, the success of female Renaissance artists provided a firm foundation for future European and American women, who expanded upon their predecessors' accomplishments.

Selected Additional Southern Renaissance
and Baroque Women Artists

Italy

Margherita Caffi (1662–1700) Flower still lifes

Lucrina Fretti (1614–51) Religious subjects and portraits

Giovanna Garzoni (1600–70) Watercolors on vellum; popular with the Medici
and the Spanish and Italian nobility

Diana Ghisi (c. 1530–c. 1590) Printmaker and sculptor usually of religious
and mythological subjects; both father and brother were engravers

Irene di Spilimbergo (c. 1540–59/61) Religious paintings; was student of Titian,
who also painted her portrait

Teresa del Pò (1649–1716) Religious and mythological scenes

Spain

Josefa de Ayala (1630–84) Still lifes, portraits, religious scenes

Maria de Abarca (died c. 1656) Highly regarded miniaturist active in Madrid,
1640–1653

Luisa Roldán (1656–1704) First known Spanish female sculptor; received church
commissions and was court sculptor to Charles II

Teresa del Niño Jesus (n.d.) Nun who painted and sculpted

Chapter 3

The 15th–17th Centuries in Northern Europe:
Revealing the Surrounding World

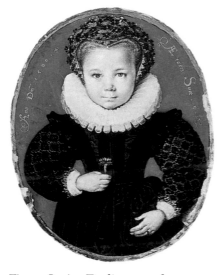

Fig. 3-1 Levina Teerlinc earned an undisputed international reputation for her exquisite and delicate miniatures. She gained respect for these paintings and full-scale works both with wealthy patrons, such as the parents of this lovely young girl, and with successive royal courts. Envision the tiny bristles Teerlinc must have used to create the frilly lace and shiny satin creases of the child's dress.

Levina Teerlinc. A Little Girl Holding a Red Carnation, 1590, on vellum. Victoria and Albert Museum, London/ Art Resource, NY. Photograph © The Board of Trustees of the Victoria and Albert Museum.

Female Artists of the Northern Renaissance

Why did a relatively large number of women artists emerge in northern Europe during the fifteenth and sixteenth centuries? How did the circumstances here differ from those in Italy? In the north, the Protestant Reformation emphasized knowledge of the Bible, and universal literacy became a societal goal. Consequently, coeducational elementary schools were established throughout the region. The spread of Humanism from the south also influenced the concept of a cultivated society in the northern countries, where both females and males were well educated. Northern women were less constrained by religious ideology in comparison with their southern counterparts. In Italy, Catholicism supported and encouraged strong patriarchal beliefs. Furthermore, in the north, abundant court patronage provided female artists with an important alternative to the guilds and academies that routinely barred them.

During the Renaissance, northerners favored portraiture far more than the Italians. Wealthy individuals used this genre as a means of symbolizing their social status. Women artists excelled in miniatures, and by the seventeenth and eighteenth centuries, the rich often wore them as pins and necklaces with their expensive finery.

As elsewhere in Europe, northern female artists frequently came from artistic families. LEVINA TEERLINC (c. 1515/1520–76) was the eldest of five daughters; she followed in her father's and grandfather's footsteps, creating miniature paintings. (Fig. 3-1) Teerlinc gained a place within the English court, where, as a result of her accomplishments, she worked for four successive monarchs. Documents reveal that Teerlinc's annual stipend was greater than that of Hans Holbein, the long acknowledged "master" of northern miniature painting.

CATERINA VAN HEMESSEN (1528–after 1587), who also trained in her father's studio, is believed to have painted the details of his *genre paintings* (compositions describing everyday life). She created some religious works but became best known for her highly realistic dark-background

portraits in which she paid meticulous attention to the details of her sitters. (Fig. 3-2) Van Hemessen's principal patron was Queen Mary of Hungary, at the Spanish court, which then ruled her Flanders homeland.

Holland's Emergence as an Artistic Center

Was southern Europe the only hotbed of creative activity during the Baroque era? Artists in the Provinces, now called Holland, suddenly came into their own in the seventeenth century and established a thriving northern cultural center. The period became known as the Golden Age of Dutch art, and the country's illustrious women artists commanded attention equal to their male counterparts, including Rembrandt van Rijn, Jan Vermeer, and Frans Hals.

Portraiture
The interest of the middle class in portraiture during the Renaissance both in the north and south reflects their deep attraction to individualism as well as the erosion of the church's and nobility's exclusive power. Portraits were a tangible means for the growing urban elite to celebrate their own personalities and unique ambitions.

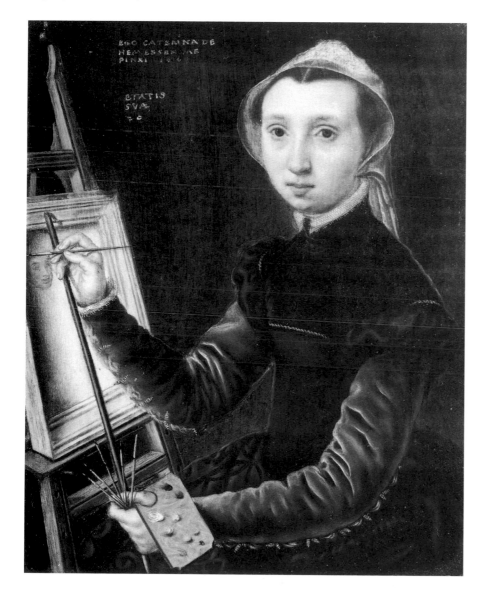

Fig. 3-2 What is this young woman painting on her easel? Although it seems that the artist is staring at us, Caterina van Hemessen would actually have had to be gazing intently ahead into a mirror to paint her own features for this double self-portrait.

In the upper-left-hand corner, van Hemessen wrote in Latin, "I Caterina de Hemessen, painted myself in 1548," and below she noted her age as twenty. Van Hemessen wears the typical warm clothes of well-to-do northern women — an elegant high-necked black velvet dress with lush red velvet sleeves and a white lace collar and cuffs.

Caterina van Hemessen. Self-portrait, 1548, distemper on oakwood panel. Oeffentliche Kunstsammlung Basel, Kunstmuseum. Photograph Oeffentliche Kunstsammlung Basel, Martin Buhler.

Fig. 3-3 In the seventeenth century, Amsterdam was an important European city, bustling with trade from around the world.

View of Amsterdam.

A Woman's Hand in Northern Renaissance Needle Arts
Flemish tapestry reached its height between 1480 and 1520 and was unparalleled in western Europe. As in earlier times, females helped weave the splendid textiles that added warmth to cold castle walls and reduced the noise of the deafening echoes in the buildings' stone hallways.

What historical events played a vital role in propelling Holland to the creative forefront? Prior to the mid-sixteenth century, the Dutch Republic had been under Spanish rule. By the time it won complete independence from the Hapsburg Empire in 1648, the Provinces had become a major maritime power, a center of world commerce, and the first Protestant democratic state in Europe. Holland's economic and social growth led to the establishment of an influential, wealthy middle class. These hard-working bankers, merchants, and tradesmen replaced the Catholic Church as the primary art patrons. The citizens' desire for artworks that reflected their involvement in trade, finance, and government contributed to the near abandonment of religious, historical, and mythological themes. Additionally, Protestant doctrine forbade sacred imagery, which was regarded as a sign of popish idolatry. These factors, along with a sweeping nationalistic zeal, resulted in a new recognition of certain types of painting that the art establishment previously had considered only minor endeavors.

Seascapes and landscapes symbolized the republic's newfound independence. Still lifes recorded scenes of the riches pouring into Holland's great ports; genre paintings illustrated events from people's everyday lives; and portraits conveyed the burghers' increasing economic, political, and social clout. Most artists specialized in one of these fields because they found it most profitable in the country's open art market to focus their efforts on a particular theme. One unifying factor among the new art categories was an unfaltering adherence to realism. During Holland's "Age of Reason," Dutch art, science, and philosophy all displayed a strong faith in rationality and a belief that the awesome reality of the world ultimately was explainable.

Artistic Opportunities for Dutch Women

Dutch females had a decided advantage over southern European women in pursuing creative endeavors. Unlike their Italian sisters, females in the north did not have to cultivate eccentricities, be child prodigies, or endure public scandal. Women from artist families were important participants in lucrative businesses. They also faced fewer restrictions in art guilds, where, as master painters, they could take on apprentices, both male and female, who paid them tuition. Women in Holland were also able to compete equally with male peers because of the virtual absence of nudes in Dutch art, which would have required them to study from a live model and thus possibly tarnish their reputation. The artists in the following section are just a small sampling of impressive individuals who represent Dutch women's significant contributions. Furthermore, because students

in European workshops customarily painted portions of their master's canvases anonymously, many female artists' names remain unknown.

The Artists

Still Lifes and Multiple Meanings: *Vanitas* Paintings

In previous eras, still lifes usually were included as part of larger, figurative religious scenes or illustrations of the seasons. However, in the seventeenth century, the Dutch became fascinated with scientific visual records and the aesthetic allure of the trade items that surrounded them. They also wished to convey an underlying Protestant ethic, which served to stimulate the creation of *vanitas* paintings. Women soon excelled in these works; Clara Peeters was one of the genre's originators.

Clara Peeters The art of CLARA PEETERS (c. 1594–1657) reveals much about seventeenth-century Dutch society. (Fig. 3-4) The luxurious objects depicted in her painting document some of the exotic goods that were arriving at Holland's recently free harbors. But to Dutch eyes of the day, Peeters' arrangement was no mere record of the market's opulence. Her *vanitas*, stemming from the Latin word for "vanity," carries a complicated symbolic meaning that celebrates the beauty of the physical world, while simultaneously warning viewers about the transience of earthly existence and about human mortality.

These underlying implications in Peeters' still life would have been immediately obvious to seventeenth-century viewers. The glistening

Genre Painting
Middle-class art patrons particularly liked intimate scenes of daily life. These genre paintings, reflecting realistic aspects of everyday life, were small and, thus, suitable for hanging in ordinary homes.

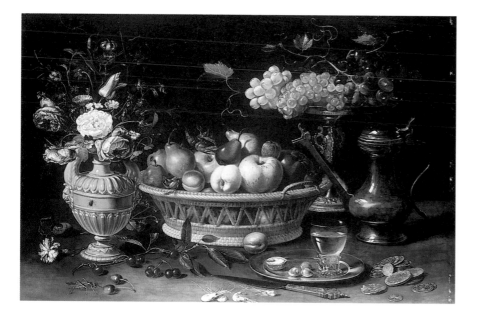

Fig. 3-4 In the seventeenth century, Holland's citizens enjoyed hanging in their homes pictures that displayed the range of exotic goods that were pouring into the country's busy ports. Clara Peeters' details are so precise that there is a reflection of a distant window on the metal vessel to the left. Of course, her painting was more than a mere visual document. Peeters infused a moral overtone into all her *vanitas* works.

Clara Peeters. Still Life with Nuts and Fruit, *after 1620. © Ashmolean Museum, Oxford.*

Fig. 3-5 Can you locate images of
birth and regeneration in Maria Sybilla
Merian's exquisitely accurate water-
color? She presents the butterfly in
every stage of its development and
indicates the flower's transformation
from seed to full-blown blossom.
Merian traveled to the Dutch colony
of Suriname in South America to docu-
ment the country's indigenous insect,
plant, and animal life during an era
when it was unusual for females to
even work outside the home, let alone
travel by themselves to exotic, foreign
destinations

Maria Sybilla Merian. Plate #9,
Grenadier, *from the* Dissertation on
the Generation and the Transformation
of Insects of Surinam, 1726, *handcolored
with watercolors from inked engravings.
Courtesy and © The Academy of
Natural Sciences, Philadelphia.
Photograph by Peter Harboldt.*

coins illustrate worldly possessions; flowers, insects, food, and wine
signify the brevity of life; and the glass and polished metalware caution
against vanity. Peeters meticulously reproduced every nuance of texture
and color, and she added a dramatic lighting effect that causes particular
objects to shine with an almost celestial light while pushing others back
toward a mysterious darkness. Her keen eye for compositional drama
and beauty generate an appealing image that satisfied the appetite of the
burgeoning middle class for a secular art that mirrored their affluent lives
and communicated an important moral message.

Peeters was one of the forerunners of *vanitas* painting, but relatively
little is known about her life. Only a few records exist of previous female
still-life artists, such as the Italian Fede Galizia (1578–1630), discussed on
page 32. Peeters signed her first painting at age fourteen and produced
at least thirty-one signed works between 1608 and her death in 1657. She
married in 1639, at age forty-five. Most women of the time wed before
they were twenty years old. Perhaps Peeters married at an age later than
her peers because she wished to devote most of her life to art. Maybe she

finally found a husband who respected her desire to paint. Or possibly Peeters was forced into matrimony out of economic necessity if she had been no longer able to support herself solely through painting.

Maria Sibylla Merian After several decades of successfully writing and illustrating books about European insects and flora, MARIA SIBYLLA MERIAN (1647–1717) set off, without the customary protection of a male companion, on a long and dangerous adventure to the jungles of present-day Suriname, in South America, to record the Dutch colony's wildlife. How did Merian's life prepare her for such an undertaking?

Merian was born in Germany to a family of engravers, and as an adult, she lived in Holland. Merian's father was an etcher and a publisher, who died when his daughter was young. His books of floral illustrations, some of the first of the period, later inspired Merian's own volumes. (Fig. 3-5) Merian's Flemish stepfather, a specialist in flower painting, also introduced her as a child to the elements of his craft and brought her on field trips. Merian wrote of her early botanical curiosity, "From my youth I have been interested in insects…. First I started with silkworms in my native Frankfort-am-Main. After that I started to collect all the caterpillars I could find in order to observe their changes…and I painted them carefully on parchment."

Merian married one of her stepfather's students in 1665. She later left her husband to join her mother, who had become a widow for the second time. After her mother's death, Merian moved the family to Amsterdam, a flourishing artistic and scientific community, primarily to study the rare East and West Indies botanical collections in the city's museums. She then obtained funding from the Dutch government for her trip to Dutch Guiana (Suriname), where she worked for two years before returning to Amsterdam because of ill health.

Merian synthesized sharp observation with scholarship to create stately, formal compositions that reflected the inquiring philosophy of Holland's "Age of Reason." In addition to their artistic merit, Merian's scrupulously exact and well-researched images provided a wealth of information. Natural scientists paid this extraordinary, pioneering seventeenth-century spirit lasting tribute by giving insects and plants her name.

Rachel Ruysch RACHEL RUYSCH (1664–1750), like Maria Sibylla Merian, also painted meticulous depictions of plants, animals, and insects, although her works are clearly arranged constructions, compared to Merian's scientific inquiries. Is Ruysch's *Flower Still Life*, shown here, truly "still"? (Fig. 3-6) The explosive vitality of her image captures the

The Scientific Revolution (1550–1700)

The desire of Dutch artists to portray the world around them in exacting detail corresponded to the quest for hard, quantifiable truth, as expressed by Copernicus, Galileo, Pascal, Newton, Bacon, and Descartes.

Fig. 3-6 Does Rachel Ruysch's arching niche adequately contain her botanically accurate flower arrangement? Ruysch subtly reminds us of the transitory yet vital energy of life with her tangle of overlapping plants and blooms that spill forth from a single bulbous vase.

Rachel Ruysch. Flower Still Life, *n.d., oil on canvas. The Toledo Museum of Art. Purchased with funds from the Libbey Endowment, Gift of Edward Drummond Libbey.*

Notoriety and Prosperity

Rachel Ruysch's sixty-six-year career spanned the height and the initial decline of Dutch flower painting. As one of the last of the great northern Baroque flower painters, she was admired widely during her lifetime and maintained an international reputation and steady clientele. Ruysch's canvases frequently sold for 750 to 1,250 guilders, as compared to the income of another notable Dutch artist, Rembrandt van Rijn, who rarely received more than 500 guilders for his paintings.

energy of the blooms cascading over the vase's rim. Her tranquil architectural background forms a faint halo on the right, which surrounds the floral composition and adds a soothing stability to the animated subject. Each petal and leaf is visually exact, and Ruysch's deliberate combination of flowers, which bloomed at different times of the year, indicates that she worked from scientific prints as well as live specimens. Despite her precise adherence to nature, Ruysch ultimately fabricated an idealized vision of reality: She used flowers that are known to blossom and die quickly to indicate life's impermanence and hence transformed her lavish arrangement into a rich metaphor symbolizing both morality and imminent mortality.

Ruysch was born into a distinguished, culturally elite family, and her parents encouraged her talents. Ruysch's mother was the daughter of a noted architect, Pieter Post, who designed the royal residence near The Hague. Her father was an eminent professor of anatomy and botany. Undoubtedly, Ruysch's exposure to her father's work enriched her understanding of zoology and botany.

Ruysch was apprenticed at fifteen years old to the most highly recognized still-life painter in Amsterdam, Willem van Aest. At age eighteen, she went off on her own and developed a unique style typified by large, still-life compositions that loom out from shadowy, natural environments. Ruysch became a member of the guild of painters in The Hague in 1701 and held a position as a court painter to the Elector Palatine in Düsseldorf from 1708 to 1713. She married an undistinguished portrait artist in 1693, and, even with the responsibilities of raising their ten surviving children, she continued to work professionally; records document at least one-hundred canvases. At a time when many female artists were not able to continue painting after they married, it is notable that Ruysch was active until at least age eighty-three, the date of her last signed canvas. Ruysch was probably able to pursue her passion because her lucrative career helped to pay for the household servants.

Maria van Oosterwyck MARIA VAN OOSTERWYCK (1630–93) created *vanitas* scenes in a detailed style of tight, complex compositions and sparkling surfaces. (Fig. 3-7) Van Oosterwyck, belongs to the growing number of women painters of her time who did not come from artistic families. Her father was a Protestant minister. At the age of twenty-eight, in 1658, she trained with a prominent flower painter in Antwerp. Although van Oosterwyck produced little, her international reputation led to patronage from the royal courts of England, France, and Germany.

Fig. 3-7 Beyond the flowers, coins, fruit, and insects frequently depicted in still lifes, what additional items does Maria van Oosterwyck use in her *Vanitas* painting to represent decay, the passage of time, and frivolous pastimes?

Maria van Oosterwyck. Vanitas, *1668, oil on canvas. Vienna Kunsthistorisches Museum.*

Van Oosterwyck was courted by the artist Willem van Aest (Rachel Ruysch's early teacher). Van Aest, however, did not meet van Oosterwyck's exacting standards. He failed her challenge of spending a requisite ten hours a day at his easel, and so she eventually refused his proposal. Van Oosterwyck not only chose to devote herself exclusively to art but also to provide lessons to her maid, GEERTJE PIETERS, examples of whose work also exist.

A Note About Dutch Seventeenth-Century Flower Painting

It is not surprising that flower paintings became an important subcategory of Dutch still lifes, because the blossoms themselves were significant to Holland's economy. Over the century, trade firms such as the East and West Indian Companies, which were competing with British companies to establish a colonial empire, introduced various foreign botanical specimens to Europeans. Soon, members of the newly prosperous merchant class, who began cultivating species in their own private gardens, sought painted records of their best or rarest blooms. The attention to detail in these flower paintings also served a spiritual end—the canvases were seen to confirm the Christian God's wisdom and grand scheme.

The status of both still-life and particularly flower painting in Holland declined after the seventeenth century. The pieces ultimately were perceived as appropriate subjects for women painters, and the images came to represent the "feminine," domestic world. Despite or

Fig. 3-8 What similarities and differences in style can you find between this genre painting and Judith Leyster's later work, *The Flute Player* (Fig. 3-9)?

Judith Leyster. The Lute Player, c. 1626. Rijksmuseum. Courtesy and permission of the Netherlands Board of Tourism.

perhaps because of the fact that so many female artists excelled in flower painting, the genre soon acquired a second-class status.

Judith Leyster: A Diverse Master

Compared with the majority of male and female Dutch artists who concentrated on a single theme, JUDITH LEYSTER (1609–60) demonstrated versatility in three areas: still lifes, portraits, and genre scenes. (Fig. 3-8) Leyster studied painting at an early age, not uncommon for middle-class Dutch girls. However, her subsequent poverty, which occurred when the family's brewery business failed, may have prompted Leyster's initial participation in the lucrative free art market, where she quickly established herself as a successful independent artist.

Leyster was the first woman admitted to, and one of only two female members of, the Haarlem Guild of Saint Luke. The affiliation reinforced her professional status, and the institution provided benefits similar to those of a modern-day insurance company, offering protection against illness or disability. Leyster's membership also enabled her to acquire three male pupils. In fact, the issue of apprentices actually establishes a documented link between her and another Dutch master, Frans Hals. Court records reveal that, although the two painters were friends,

Fig. 3-9 Scholars speculate that this painting symbolizes the sense of hearing. How does Judith Leyster visually communicate the high, harmonious sounds of the child's flute? The young boy gazes upward and is bathed in a heavenly light that abstractly evokes the delicate music of his instrument.

Judith Leyster. The Flute Player, c. 1635, oil on canvas. National Museum, Stockholm.

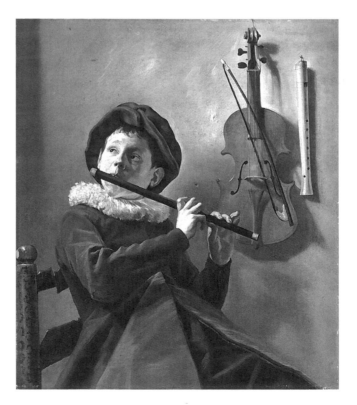

Leyster successfully sued Hals for having lured one of her students into his studio without compensating her. Because apprentices paid their masters a fee, Leyster initially had lost an important source of income.

Leyster and Hals also shared a stylistic connection, even though their artistic relationship remains unclear. They both employed an open, vigorous brush style and a tendency to concentrate on a central figurative composition often lit by a dramatic, almost theatrical light. Leyster's application of paint was somewhat more restrained then that of Hals, but her compositions and psychological investigations were frequently more complex. For example, compare Leyster's *The Flute Player* (c. 1635) (Fig. 3-9) to Hals' *Boy with Flute* (c. 1623–25). (Fig. 3-10) Hals' isolated young sitter is caught mid-action, and the expressive brushwork enhances the sense of movement. Leyster bathes her calmer lad in a nearly holy light that, along with the boy's upward gaze, evokes the sweet, spiritual sounds of his music. The composition itself is full of daring and contradictory angles. Leyster contrasts a series of verticals created by the chair, the boy's torso, and the instruments on the wall with the strong diagonal thrusts of the flute, the youth's open coattails, and the tilt of his head.

Leyster's painting *The Proposition*, 1631, further reveals her unorthodox interpretation of a traditional subject. (Fig. 3-11) Illustrations of similar scenes rendered by male artists typically portray women as "vessels of pleasure"—either luring men into sin or at least being willing participants to the males' lusty pursuits. (Fig. 3-12) Leyster, in contrast, depicts this interaction from a decidedly female vantage point, showing that not every woman was so inclined. Here the virtuous housewife, not a female of loose morals, continues to sew, expressing her complete lack of interest in the man's degrading proposition. His face indicates that he has not yet accepted her steadfast decision. Hers reflects the deep look of concentration she needs to convey her intentions. Although the woman expresses herself indirectly, Leyster's frank female perspective makes the painting a courageous statement for the day. Male artists usually moralized against earthly vices by showing wild visions of gluttony and sexual pleasure. Leyster accomplished the same goal with a depiction of an ordinary woman clearly choosing honor over money.

Leyster achieved astonishing success during her short career. She maintained a workshop with students and sold art on the open market. Similar to her female contemporaries, Leyster later exchanged her brush for an apron after marrying the artist Jan Meinse Molenaer and giving birth to their five children.

Fig. 3-10 Compare this painting by Frans Hals to Judith Leyster's of the same subject. (Fig. 3-9) How do the two artists' depictions subtly differ?

Frans Hals. Boy with a Flute, 1623–25, oil on canvas. Staatliche Museen zu Berlin –Bildarchiv Preussischer Kulturbesitz Gemäldegalerie. Photograph by Jorg P. Anders.

Rediscovery
Judith Leyster used her initials, boldly shot through with a horizontal line and tipped by a star, to sign completed paintings. This distinctive mark—a pun on her name, which means "leading star"—helped reassign a significant number of artworks to Leyster that, until the late nineteenth-century, scholars often had misattributed to Frans Hals.

A Sound Foundation

By the end of the seventeenth century, female artists were working in small pockets throughout much of western Europe. As England, Spain, and France established colonies in North America, these women were sowing the seeds for a visual dialogue between the two continents. In future centuries, females on both sides of the Atlantic would continue to struggle for recognition within traditional avenues of artistic expression.

Selected Additional Northern Renaissance and Baroque Women Artists

England
Mary Beale (1632–99) Portraits

France
Genevieve de Boulogne (1645–1708) Landscapes and still lifes
Madeleine de Boulogne (c. 1646–1710) Decorated palaces
Elizabeth Sophie Chéron (1648–1711) Miniatures and enamel paintings
Suzanne de Court (active c. 1600) Enameling

Fig. 3-11 As a result of increasing prosperity in Holland, seventeenth-century paintings often portrayed sex with females as a service to be bought and sold. Although images of women spinning, embroidering, making lace, and sewing had long been associated with feminine virtue, they were now sometimes infused with ambiguity or sexual implications. (For example, see Jan Vermeer's *The Procuress.* [Fig. 3-12]) In contrast, Judith Leyster clearly imbues her heroine with domestic morality, as the woman flatly refuses to acknowledge the man's straightforward advances.

Judith Leyster. The Proposition, *1631, oil on panel. © Mauritshuis, The Hague, Holland.*

Catherine Duchemin (1630–98) Still lifes; first woman admitted to
 Académie Royale
Jacquette de Mombrom (n.d.) Architectural planning, sculpture, and painting
Louise Moillon (1615–75) Still lifes
Antoinette Bouzonnett Stella (1641–76) Engraver; daughter of a goldsmith
 engraver
Claudine Bouzonnett Stella (1636–97) Engraver; sister of Antoinette

Netherlands

Margaretha de Heer (c. 1650s) Bird and insect paintings
Anna de Smytere (active c. 1604) Landscapes
Magareta Haverman (1693–after 1750) Flower paintings; accepted into French
 Académie in 1722
Anna Janssens (active second half of seventeenth century) Flower paintings;
 wife of Jan Brueghel II
Joanna Koerton (1650–1715) Drawings, painting, and embroidery
Catharina Peeters (active c. 1657) Sea battles
Geertje Pieters (c. second half of seventeenth century) Flower and fruit
 paintings; studied with Maria van Oosterwyck, for whom she worked
 as a maid
Helena Rouers (c. mid-seventeenth century) Flower paintings
Anna Elisabeth Ruysch (c. 1680–1741) Pupil of sister Rachel Ruysch
Cornelia van der Mijn (1710–72) Still lifes
Jacoba Maria van Nikkelen (c. early 1700s) Flower paintings
Mayken Verhulst (a.k.a. Marie de Bessemers, c. 1520–c. 1600) Miniatures;
 mother-in-law of Pieter Brueghel the Elder and first teacher of her
 grandson, Jan Brueghel
Alida Withoos (1659–1715) Flower paintings
Maria Withoos (1657–1705) Flower paintings

All born in the Netherlands but active in English court:
Alice Carmillion (sixteenth century) Miniatures
Susannah Hourbout (1503–after 1550) Miniatures
Katherine Maynors (n.d.) Miniatures
Justina van Dyck (1641–90) Flemish painter who was active in London
 and Antwerp; daughter of the renowned artist Anthony van Dyck

Germany

Ida van Meckenen (late fifteenth century) Earliest known female graphic artist,
 worked with her husband in his print workshop
Anna Maria van Schurman (1607–78) Portraits

Switzerland

Anna Waser (1676–1713) Miniatures

Fig. 3-12 Compare the way in which the male artist Jan Vermeer portrays the woman to how Judith Leyster portrays the one in her painting *The Proposition.* (Fig.3-11).

Jan Vermeer. The Procuress, 1656. Staatliche Kunstsammlungen Dresden.

Seventeenth-Century Artist Workshops

Art students in the seventeenth century typically apprenticed for approximately six years with a recognized master. In the artist's studio, young trainees ground pigments, prepared canvases, made preliminary sketches, and sometimes added backgrounds or details to their master's work.

Chapter 4

The 18th and Early 19th Centuries in Western Europe:

Mirroring High Society

The history of all times, especially today, teaches that…
women will be forgotten if they forget to think about themselves.

—Louise Otto-Peters, 1849, German essayist, poet,
and novelist who demanded the vote for women
and equal rights for all people.

The General Climate in Europe

Did women artists benefit from the dramatic changes of the eighteenth-century Enlightenment? Western European civilization was shifting in exciting new directions as people embraced the belief in natural law, universal order, and the supreme abilities of human reason. Yet despite advances in thinking, only a handful of female artists earned significant acclaim, and most fared no better than their sisters of previous generations.

Fig. 4-1 The Palace of Versailles was the ultimate expression of the sumptuous Baroque era. French royalty and some 2,000 nobles and their ladies, 9,000 soldiers, and 9,000 servants retreated to this court whenever politics or the weather became too hot in Paris. Women were important players in court society as conveyors of taste and influential gossip.

Louis Le Vau and Jules Hardouin-Mansart. Palace of Versailles, France, 1669–85. Aerial view, garden in foreground. Courtesy of the French Government Tourist Office.

Fig. 4-2 a, b, c In the 1700s, wealthy girls and boys sported the same fashions as adults, although in smaller sizes.

Late-Eighteenth-Century Children's Garments.

During this period, also known as the Age of Reason, people felt that "man" could use his will and intellect to advance society. At the same time, a growing middle class, whose strength came from increased wealth and education, began demanding more power. Across much of Europe, bankers, merchants, and others challenged the elite's traditional authority and privileges. However, only men profited from the resulting reforms, while women's roles and activities fundamentally remained unchanged.

Women in France

Education and Work for Females of Different Classes

French upper-class women were educated primarily in practical subjects. They learned math to keep household accounts, law to understand property rights for their husband's holdings, and French history to inspire noble feelings. The tutor for Louis XIV's grandson stated that women also could read literature, as long as the books did "not incite the imagination nor stimulate the passions." The eighteenth-century philosopher and writer Jean-Jacques Rousseau summed up his view of a female's proper role in 1762: "The whole education of woman ought to be relative to man. To please them, to be useful to them, to make themselves loved and honored by them, to educate them when young, to care for them when grown, to counsel them, to console them and to make life agreeable and sweet to them."

In contrast, young ladies from the middle class chiefly learned domestic skills and only a smattering of academic subjects. Venturing into intellectual territory went against the social norm. Madame de Maintenon, the founder of a school for such girls, warned, "Tell them that nothing is more displeasing to God and men than stepping out of one's social station."

Fig. 4-3 In western Europe, numerous well-to-do ladies wore elaborate aprons made from layers of silk and often embroidered with gold and silver metallic thread to create a dazzling effect.

Woman in Fancy Apron, *First Half of Eighteenth Century.*

Early Public Museums

People during the Age of Reason hoped to discover all the basic laws of nature that framed the universe and humanity. Within this context, museums, which originally had been royal or private holdings, now welcomed the public for the first time. The vast collections of natural specimens, as well as artistic and scientific creations, were meant to stimulate viewers to help society strive for a standard of perfection.

Greuze's moralistic paintings shown.

The Broad Influence of French Culture

Eighteenth-century France was the leader of Western culture. Other countries imitated its government, army, architecture, furniture, art, accessories, literature, and fashions. French was the international language of scholarship and diplomacy. However, after the Revolution, Napoleon transformed France into the most feared nation in his quest to dominate Europe.

Life continued to be difficult for urban working-class and under-class women. They lacked formal education or training in a trade, which in turn limited them to three choices—early marriage, employment in a low-paying job, or prostitution. Females in rural areas had virtually no choices about their work; schooling for them was even more scarce. Single women went into domestic service for room and board and attempted to save enough money for a *dowry* (money or property a bride brings to her husband in marriage). Peasant wives were often treated as little more than servants, and their lives were tied tightly to the fields, house, and family.

The Salons: Women's Limited Sphere of Influence

Given the circumstances in France, were females completely absent from eighteenth-century cultural life? Learned aristocratic women did maintain a small degree of control in the *salons*. Salons were elaborate gatherings in which people discussed fashion, philosophy, science, and the arts. These events embodied the Age of Reason's preoccupation with intellectual pursuits. For females, the French salons provided an intermediary realm between family life and the public arena of the court. Hostesses skillfully orchestrated these intricate affairs, but once their guests left, they immediately returned to the role of obedient wife and mother.

Females and the French Revolution

Middle- and lower-class females participated actively in the French Revolution. Many were enticed by promises of equality and liberty and fought alongside men to overthrow the old regime. Women also tore up their linens for bandages, sold cherished jewelry to help finance the bankrupt forces, and joined in the marches and riots. Sadly, it was mostly men who benefited from the rights won by the Revolution. Furthermore, many women were now unemployed because the fighting had all but destroyed the luxury trades in which they had worked, including lace making, millinery work, dressmaking, and flower vending.

Women in Post-Revolutionary France

After the Revolution, wealthy females lost the power that they once had wielded in the salons because their aristocratic guests had fled Paris. The country's new leading intellectuals further restricted women's freedom. Male philosophers and writers who had been uncomfortable with the influence the salon hostesses formerly had held now strongly promoted and romanticized the virtues of home and motherhood. Consequently, family structures changed. Mothers now were responsible for the moral and academic education of France's youth, whereas privileged children

previously had been raised primarily by servants, and many young boys
had been sent away to school or apprenticed outside the home. In this
new age, patriarchal society once again redirected women's energies
almost exclusively to domestic matters.

French Art and Female Artists

The Influence of the Academies

The emergence of *academies* (societies of higher learning) in France,
Italy, and England reflected the growing institutionalization of nearly
every aspect of eighteenth-century European life, including the arts.
These organizations originally were founded to distinguish artists from
artisans but soon became the controlling force within the art world. The
academies promoted their members as sophisticated, well-educated
scholars rather than as craftspersons or amateur artists. This concept was
a natural outgrowth of the earlier Renaissance notion of artists as unique,
creative individuals. For aspiring artists, academy membership was
crucial because these institutions gave them access to training, commis-
sions, and exhibition opportunities. Perhaps most importantly, the
academies determined national style and taste because their directors
selected which artists and paintings would gain public exposure.

Louis XIV founded the French *Académie Royale de Peinture et de
Sculpture* (Royal Academy of Painting and Sculpture) in 1648, declaring
it open to all gifted artists. The first female was elected in 1663, yet
officials admitted only fifteen more women in the academy's initial
eighty years. In 1706, the administration barred females altogether, finally
agreeing in 1770 to accept four women, a number that safely prevented
the institution from being "overrun" by female members.

The academies also devised unofficial barriers. For instance, male
members frequently cast doubt on the authenticity of a woman's work,
insinuating that her art was painted by a man. Equally as destructive
were instances in which academy members intentionally circulated
rumors about a woman's supposed improper sexual conduct to taint her
reputation and further impede her status.

Why were the academies so vital to women's artistic progress?
Exclusion denied them public recognition and, even more crucially, pro-
hibited their access to the prescribed artistic curriculum. Without train-
ing in human anatomy, perspective, multifigure composition, and the
classics, females could not produce *history paintings* (large figurative
compositions of significant events based on ancient and modern history,
myths, or legends), which had been the most highly prized subject mat-
ter since the Renaissance. As a result, women primarily created portraits,

The French Rococo Style
**Objects in eighteenth-century France
often were covered with curvilinear
surface patterns, lavish gold *gilding*
(thin coats of gold), and dainty dec-
orations of flowers and garlands, all
of which visually symbolized the
superficial, stylized atmosphere of
the period.**

Fig. 4-4 In one of her many self-portraits, Elisabeth-Louise Vigée-Lebrun captures her own fascinating character, which was a mixture of beauty, charm, and artistic talent. What is the most distinct element of the artist's face? Can you imagine what Vigée-Lebrun might be expressing through her eyes, which steadily hold our gaze?

Elisabeth-Louise Vigée-Lebrun. Pastel Self-Portrait, *c. 1789–90. Private Collection.*

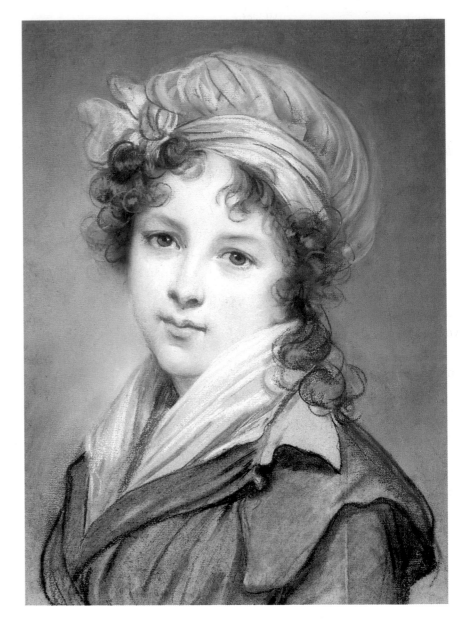

Vigée-Lebrun's Salon
Elisabeth-Louise Vigée-Lebrun's fashionable salons were so popular that "the marshals of France had to sit on the floor"—an amusing sight because the overweight, elaborately dressed aristocrats reportedly had trouble rising once again. Unlike other hostesses, Lebrun adamantly banned political talk at her salons. The evenings of music, witty conversation, and elegant costume parties delighted guests and fulfilled her own social fantasies. Vigée-Lebrun's salons, however, led to speculation about the purity of her reputation. Whether the accusations were justified, she reasoned, "Has one ever known a great reputation, in whatever matter, that failed to arouse envy?"

miniatures, floral and animal pieces, still lifes, and intimate genre scenes. Because these themes were considered lesser achievements, females themselves were held in lower esteem and often were unable to command respect or fair prices for their work. When women were praised, it was commonly said that she could "paint like a man." In the Age of Enlightenment, art created by men was the only measure of excellence.

As the period progressed, female artists responded to the restrictive professional situation in numerous ways. A few established women's academies took on female students, and still others petitioned for changes within the official institutions. Women also began to study the

great masterpieces firsthand, when the Revolution finally opened France's royal collections to the public. Despite the obstacles females faced in the eighteenth and nineteenth centuries, it is notable how many still acquired international recognition. The following discussion represents just a small selection of such pioneers.

French Women Artists

Elisabeth-Louise Vigée-Lebrun: The Last of the Ancien Régime

ELISABETH-LOUISE VIGÉE-LEBRUN (1755–1842), similar to most artists of the era and those of the past, came from an artistic family. Her father was a portrait painter and professor at the Academy of St. Luke in Paris, and she met famous artists, philosophers, and writers of the day at his studio. Her memoirs reveal that as a child, she created drawings on every available surface, including book covers and the walls of the convent school she attended. At age fifteen, Vigée-Lebrun began her professional career, already able to support her recently widowed mother and younger brother.

Vigée-Lebrun was considered beautiful, (Fig. 4-4) which meant that she faced unwanted advances from some of her male patrons. She was reluctant to follow her mother's advice to marry a particular suitor, the art dealer Pierre Lebrun. She later reflected, "I was earning a great deal of money so that I felt no manner of inclination for matrimony." Vigée-Lebrun eventually accepted Pierre's proposal largely to distance herself from her mother's new husband, a man who insisted on taking all of Vigée-Lebrun's earnings. "At last I consented to marriage, desiring above all to escape from the torment of living with my stepfather. So small, however, was my enthusiasm to give up my freedom, that on the way to the church I kept saying to myself 'Shall I say yes? Shall I say no?' Alas, I said 'yes' and changed my old troubles for new ones."

Vigée-Lebrun's first husband turned out to be a womanizer and used her earnings to pay off his gambling debts. He also forced her to give lessons to support his extravagant life-style. The pair ended up living in separate quarters of their house, but Pierre did not follow Elisabeth and their daughter when they fled into exile during the Revolution. The couple finally divorced in 1794, after the Revolution brought about laws that made it legal to do so.

Vigée-Lebrun lived at a time when women artists could not succeed on the basis of talent alone. They needed a combination of education, beauty, wit, and social grace to entertain and put their wealthy sitters at ease. Fortunately, Vigée-Lebrun had all these qualities and attracted a vast array of affluent patrons whom she painted in flattering, often idealized portraits. (Fig. 4-5)

Vigée-Lebrun's Artistic Style
Elisabeth-Louise Vigée-Lebrun avoided exploring the emotional side of her sitters, paralleling the era's penchant for pleasing external appearances. She understood the tenor of the times, saying, "I endeavored to capture the women I was painting and whenever possible, the attitude and expression of their countenance; with those who lacked character, I painted dreamy and languid poses."

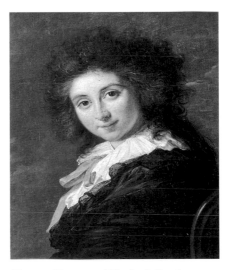

Fig. 4-5 Compare Elisabeth-Louise Vigée-Lebrun's use of oil paints here to the pastels she used in her self-portrait. Observe how skillfully she conveys an accurate sense of textures in both media. Vigée-Lebrun was a tremendously prolific artist, producing over 1,000 recorded portraits during her eighty-seven years.

Elisabeth-Louise Vigée-Lebrun. Madame Étienne Vigée, née Suzane Marie Fraçoise Rivère, 1785. *Private Collection.*

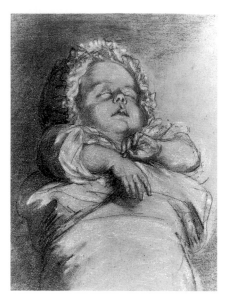

Fig. 4-6 How has Elisabeth-Louise Vigée-Lebrun used her medium to capture the essence of the French queen's sleeping baby? She drew with a minimal amount of soft dark and light pastels to convey the child's essential nature.

Elisabeth-Louise Vigée-Lebrun.
Sleeping Child Study (Study for Marie Antoinette and Her Children), 1786.
Private Collection.

Vigée-Lebrun not only painted portraits of princes, princesses, dukes, duchesses, and heads of state but also became the official court artist to Marie Antoinette, with whom she developed an intimate relationship. (Fig. 4-6) Vigée-Lebrun was so closely associated with the royal court that she feared for her life when the king and queen were arrested. This prompted her flight from Paris with her daughter. Vigée-Lebrun was nearly penniless because of her husband's gambling, but she easily obtained commissions during her subsequent twelve years of traveling throughout Europe.

At the age of forty-six, Vigée-Lebrun finally was allowed to return to France after 255 fellow artists had signed a petition on her behalf. However, the aristocratic culture in which she had thrived had disappeared, and Vigée-Lebrun's style of fashionable court painting was no longer relevant. She lived out the rest of her long life in a country retreat outside of Paris, painting and entertaining the survivors of the Revolution, nostalgically reminiscing about an earlier age.

Adélaïde Labille-Guiard ADÉLAÏDE LABILLE-GUIARD (1749–1803) shared many of the same patrons as Vigée-Lebrun, but, unlike her, Labille-Guiard successfully adapted her talents to meet the expectations of the French governments that held power after the Revolution.

Labille-Guiard always approached her sitters with a sensitive eye, regardless of their political preferences. Perhaps her minute attention to the nuances of costume, gesture, and facial expression stemmed from her childhood environment. Labille-Guiard's father was a clothes merchant to the courts; therefore, she grew up surrounded by the ribbons, lace, and satins that she later painted with great authority.

In contrast to Vigée-Lebrun, Labille-Guiard neither mixed socially with her patrons, nor did she purposely cultivate a flamboyant artistic personality. Yet, like her peer, Labille-Guiard saw no reason to be chained to the domestic front. Both artists divorced their husbands and were able to earn a living through their artwork. Furthermore, although they were considered "ladies," the two women exuded confidence and a professional attitude. Vigée-Lebrun commanded extraordinarily high fees, even in comparison to male artists, and Labille-Guiard did not hesitate to send payment notices frequently to her noble patrons who, on the eve of the Revolution, were more concerned about their lives than about paying off debts.

Labille-Guiard took a more active role in improving circumstances for female artists than did her compatriot. Whereas Vigée-Lebrun had little taste for teaching, Labille-Guiard ran a thriving studio, regularly mentoring talented young girls. She was a gifted and supportive instruc-

tor, and several of her students became successful painters themselves. (Fig. 4-7)

Labille-Guiard advocated women's causes in other ways, such as rallying for women's rights at the academy and urging the institution to lift its restrictions on admitting female artists. In addition to abolishing the arbitrary quota of only four women members, her motion passed for increased numbers of female professors at the art school, despite strong opposition. In 1791, Labille-Guiard also introduced a proposal requesting state-subsidized education for girls from less privileged families.

As with other successful women artists of her generation, Labille-Guiard, too, became the target of scandalous accusations designed to tarnish her reputation. In 1782, Labille-Guiard confronted a challenge regarding the authenticity of her work by inviting exhibition jury members to her studio, where she painted their portraits "live," as they looked on.

Both Labille-Guiard and Vigée-Lebrun were admitted to the academy in 1783. Their paintings were hung side by side purposely to create an artificial rivalry between them. At the time, female artists frequently

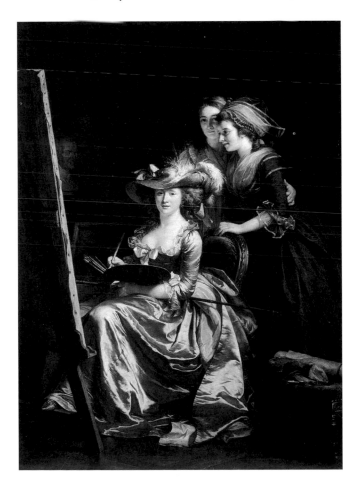

Fig. 4-7 How did aspiring female artists, forbidden from attending the academy's classes, learn to paint? Adélaïde Labille-Guiard's canvas illustrates how established women helped younger female students by training them in their studios. In this work, Labille-Guiard represents herself with two of her most famous followers. The painting represents Labille-Guiard's influence on others, a criterion that has long been considered important in judging an artist's significance.

Adélaïde Labille-Guiard. Portrait of the Artist with Two Pupils, Mlle. Marie Gabrielle Capet and Mlle. Carreaux de Rosemond, 1785. *The Metropolitan Museum of Art. Gift of Julia A. Berwind, 1953.*

Fig. 4-8 Rosa Bonheur produced one of the largest animal scenes ever completed in a period when a painting's size was associated with prestige. How does Bonheur's canvas affect you? Do these horses seem tame or wild? What do you think the relationship is between the men and the enormous steeds? The men's struggle to try to dominate the horses' wild spirits creates excitement and tension.

Rosa Bonheur. Horse Fair, 1853, oil on canvas. The Metropolitan Museum of Art, Gift of Cornelius Vanderbilt, 1887. © 1979 by The Metropolitan Museum of Art.

Early Mass Marketing of Fine Art
Many people throughout western Europe owned prints of Rosa Bonheur's *Horse Fair*, which became one of the best-known nineteenth-century paintings. Queen Victoria of England even arranged for a private viewing when Bonheur brought the work to London.

were compared only with one another rather than with their male contemporaries, whose work was equally, or sometimes more, relevant to the women's paintings. Thus, male jury members who hung the exhibitions were further able to marginalize and undervalue female achievements.

Rosa Bonheur: A Nineteenth-Century Renegade How did ROSA BONHEUR (1822–99) differ from her French female predecessors? This cigarette-smoking, land-owning, self-supporting artist must have amazed both her male and female peers.

Bonheur's childhood shaped her belief that she could live a spirited, independent life. Her father belonged to the Saint-Simonians, a utopian socialist movement that strongly supported women's rights and valued artists' contributions to society, indeed insisting that they must lead the way to a new world. Bonheur later wrote, "The moral brace which I received from the Saint-Simonian connections has remained with me to this day."

Both Bonheur's parents were artists. By age seventeen, she was producing landscapes, historical paintings, and genre scenes—but she was most passionate about serious, large-scale animal studies. Bonheur was the first female to create animal compositions on the same size and scale as history paintings. (Fig. 4-8) She studied animals firsthand and spent much of her time dissecting carcasses at slaughterhouses and observing various creatures at stockyards, open fields, horse fairs, and markets.

To move about freely and work comfortably, Bonheur dressed in men's clothing after obtaining the required legal permission to do so, and she wore her hair short and bobbed. Appearing in such an unladylike manner when painting out-of-doors, Bonheur openly challenged European society's concept of acceptable female behavior. Her paintings also were far from the dainty, domestic compositions that more traditional women artists produced. Bonheur's works were not small, romanticized images of animals in an idyllic setting, but rather powerful, dramatic scenes that realistically captured the energy and spirit of her animal subjects.

Bonheur deliberately chose not to marry: "I well knew that I would lose my independence were I to take on household and wifely duties." She was fortunate to have a lifelong companion, Nathalie Micas, herself a painter, who took care of the details in Bonheur's life so that Bonheur could devote herself completely to art. It appears that Bonheur's success was aided partially by having someone—in this case, another woman—take over the "wifely duties." With the same advantages as male artists, Bonheur's career thrived. She was known internationally, and prints of her paintings sold throughout Europe and the United States. The "renegade" artist became so popular that a Rosa Bonheur doll was manufactured, providing a positive role model for young girls.

Bonheur received numerous official acknowledgments throughout her life. In 1849, she took over her father's post as director of the state-run School of Design. She also was the first woman to receive the French Cross of the Legion of Honor, personally presented in 1864 by Empress Eugénie, acting for her husband, Napoleon II. The empress stated, "[I] wished the last act of my regency to be dedicated to showing that in my eyes genius has no sex."

Bonheur was the first female French artist to gain recognition solely as a result of her merits. Her success also marked the end of an era. By the late nineteenth century, it was no longer required for women to cultivate superficial "feminine" charms in order to work as professional artists.

Women in England

In the previous era, during the late seventeenth century, church reforms had initiated profound changes in British law that subjugated women. A letter from Lord Chesterfield, the British author and statesman, demonstrates that by the mid-eighteenth century, not much had changed for British females: "Women, then, are only children of a larger

Animals at Home
Even as a child, Rosa Bonheur loved painting animals and kept a large collection of subjects in her family's apartment. Legend has it that her brothers regularly carried Bonheur's pet goat down six flights of stairs to walk it in the open air. Also, she and her siblings reportedly learned the alphabet by associating letters with familiar creatures on their grandparents' farm. As an adult, Bonheur kept exotic animals on her property, including lions, gazelles, Icelandic ponies, and yaks, along with the more usual European household pets.

Fig. 4-9 Notice the lacy, vertical texture of the Houses of Parliament, which punctuated the nineteenth-century London skyline. These government buildings were primarily men's domain, while most women remained at home.

Sir Charles Barry and A. Welby Pugin. Houses of Parliament, 1836–60. Courtesy of the British Tourist Authority. Photograph © the British Tourist Authority, London.

Fig. 4-10 If Queen Victoria (1819–1901) sketched daily activities around her, then what kind of life does her drawing indicate she might have led?

Queen Victoria. **Study of Veiled Woman with Hawk, 1855,** *pen and ink over pencil. The Forbes Magazine Collection, New York. All Rights Reserved.*

The Arts in Education
By 1851, approximately 25,000 governesses worked in England. These women were educated in, and then taught their own students, fine art, needlecraft, and music.

growth…. A man of sense only trifles with them, plays with them, humors and flatters them, as he does with a sprightly, forward child."

As in the rest of western Europe, British society encouraged females to focus on marriage and motherhood. By the nineteenth century, QUEEN VICTORIA's impeccable family life during her sixty-four-year reign, from 1837 to 1901, set the standard for women to be faithful to their husbands and to bear many children. In contrast, a spinster, who might forever be dependent on relatives, was universally pitied. Marriage provided a female with some financial security; yet once wed, a wife, everything she owned—even the children—automatically became her husband's property. The government established these laws to "protect" the "fairer" sex, who were perceived as incapable of taking care of themselves.

British education, primarily available only to the wealthy until the mid-nineteenth century, invariably reinforced women's subservient position. Females were taught accomplishments that would attract and hold a man. If a young lady studied subjects beyond this, she was advised strictly to conceal her intellect to maintain her "feminine" role. Edmund Burke, the Irish-born statesman and writer, noted in his book *On the Sublime and Beautiful* (1756), "The beauty of women is considerable owing to their weakness or delicacy and is even enhanced by timidity."

Later educational reforms in England during the mid-nineteenth century led to the establishment of a few colleges and universities for middle-class females, designed to train the growing number of women who remained single because of mass male emigration. Without husbands or family inheritances to support them, middle-class females had to seek employment. Social rank and custom prevented these gentlewomen from working in factories, trades, or domestic services; instead, many became governesses—the only respectable career available. Ultimately, British school reforms advanced so slowly that women were no better educated in 1860 than they had been 200 years before.

Females and the British Industrial Revolution

As in previous generations, working-class and underclass women continued to assist their husbands, brothers, or fathers at shopkeeping, farming, innkeeping, and so on, often running the businesses alone after the men's death. These females also maintained jobs in the spinning, weaving, and lace-making trades. Women's participation in the work force expanded with the onset of the Industrial Revolution, although not always to their benefit. The invention of machines such as the spinning jenny and the power loom shifted the site of weaving and spinning industries from the home into large factories. These businesses hired females and orphaned children because they could be paid lower wages

than male workers. Conditions quickly grew so deplorable that men and women joined together to fight the inequities. Females eventually organized separately to achieve their own rights and forced the government to make modest improvements. By the end of the nineteenth century, economic changes stemming from the Industrial Revolution helped empower middle-class British women for the first time in history.

Women and the Arts

In the upper classes, a group of intelligent, charming hostesses emerged who paralleled those in French salon society. Similar to their counterparts across the channel, these British ladies entertained leading intellectuals in grace and luxury. A number of extraordinary women rose from within these social circles to become recognized writers, politicians, and artists.

During the sixteenth and seventeenth centuries, England had imported painters from abroad. Women such as Susannah Hourbout (1503–after 1550), Levina Teerlinc (c. 1515/1520–76), and Artemisia Gentileschi (c. 1593–1652/53) were among those who had been invited to the royal court. By the latter half of the eighteenth century, the renowned British artist Sir Joshua Reynolds addressed the lack of native-trained painters by helping to establish an academy. As its first president, he opened the Royal Academy in 1768 with thirty-six founding members, among them, two women—Mary Moser and Angelica Kauffmann. By the end of the eighteenth century, however, only about a dozen women had become honorary members, and no females were elected to full membership until 1922. British women artists faced the same obstacles as did their counterparts in the French academies. For instance, they were forbidden to sketch from a nude model until after 1893, when the partially draped figure was introduced into female life-drawing classes.

British Female Artists

Portraiture was the most common subject matter in England because the Protestant Church forbade the creation of monumental religious works. Interestingly, it was a woman artist who introduced the new category of history painting to the country.

Angelica Kauffmann: British History Painting England claims ANGELICA KAUFFMANN (1741–1807) as its own, even though she actually was born in Switzerland, where her father was an itinerant artist who moved his family from village to village throughout Europe. He taught his only child how to paint, and even before she was twelve, Kauffmann had helped him with several commissions. During their wanderings, Kauffmann studied the great masters and came into contact with prominent artists who used the formal, elegant neoclassical style.

Fig. 4-11 Art ran in Queen Victoria's family, as seen in this accomplished still life by her daughter. Can you detect how PRINCESS ROYAL VICTORIA (1840–1901) captured the light shining in from the left-hand side? She delicately highlighted the grapes, apples, pear, and leaves, and plunged the receding areas into darkness.

Princess Royal Victoria. Fruit in a Basket, *1873, oil on canvas. The Forbes Magazine Collection, New York. All Rights Reserved.*

Royal Female Artists
Through the ages, members of royalty never became professional artists, although quite a few pursued creative endeavors. Both the queen of Bohemia in the seventeenth century, and Madame de Pompadour in the eighteenth, displayed drawing talent, which by then had become a virtue on the order of embroidery or music. In the nineteenth century, drawing was an accepted part of every gentlewoman's education. Queen Victoria (1819–1901) and her daughter the Princess Royal (1840–1901) were fairly accomplished painters. (Figs. 4-10 and 4-11)

The History of History Painting
During the Italian Renaissance, academic art theorists insisted that painting inspire patriotism. History painting was the most suitable theme to glorify the church and state, and it remained the highest-ranking category for centuries.

Fig. 4-12 In the nineteenth century, upper-class British women instructed their daughters in reading, writing, and the needle arts.

From 1800 Woodcuts by Thomas Bewick and His School. *Dover Publications, Inc., NY.*

Fig. 4-13 Artists typically sold their work through art dealers or at the salon and Royal Academy exhibitions.

From 1800 Woodcuts by Thomas Bewick and His School. *Dover Publications, Inc., NY.*

Kauffmann's beauty, charm, modesty, and talent opened the doors for her to enter the best of European society. Local nobility and foreign visitors flocked to her studio starting when she was only sixteen years old. In London, Kauffmann completed many portrait commissions to support herself, but her true interest lay in history painting. (Fig. 4-14) As noted, this genre was regarded as the most prestigious category of art because it required a thorough knowledge of figure drawing, perspective, history, classical literature, mythology, Bible stories, and art theory. Kauffmann excelled in this genre even though women still were not allowed to study from live nude models. Her paintings of heroic subjects on a magnificent scale significantly advanced the acceptance of the neoclassical style in England.

Unfortunately, Kauffmann's professional success did not extend to her early domestic life. In 1767, Kauffmann married a man she believed to be a Swedish count, only to discover later that he was an impostor who already had a wife. Although she could have divorced him, Kauffmann remained legally married until he died fourteen years later. She then wed a Venetian decorative painter, Antonio Zucchi, whose reputation and fortune were securely intact.

The couple settled in Rome and became the center of the city's sophisticated artistic community. Zucchi freed Kauffmann from tiresome daily duties by managing the household, ordering her canvases and frames, shipping completed works, and keeping careful accounts of all business transactions. Relieved of these tedious tasks, Kauffmann devoted herself entirely to painting. Perhaps equally important to Kauffmann's success in the male art world was her ability to preserve her "feminine" virtues. She deliberately cultivated these qualities to help make her professional career acceptable. In contrast, Kauffmann's friend and fellow Royal Academy member MARY MOSER (1744–1819), who was considered plain and lacking in the necessary social graces, faded into obscurity despite early acknowledgment of her artistic skills.

Anne Seymour Damer: Sculpture Female sculptors were even more rare than successful women painters. ANNE SEYMOUR DAMER (1748/49–1828) was a sculptor who enjoyed considerable fame during her lifetime. The granddaughter of a duke, Damer grew up in an aristocratic environment and received a thorough formal education.

Legend has it that an incident with her friend, the philosopher David Hume, initiated Damer's career when she was still quite young. While on a walk, the two came upon an Italian boy selling plaster vases

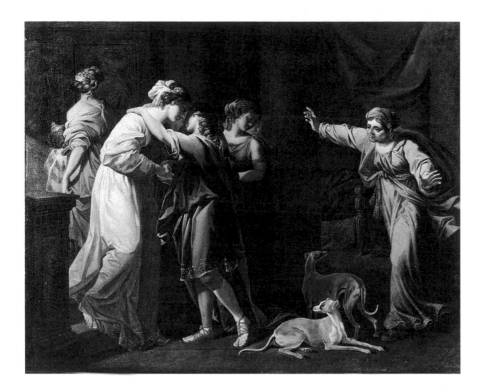

and figures. After Hume examined the objects, Damer ridiculed him for his taste in art. Hume retorted that no woman even had the creativity to make these mundane plaster casts. Damer resolved to meet his challenge. She obtained wax and carving tools and produced a head that was reportedly Hume's portrait. Hume still was unsatisfied and suggested that working with wax was easy compared to sculpting in marble. Although her resulting piece did not quite meet Hume's standards either, Damer was off to a promising career.

In an age when it was barely conceivable for ladies to paint, it was almost completely unthinkable for them to work with their hands in wet clay or to be covered with marble and plaster dust. Damer persisted, nonetheless, and steadily produced portrait busts, full-length figures, and animal subjects in a pristine neoclassical style. (Fig. 4-15) She was labeled an eccentric by her friends and ridiculed in the British press for daring to carve an academic nude figure; yet Damer was the only female British sculptor of renown until the twentieth century. She was an artist to the end—buried along with her sculpting tools, exactly as she had requested in her will.

Fig. 4-15 How does Anne Seymour Damer convey Sir Joseph Banks' character? Damer gives Banks an air of authority through his intense expression, flowing hair, and the spare, crisp elements of his dress.

Anne Seymour Damer. Sir Joseph Banks, *1813, bronze. Courtesy of the Trustees of the British Museum, London. © British Museum.*

Italy

Rosalba Carriera: Pastel Portraits Come of Age

The Italian artist ROSALBA CARRIERA (1675–1757) is credited with raising pastel portraiture to new heights in the eighteenth century. Carriera came to art through craft. She initially pursued her mother's trade as a lace maker, helping to design patterns at a young age. When the lace market collapsed, Carriera began to decorate the lids of small ivory snuff boxes, which tourists greatly favored. Carriera's father was also a painter, who was employed as a government official. He recognized his daughter's talents and sent her off to study anatomy and miniature painting.

Carriera's teacher introduced her to pastels. Originally, soft black, red, and white chalks had been used only for preliminary sketches. However, in the fifteenth century, the materials were improved and many colors added. A few centuries later, Carriera was one of the first to use pastels as an independent medium. She carefully built subtle layers of color and form to imitate exquisitely the lacy, elegant clothing and powdered wigs of her privileged sitters. The jewel-like quality of Carriera's portraits reflected eighteenth-century society's obsessive love of surface decoration. (Fig. 4-16)

Fig. 4-16 Rosalba Carriera deliberately avoided communicating anything about her sitter's inner emotions or psychology. Instead, she concentrated solely on the person's exterior beauty, a concern that fully consumed her upper-class patrons. Carriera's ability to flatter her models visually made her famous and also succinctly captured western Europe's age of extravagance.

Rosalba Carriera. Young Lady with a Parrot, *c. 1730, pastel on paper. Helen Regenstein Collection, 1985.40. The Art Institute Chicago. Photograph © 1996, The Art Institute of Chicago. All Rights Reserved.*

Fig. 4-17 Given her subject matter, who might have typically bought MARGUERITE GÉRARD's paintings? The emerging wealthy, educated bourgeoisie greatly enjoyed her painstaking genre scenes of Enlightenment women engaged in domestic activities. Here the mother, rather than a music tutor, devotes herself to teaching her daughter the requisite knowledge of music. Similar to the Dutch a century earlier, French well-to-do patrons filled their homes with images that represented traditional family values.

Marguerite Gérard. The Piano Lesson, 1785–89, oil on canvas. Private Collection.

In 1705, Carriera was elected unanimously as a member of Rome's Academy of St. Luke, the first female to receive this distinction. The academies in Paris and Bologna followed suit, a rare honor for any woman of the period. Carriera was plagued by blindness in her later years, but she continued to teach and influence students, including two of her own sisters.

Advances and Challenges in the Age of Reason

The patriarchal social reforms and revolutions that underpinned the Enlightenment kept most women confined to the drawing room, hearth, and homefront. Nonetheless, a few did achieve international success as artists despite the stigma attached to their professional ambitions. In the eighteenth century alone, records show that at least 290 female creators practiced throughout western Europe. But women continued to struggle for recognition within the male-dominated art world, which frequently pushed them to the sidelines or treated them as eccentric oddities. In the meantime, women across the ocean faced both similar and different challenges in the new, emerging American nation.

Portraits: The First Snapshots
In the days before popular photography, wealthy patrons often commissioned artists to paint their portraits as records of themselves and the places they had visited. The patrons frequently were young men who were traveling through Europe on a "grand tour," considered the traditional conclusion of their formal education.

Fig. 4-18 EDITH HAYLLAR, who recorded her family's activities in their large, rambling Victorian home, illustrates how British women first began to participate in sports during the period. What must it have been like to play an invigorating game of tennis dressed in the clothes this couple wear?

Edith Hayllar. A Summer Shower, *1883, oil on board. The Forbes Magazine Collection, New York. All Rights Reserved.*

Selected Additional Eighteenth- and Nineteenth-Century Women Artists

France

Marie Guillemine Benoist (1768–1826) History painting, portraits, genre scenes of family life; student of Elisabeth-Louise Vigée-Lebrun and Jacques Louis David

Marie Gabrielle Capet (1761–1817) Student of Adélaïde Labille-Guiard

Constance Marie Charpentier (1767–1849) Life-size portraits and genre scenes; leading neoclassical artist

Françoise Duparac (1726–78) Genre scenes of the working class

Félice de Fauveau (1802–86) Sculptor in marble, wood, and metal; became sole supporter of her family of six after her father's death

Marguerite Gérard (1761–1837) History painting, portraits, and genre scenes; pupil and collaborator of Jean-Honoré Fragonard, who was her brother-in-law; gained great commercial success selling paintings to Napoleon and Louis XVIII (Fig. 4-17)

Adrienne-Marie-Louise Grandpierre-Deverzy (active 1798–1855) Pupil and wife of French artist Abel Pujol; learned anatomy by drawing from plaster casts of antique sculptures

Antoinette Cécile Hortense Haudebourt-Lescot (1784–1845) First of the few French female artists to study in Rome; credited with helping to initiate Italian genre painting; only woman depicted in a painting of King Charles X distributing awards to artists

Constance Mayer (1778–1821) Student, friend, mistress, and housekeeper to the artist Pierre-Paul Prud'hon; painted portraits and allegorical subjects in soft, languid colors

Marie-Geneviève Navarre (1737–95) Student of an artist who helped spread Rosalba Carriera's influence of pastel portraits through western Europe

Anne Vallayer-Coster (1744–1818) Flower still lifes and portraits; fell out of favor after the French Revolution

England

Barbara Leigh Smith Bodichon (1827–91) Renowned artist and feminist; fought for the abolition of slavery after visiting the United States; worked in oils and watercolors; known as the "Rosa Bonheur" of landscapes; painted in South Africa, Spain, America, Canada, and Brittany; cofounded Girton College for Women in England, offering female students equal educational opportunities

Joan Carlile (1600–79) First British woman whose name appears in the history of British art; along with Anthony van Dyck, she was a favorite of King Charles I

Margaret Carpenter (1793–1872) Leading early-nineteenth-century portrait painter

Marie Cosway (1759–1838) Nurtured by Angelica Kauffmann; produced everything from miniatures to history painting

Edith Hayllar (1860–1948) Exhibited at the Royal Academy; she and her three sisters produced paintings that reflected the ideals of middle-class British life (Fig. 4-18)

Emily Mary Osborn (1834–after 1893) Genre painting, portraits, and literary subjects; best known for works making strong statements about the perils of being poor—particularly for women; Queen Victoria purchased at least two of her paintings

Henrietta Rae (1859–1928) Portraits, nudes, genre scenes, classical and literary subjects (Fig. 4-19); exhibited in both London and Paris

Catherine Read (1723–78) Received many royal commissions for oil and pastel portraits

Frances Reynolds (1729–1807) Younger sister of Sir Joshua Reynolds, whose household she managed for over twenty-five years; became well-known for painting miniatures

Lucy Maddox Brown Rossetti (1843–94) Leading female artist in the Pre-Raphaelite Brotherhood, a mid-nineteenth-century group of militant painters who organized the first revolt against the Royal Academy and its pretentious history paintings; advocated a return to purity of art before the High Renaissance, believing this would help reform the ills of modern civilization

Elizabeth Thompson (c. 1846–1933) Acclaimed for large-scale military scenes; additional police were hired to control the crowds that lined up at the Royal Academy to view her first submission (Fig. 4-20)

Italy

Marianna Candida Dionigi (1756–1826) Landscape painter and archaeologist

Giulia Lama (c. 1685–after 1753) Large-scale religious and narrative paintings

Fig. 4-19 HENRIETTA RAE transforms her model into Flora, the Roman goddess of flowers and fertility, with garlands and classically ideal facial features. Rae began studying art at age thirteen in London and exhibited at the Royal Academy during her career.

Henrietta Rae. Passiflora, n.d., oil on canvas. The Forbes Magazine Collection, New York. All Rights Reserved.

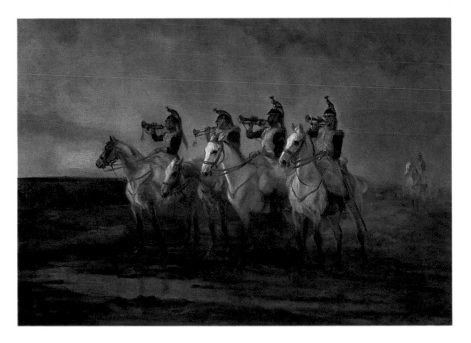

Fig. 4-20 ELIZABETH THOMPSON, later known as Lady Butler after her marriage to a soldier in 1877, was the next female artist after Angelica Kauffmann to create quite a stir in Britain. As a child, she began drawing fighting men and horses in her schoolbooks while her father read aloud accounts of England's military glories. Although Thompson frequently portrayed the heat of battle in her military scenes, here she depicts four lone men rousing the resting army on the morning of the historic battle at Waterloo.

Elizabeth Thompson (Lady Butler). On the Morning of Waterloo, 1914, oil on canvas. The Forbes Magazine Collection, New York. All Rights Reserved.

Chapter 5

Early America:

Diverse Legacies and Living Traditions

Fig. 5-1 Identify the materials a Pomo woman from California added to her basket to transform it into an object of great beauty. What did she use to make her vessel appear red?

Pomo, California, Basket, c. 1880, reeds, woodpecker feathers, abalone shell, black quail plumes, and hand-drilled and polished clam shells. Courtesy of the Montclair Art Museum, Montclair, NJ, Florence O. R. Lang Collection.

A Variety of Vessels
Traditional southwestern ceramics had many uses. In addition to making vessels for cooking, serving, and storing, women crafted ladles, scoops, and spindle whorls from clay. Even broken fragments were reused as gaming pieces or pottery scrapes and scoops, or were drilled with holes to be worn as ornaments.

Native American Females: America's Earliest Women Artists

Who were the first female artists in North America? Some 10,000 to 15,000 years before the earliest European settlers invaded the continent, Native American women fashioned countless practical items for both everyday life and ceremonial use. Their works illustrate not only artistic skill but also a deep respect for nature and spirituality. Females in the majority of nations, also known as tribes, produced finely crafted clothing, accessories, shelters, and household implements, reflecting their keen sensitivity to form, color, and design.

Virtually all Native American art contained an important spiritual component, following Native people's belief that everything in the universe has its own life force. Sacred forces guided artists in their efforts and endowed the objects themselves with special powers.

Native American Women's Artistic Training and Traditions

Older female relatives passed down imagery and technical knowledge to young girls through the generations. Women worked alone and communally, and in some cultures they formed female societies or guilds. Native American women's skills and artistry are evident particularly in their basketry, pottery, weaving, quillwork, beadwork, and hide painting. Today, many female Native artists carry on these ancient traditions, while others invent new modes of creative expression.

Basketry Native American women have crafted baskets since at least 7000 BC. These lightweight, sturdy items were ideally suited for the often mobile nations. Females wove food containers, cradles, hats, mattresses, wood carriers, foot gear, and gaming boards. They relied on local resources, including reeds, bark, bird feathers, and shells to create decorative and functional belongings. (Fig. 5-1)

Pottery Archaeologists believe that Native American women have made pottery for cooking, eating, and storing food and liquid since prehistoric times. Between 900 and 1700 AD, Native females from the Southeast crafted expressive clay funeral vases in the shape of human heads, birds, frogs, fish, and other living beings. Around 1000 AD, the *Anasazi*—ancient ancestors of certain Southwest cultures—created white ceramics covered with geometric designs. In addition, the *Mimbres* women of New Mexico produced vessels with intricate compositions that mingled abstract shapes with insects, animals, or figures. The often whimsical depictions drawn from life, legend, and ceremony greatly influenced subsequent Native artists.

Weaving: Navajo and Chilkat Textiles Navajo (*Diné*) females of the Southwest once created splendidly colored textiles into blankets, shirts, breechcloths, dresses, ponchos, shoulder blankets, leggings, and belts. In the late 1860s, the transcontinental railroad brought increased contact with non-Natives and significantly altered women's approaches to art. White traders supplied bright dyes and yarn and requested that weavers devise new patterns for the expanding commercial market. When the Navajo began to wear manufactured rather than handmade clothing, females turned to developing heavier products. Today, artists continue to sell their rugs and saddle blankets to an outside market.

Women of the Chilkat branch of the Tlingit nation weave blankets from cedar bark and mountain goat hair. Traditionally, wealthy and noble leaders of this Northwest group wore these garments at special ceremonies. Today, each piece still bears an abstracted or imaginary creature considered to have a special relationship with an ancestor. (Fig.5-2)

Weaving, Nature, and the Spirit World

The poem *Song of the Sky Loom*, from the Southwest's Tewa nation, illustrates the connection between women's weaving and the life force of nature and the spirit world.

> O our Mother the Earth, O our Father the Sky,
> Your children are we and with tired backs
> We bring you gifts you love.
> Then weave for us a garment of brightness;
> May the warp be the white light of morning,
> May the weft be the red light of evening,
> May the fringes be the falling rain,
> May the border be the standing rainbow.
> Thus weave for us a garment of brightness,
> That we may walk fittingly where the birds sing,
> That we may walk fittingly where grass is green,
> O our Mother the Earth, O our Father the Sky.

Fig. 5-2 Can you locate the face and other body parts of the clan creature in this robe? The fragmented and rearranged body parts fit snugly within the garment's overall shape. It can take a skilled Tlingit woman approximately six months to complete a Chilkat blanket.

Tlingit, Northwest Coast, Chilkat Robe, c. 1880, mountain goat hair wool and cedar bark string. Courtesy of the Montclair Art Museum, Montclair, NJ.

Fig. 5-3 Each nation had its own visual style, and Native Americans could tell to which tribe people belonged solely from the patterns on their moccasins. Among the Cheyenne, quillwork was particularly well regarded, and a woman's accomplishments could earn her great honor.

Plains, Cheyenne, Moccasins, c. 1890, rawhide, tanned hide, dyed porcupine quills and European trade beads. Courtesy of the Montclair Art Museum, Montclair, NJ, Florence O.R. Lang Collection,.

Early European Female Arrivals
Francisca Hinestrosa was the first European woman after Columbus' voyages to arrive in North America. She followed her solider-husband Hernando de Soto on his expedition to Florida in 1539. Other Spanish and Portuguese females traveled to Florida in 1550 and 1565. Seventeen women were among those who mysteriously disappeared in the Roanoke, Virginia, colony in 1587. In 1609, 120 of the 620 settlers in Jamestown, Virginia, were females. During the next two decades, British and Dutch women immigrated to various settlements along the East Coast.

Quillwork, Beadwork, and Hide Painting What materials did women from various nations originally use to decorate clothing, moccasins, accessories, and utensils? They incorporated porcupine or bird quills into functional and decorative objects for at least 200 years before Europeans arrived. Native people believed that the spirit of the animal lived on in the quills, thus guiding the artist in her creation and bestowing blessings on the piece's owner. Women's painstaking and time-consuming skill was regarded highly in many cultures. (Fig.5-3)

Before European traders introduced commercial beads in the sixteenth century, Native American females fashioned small ornaments from carefully cut, drilled, and polished seashells, stones, bones, and animal teeth. Later, they continued to decorate clothing, headwear, belts, necklaces, and bags with European colored-glass beads. Their varied designs resonated with mythic, spiritual, and personal references.

In the northern and southern Great Plains, women skinned, stretched, and tanned buffalo hides into leather, painting their works with natural pigments in striking geometric designs usually associated with nature or the spirit world.

Modern Native American Female Artists: Evolution and Change

Native American artistic traditions have evolved continuously. In the mid- to late nineteenth century, some of the age-old traditions were lost when the U.S. government forcefully tried to assimilate Native Americans into mainstream culture, forbidding artists from practicing their crafts and urging Native people to use commercially manufactured goods.

In the early twentieth century, Native Americans consciously began to revive their own cultural heritage, sometimes fusing their artistry with modern Western influences. (Fig. 5-4) The advent of a booming tourist and commercial art market has brought previously anonymous female Native American artists widespread and well-deserved recognition. (See pages 137–139, "Women of Color: Probing Cultural Identity.")

Colonial Women Artists: The Ongoing Vitality of the Domestic Arts

Who beautified early colonial life? European females brought many artistic traditions with them, becoming the first artists in the settlements. Yet their creative endeavors were, and remained, relegated to the lower status of crafts because they were not just decorative; they were also functional.

Before the Renaissance, there was no real distinction between "craft" objects made by ordinary people and the "high art" paintings and

Fig. 5-4 How does Jean Bales indicate the inner strength of the Native American woman in *Blue Shawl*? The figure's dance garment sweeps majestically across the canvas in bold colors and a strong pattern. Although of Iowa Indian heritage herself, Bales deliberately suggests the tremendous capacity of all Native American females to carry on their people's cultural legacy.

Jean E. Bales-Lacy. Blue Shawl, 1982, *acrylic on canvas. Collection of Burt and Bonnie Seaborne. Courtesy of the artist.*

sculptures produced by professionally trained artists. However, in the seventeenth and eighteenth centuries, the term *artist* ceased to imply a kind of worker; instead, it suggested a person who often was perceived as exotic, creative, and unconventional. Consequently, craft became associated with the construction of utilitarian articles, and in America's infancy, it was virtually the colonies' only artistic form.

Women's Lives in the Early Colonial Period

It is surprising that anyone produced art during the colonial period, because both females and males were almost entirely consumed with basic survival needs. However, this situation also provided women with greater opportunities than those of their European counterparts.

Regardless of class status, all colonial females carried out vital social roles. They were responsible for childbearing, managing the household, and processing the raw materials from the fields. Women also served as physicians, pharmacists, midwives, and nurses at a time when disease and death were all too common because of harsh weather and unsanitary conditions. Some female settlers ran ferries, taverns, or inns, while others worked as printers, publishers, postmistresses, weavers, milliners, or blacksmiths.

Marriage was based largely on financial necessity because each relative was an essential contributor to the family economy; "love" was a secondary consideration. Wives retained few privileges after their wedding. A husband owned everything that originally was hers—money,

Fig. 5-5 Records from the time of the American Revolution show that while most working women held traditional jobs such as seamstress, innkeeper, or boardinghouse operator, others worked as gunsmiths, shoemakers, blacksmiths, watchmakers, brick-kiln operators, and newspaper print-shop managers. In fact, one of the earliest copies of the Declaration of Independence was printed in a shop owned by Mary Catherine Goddard.

**A Colonial Woman's
Eighteen-Hour Work Day**
Ordinary housewives spent from
sunup to sundown spinning cotton
and flax, sewing clothing and quilts,
building spinning wheels, feeding
barnyard animals, preserving and
pickling meats and vegetables,
milking cows and making butter,
planting gardens, and brewing all
the beer and cider the family drank.
Women also harvested crops along-
side their husbands and helped
shoe horses, cane chairs, stitch shoes,
and keep financial records. Females
accomplished all this while also
usually carrying ten to fifteen preg-
nancies to term, as well as nursing
the sick and elderly.

property, clothes, even the children and her body. Women needed their husband's approval to will their jewelry or clothing to their daughters. In colonial America, where property determined power, married females officially held none of their own. With little legal recourse against abuse, many wives ran away, as evidenced by the numerous newspaper adver-tisements of the time, which offered rewards to anyone aiding in a women's return.

Colonial Women as Cultural Bearers

Pioneering colonial females infused culture into the early settlements through the domestic arena. Young girls learned needlework, spinning, weaving, and sewing from their mothers. Eventually, these art forms also were taught in school.

Each girl acquired the skills necessary to provide clothing, bedding, and rugs for her family once she married. Women devoted much time and labor to these accomplishments. Later, they naturally began to pour their creative energies into what became America's first colonial artworks.

Samplers Young girls first practiced sewing on *samplers*, which were sim-ilar to stitchery paintings. The word comes from the Latin *exemplum*, which describes anything that serves as a pattern for imitation, and from the old French *essamplaire* and the Middle English *samplere*. British females sewed samplers for at least 300 years before any Europeans set-tled in North America.

Learning to create needlework samplers was a critical aspect of a girl's education from the founding of the colonies through much of the nineteenth century. A young lady was required to demonstrate that she could turn at least twenty different stitches, a task that she eventually would apply to making, mending, and marking her family's linens and clothing. (Fig. 5-6)

Little girls, even those five years old and younger, decorated samplers with the alphabet or numbers that their mothers had drawn on narrow linen strips. Daughters often perfected their stitches while watch-ing sheep or rocking a baby sibling to sleep. They ultimately graduated to incorporating more challenging stitches into rhymes, Bible verses, poems, or personal information, such as their own or their parents' names, and decorating borders with intricate geometric patterns, fruits, flowers, animals, or small figures.

Older girls embroidered elaborate samplers with multiplicationta-bles and pictures of buildings, animals, people, biblical stories, or per-sonal prose. (Fig. 5-7) Adult women made samplers as expressions of religious devotion; commemorations of national, community, family, or individual events; and as symbols of friendship.

Sampler Verses from Tots
At age five, one child stitched: "Mary
Smith is my name and with my nedel
I wrought the same." Another young
girl did not enjoy her labor much at
all: "Patty Polk did this and she
hated every stitch she did in it. She
loves to read much more."

Fig. 5-6 How many distinct sorts of stitches can you identify in Rhoda Milford's work? She created each object—the house, sidewalk, various trees, and foliage—in a different style. The initials at the bottom of her piece most likely refer to the members of her family.

Rhoda Milford. Sampler, 1828. © 1988 *Sotheby's, Inc.*

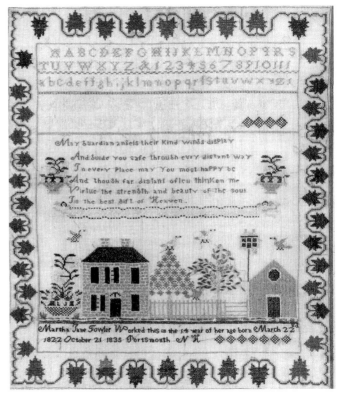

Fig. 5-7 How many different elements can you find in Martha Jane Fowler's sampler, which she stitched at age fourteen? She added a poem to the central portion surrounded by the alphabet, floral motif, row of houses, and birds. At the bottom, she wrote her name, birthdate, and place of birth—Portsmouth, New Hampshire—in a rather lengthy signature. Young ladies often incorporated poems, sayings, or Bible verses in their samplers. What do you think Mary was trying to convey about her character when she stitched in the following lines?

> May guardian angels their kind
> wings display
> And guide you safe through every
> distant way
> In every place may you most
> happy be
> And though far distant often
> think on me
> Virtue the strength and beauty
> of the soul
> Is the best gift of Heaven.

Martha Jane Fowler. Sampler, c. 1836. © *1980 Sotheby's, Inc.*

Fig. 5-8 The forty–five stars on this flag indicate that it was made around the turn of the century, when this type of quilt was quite popular and often made by church women as gifts for important people. "Beatrice, Nebraska, August 18, 1899" is inscribed in white thread across the beige background. In this type of "friendship quilt," one woman embroidered the other 440 names, which were probably signed by local residents.

American, Friendship Flag Quilt, *1899, cotton. Philip Morris Companies Inc.*

Quilts As a result of a shortage of extra fabric in the colonies, New England females ingeniously stitched together recycled scraps to make the quilts necessary to survive the bitter-cold winters. The job was a substantial undertaking—women typically had to make at least five quilts per family member.

Were colonial females the first quilters in history? *Quilted clothing* (made of a top and backing fabric and stitched together with padding between) actually had existed for thousands of years. The ancient Egyptians and Chinese quilted, but it was the Crusaders who brought the art form from Persia to Europe. In the sixteenth and seventeenth centuries, Portuguese and British traders also carried home samples from East India.

Quilts were rare and expensive items in seventeenth-century England. However, with the advent of the Industrial Revolution in the nineteenth century, the entire textile industry blossomed as innovations helped to make manufactured, colorfast, printed cotton readily available. Before the American Revolution, colonists acquired quilts from England. After the war, American mills increasingly produced their own examples from the country's abundant raw materials.

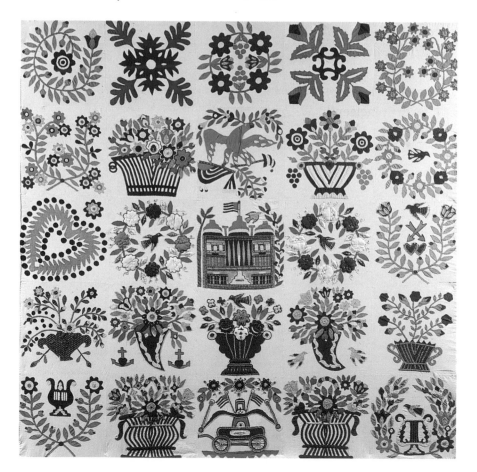

Fig. 5-9 Can you locate the landmark building and fire engine in this quilt? The two images link the piece to the port city of Baltimore. The floral baskets and hearts suggest that the quilt was made for a bride's dowry.

American, Baltimore Album or Bride's Quilt, *c. 1850–60, cotton and wool. Philip Morris Companies Inc.*

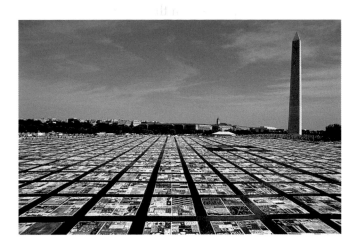

Fig. 5-10 How might it feel to walk through the approximately twenty-one-acre quilt display? Imagine passing by thousands of panels, each representing a person who lost his or her life to AIDS, while hearing volunteers read over a loudspeaker the individual names of the people who died.

The NAMES Project AIDS Memorial Quilt. 20,064 *panels at the International Display, November 1992. Courtesy of the NAMES Project AIDS Memorial Quilt. Photograph by Mark Theissen.*

Women's technical mastery of quilting was no minor feat; a covering might contain as many as 30,000 individual pieces, each measuring a mere ½" by ¾". A single artist created the top layer, using one of many possible designs. Afterward, others in the community gathered to help her sew the padding and layers together. These "quilting bees" also offered females the opportunity to cement friendships, discuss politics, and establish significant social bonds. "Friendship quilts" particularly reflected the communal aspect of the art. For these works, each woman embroidered her name in a quilt block and then sewed the pieces into a quilted cover, providing the owner with a beautiful reminder of her companions. (Fig. 5-8)

By the nineteenth century, females incorporated political and social reform themes, such as abolition, temperance, and women' suffrage, into their quilts. One example carried the sentiment, "May the points of our needles prick the slave owner's conscience." Women hoped that by drawing attention to the injustice of slavery, they would simultaneously awaken men to the lack of freedom that they themselves endured.

In the 1850s, the famous feminist campaigner and writer, Susan B. Anthony, gave her first talk on equal rights for women at a quilting bee in Cleveland, Ohio. She and her coworker, Elizabeth Cady Stanton, frequently used such gatherings to urge women toward political activism.

The invention of the automatic loom in 1826 quickly led to the use of machine-made cloth. With a greater choice of fabrics, women devoted increasing creativity to complexly pieced and *appliqué* (cut-out decorations fastened to a larger piece of material) quilts that became supreme artistic expressions of the nineteenth century. (Fig. 5-9) Today, quilts are highly prized possessions collected by individuals and museums alike. Their continued popularity demonstrates how this female art form has gained widespread recognition over time.

The NAMES Project AIDS Memorial Quilt: Healing and Remembrance Through Art
Since 1987, people of all ages, races, professions, and sexual preferences have been participating in what used to be solely a female craft, as a means of personal healing and public advocacy. By 1996, individuals and groups had contributed nearly 45,000 6' x 3' quilted panels, each commemorating a loved one who died from AIDS (Acquired Immune Deficiency Syndrome). People from over thirty-nine countries have been constructing the fabric panels, which when displayed together, cover an area equal to nineteen football fields (Fig. 5-10), making it the largest community art project in the world. The AIDS Memorial Quilt maintains the quilting tradition's continual response to crucial contemporary social issues, just as its early female practitioners used their needles to protest slavery and fight for women's suffrage.

Fig. 5-11 American females were not the only ones to use their needle skills to beautify household goods. This work is from Uzbekistan, a country bordering Turkey and Afghanistan, in Central Asia. The embroidery style is known as *Souzani*, the Persian word for needle. Women created red floral pieces such as these as ceremonial wall hangings, bedspreads, or curtains to make up part of a bride's dowry.

Uzbekian. Souzani (embroidery) Dowry Piece, *early nineteenth century, silk embroidery on natural linen. Philip Morris Companies Inc.*

Fine Stitchery Arts Some colonial women used their needles like brushes in *tambourwork*, darning decorative designs onto material that they then made into pillowcases and other domestic adornments. In *Turkeywork*, they imitated patterns from Turkish carpets with knotted colored yarn on heavy cloth. For *featherwork*, women attached feathers onto fabric to form flowers, birds, and other embellishments. American females who embroidered were often sustaining sewing traditions that had originated in their ancestors' homeland. (Fig. 5-11)

Papyrotamia Ancient Asian and European monarchs practiced cutting paper pictures as a royal pastime. Later, European artists used paper stencils to decorate borders around church paintings or on choir stalls, family chests, furniture, or household items.

 In early America, talented women spent hours patiently cutting perfect scenes of people, animals, flora, and abstract designs out of paper, which was considered a priceless material. Ladies mounted, glazed, framed, and proudly displayed their best pieces. In the eighteenth century, their paper cuttings adorned religious texts, love notes, and legal documents. One Boston woman recorded her entire family home and farm in papyrotamia pictures for future generations to cherish.

Female Folk-Art Painters

Folk artists are sometimes referred to as "primitive" or "naive" painters because they are self-taught and generally removed from the mainstream

art world. Female folk artists tended to depict subjects that were most familiar to them. Their portraits and paintings of daily life or scenes from literature were actually some of the first of their kind seen on this side of the Atlantic. Despite their individual styles, most folk artists painted with a flattened sense of depth because they had never received formal training in perspective. However, these creators expressed sharp sensitivity to detail and produced engrossing works with distinct artistic value.

Of all the successful female folk artists, many whose names have been lost through the generations, that of Grandma Moses has become essentially synonymous with American primitive painting.

Anna Mary Robertson Moses (Grandma Moses) The example of ANNA MARY ROBERTSON MOSES, known as Grandma Moses (1860–1961), demonstrates how the tradition of folk-art painting has continued uninterrupted from the colonial period to modern times. (Fig. 5-12) Moses was a hard-working farmer who began to paint seriously only in her later years, after her children had grown and left home, her chores diminished, and arthritis prevented her from sewing and needlework. Although she had been skilled in needlework and quilting, and had painted a bit previously, Moses now returned enthusiastically to her brush and pigments. Her daughter-in-law was so impressed with the results that she took examples to a women's exchange at a local drugstore, where they were seen by a private art collector. The gentleman was taken immediately with Moses' art and subsequently helped to arrange her first exhibition.

Fig. 5-12 Do you believe that this village looked exactly the way Anna Mary Robertson Moses painted it in 1941? Moses presented a poetic vision of a country settlement untouched by the reality of the modern industrial times. Her simple figures, shown producing maple sugar, nostalgically evoke a vanishing aspect of American life.

Anna Mary Robertson Moses (Grandma Moses). Maple Sugar Orchard, 1941, oil on masonite. Copyright © 1990, Grandma Moses Properties Co., New York. Courtesy Collection, IBM Corporation, Armonk, New York.

**Art Education for Girls
in Early America**
As the colonies matured, painting
and drawing eventually became part
of every proper young lady's train-
ing. Originally, girls did not invent
their own compositions; rather, they
were taught to copy from existing
prints or to arrange pre-cut stencils.
Their adaptations, variations, and
color choices were nonetheless often
quite inventive.

Selected Additional Early Female Folk-Art Painters

Ruth Henshaw Miles Bascom (1772–1848) Primitive painter of profiles in
pastel; took up art when she was about fifty-eight

Betsy Lathrop (active in New England 1810–12) Primitive painter in gouache
and watercolor on silk

Susan Merrett (1826–79) Watercolorist

Eunice Griswold Pinney (1770–1849) Watercolorist of genre scenes, landscapes,
and historical and allegorical subjects

Hannah Punderson (1776–1821) Watercolorist; began painting at about forty
years of age

Ruth Whitter Shute (1803–39) Portrait painter in pastel, oil, and watercolors;
worked with her husband in Massachusetts, Rhode Island, and New
Hampshire

Deborah Goldsmith Throop (1808–36) Professional traveling portrait and
miniature painter in upstate New York; met her husband while painting
his portrait and gave up art after their marriage in 1832

Mary Ann Wilson (active in Massachusetts 1810–25) Primitive watercolorist
known for her still lifes

Early Colonial Draftswomen: Prerevolutionary Female Artists

Women faced overwhelming challenges during the settlement of the
country, but a few did manage to work as professional artists. Two
females were either the colonies' earliest practicing artists or certainly
among their initial professionals.

Henrietta Deering Johnston: Pastel Portraits in America HENRIETTA
DEERING JOHNSTON (c. 1670–1728/9) is the first documented artist to
have worked with pastels in North America at a time when the medium
was still in its infancy in Europe. Either Irish or British by birth,
Johnston probably received her training in Europe before immigrating
to America with her minister husband in 1706, in the hopes of relieving
their financial woes.

Johnston, her husband, stepchildren, and a young niece settled in
Charleston, South Carolina. The couple suffered continued financial
and health troubles, but Johnston managed to produce more than forty
pastel portraits of the town's most prominent citizens, thereby providing
the family with necessary income. (Fig. 5-13) Her husband acknowledged
this fact in a 1709 letter to a bishop in England: "Were it not for the
assistance my wife gives me by drawing of pictures (which can last but a
little time in a place so ill peopled) I shou'd not have been able to live."

Johnston supported the family after her husband's accidental death
by drowning in 1716. As with many artists in the nation's early years, she
had no studio but instead traveled from house to house, living in a
patron's residence until a commission was complete. Johnston's hard-

Fig. 5-13 Henrietta Deering Johnston became chronically ill from malaria when she and her family initially arrived in Charleston from Dublin. Nonetheless, she nursed her husband and took care of his business while simultaneously supplementing the family income by drawing portraits of notable locals.

Johnston was the first artist to introduce pastels to America. Her translucent pastels allow the color of the paper to shine through and give an added warm hue to the colonel's picture.

Henrietta Deering Johnston. Colonel Samuel Prioleau, 1715, pastel on paper. Collection of the Museum of Early Southern Decorative Arts.

working artistic life was dramatically different from that of later amateur American female artists, many of whom pursued art solely as a leisure activity.

Patience Lovell Wright: A Colonial Sculptor Unlike Henrietta Johnston, PATIENCE LOVELL WRIGHT (1725–86) was a native of North America, raised as a Quaker in Bordentown, New Jersey. She overcame her humble beginnings and went on to attain international fame.

Wright enjoyed art in her youth and later modeled likenesses, first out of bread dough and then wax, to amuse her children. After her husband's death, Wright moved to New York City, where, at age forty-four, she gained distinction by establishing a waxworks with her sister. In 1772, she moved the family to London and opened a celebrated waxworks there as well.

Art as Life: Mistaken Identity
Although an advocate for women's rights herself, the future First Lady, Abigail Adams, found Patience Wright's nature a bit too direct and her art quite unsettling. She described the experience of visiting Wright's London studio in a letter home to her husband, John Adams:

> I went to see the celebrated Mrs. Wright.... She ran to the door and caught me by the hand,.... "Why, you dear soul, you, how young you look.... I must kiss you all." There was an old clergyman sitting reading a paper in the middle of the room; and, though I was prepared to see strong representations of real life, I was effectually deceived in this figure for ten minutes and was finally told that it was only wax.

Wright considered herself first and foremost an artist. She received numerous commissions in both the New World and abroad, from aristocrats, politicians, royalty, and the cultural elite. Wright's reputation even earned her the attention of the English court, where she boldly voiced a strong opinion on the colonies' right to freedom. Wright showed equal courage by harboring political victims and serving as a spy for her homeland while working in London. Reports of Wright's sculptures describe their uncanny lifelike quality. Sadly, because of the fragile nature of her materials, few examples remain today.

Selected Additional Early American Women Artists in the Western Tradition

Leila T. Bauman (active c. 1860–70) Painter with Currier & Ives; known for scenes depicting nineteenth-century transportation

Sarah Goodrich (1788–1853) Miniature portraits on ivory

Ann Hall (1792–1863) Miniatures on ivory; first female to become a full member of the National Academy of Design before 1900

Frances Flora Bond Palmer (1812–76) Lithographer and watercolorist of landscapes, genre, and American scenes; one of the most productive staff artists with Currier & Ives, completing approximately 200 prints, from which hundreds of reproductions were made

Sarah Perkins (1771–1831) Pastel portraits

Ellen (1769–1849) and Rolinda (1794–1838) Sharples. Both mother and daughter were active and successful artists in post-revolutionary America, traveling through New England towns and later settling in Philadelphia

Jane Stuart (1812–88) Supported her family by painting portraits, biblical scenes, and copies of famous portraits of George Washington painted by her father (Gilbert Stuart)

Females and the American Revolution

Women participated in every aspect of the American Revolution. Newspapers no longer described females as "too wise to wrinkle their foreheads with politics," but instead encouraged them to be more than "tame onlookers." Some women refused to buy British merchandise in order to hurt their enemies' finances. The Daughters of Liberty organization spun cloth to use for soldiers' uniforms and collected lead to melt down for bullets.

Wives, lovers, mothers, sisters, and daughters of soldiers tended to the sick and wounded, fed the troops, washed laundry, and even fought in battle. No female artists are known to have depicted the war, but numerous images refer to the heroine "Molly Pitcher." (Fig. 5-14) According to legend, this brave woman jumped in to fill her husband's spot when he was wounded in a fight with the British. Whether or not Molly was a specific individual, she represents the numerous females who served actively in the country's struggle for independence.

Fig. 5-14 Although this work was painted by a man many years after the Revolutionary War, it does record one of women's little-known contributions to America's struggle for independence. "Molly Pitcher" is believed to have been Mary Ludwig. She probably acquired her nickname from carrying pitchers of water to wash and cool down cannons before reloading. What do you think females in 1854 might have thought about Dennis Malone Carter's painting?

Dennis Malone Carter. Molly Pitcher at the Battle of Monmouth, 1854. *Courtesy of Fraunces Tavern Museum, New York City.*

Early America: Distinct and Mingling Traditions

Before the nineteenth century, diverse artistic traditions mingled in North America. Native American women and newly arrived female settlers produced works that frequently had little connection with established European fine-art practices. However, these women's inventive creations enhanced the quality of daily life and established strong female cultural traditions. Unfortunately, as the young republic prospered in the modern era, women would pay a price as the country "progressed," rapidly losing many of the freedoms that they initially had held.

Patriotic Acts by Female Artists
The Daughters of Liberty, who boycotted British-made goods, met regularly in 1766 to spin cloth. This was one of the earliest groups of women to band together to support a cause outside of church work. Their communal action soon set a precedent for similar patriotic demonstrations.

Chapter 6

The 19th Century in America:
Renewed Struggles As a Nation Matures

The Impact of the Industrial Revolution on Women's Lives: Benefits and Drawbacks

How did females fare at the end of the 1800s in the country's next revolution—this one within science and technology? Women increasingly were denied meaningful participation in the public sector as a result of the Industrial Revolution. Mass industrialization deeply affected commerce, transportation, agriculture, and warfare, fully transforming America's social, economic, and political arenas.

Vast and rapid changes profoundly influenced women's lives. Scores of poor and immigrant females began working in the cities' burgeoning factories. Conditions there often were horrific, and the women routinely were paid miserably low wages, especially compared to those of men.

Within the middle class, many females left the job market as men started earning more money. A husband typically insisted that his wife withdraw from the workplace, lest her presence suggest that he was an unfit financial provider. In the nineteenth century, middle- and upper-class men were the breadwinners and women the bread givers. Instead, women turned their energies toward cultivating a "proper" Victorian home. (Fig. 6-1)

Wives organized households into a miniature universe of culture and education for family and visitors. The parlor's paintings, prints, novelty displays, books, and musical instruments represented the museum, schoolroom, and concert hall. A woman's residence communicated the family's social status, reinforced moral values, and provided a sanctuary for relaxation.

At the dawn of this new era, both upper- and middle-class females again were expected to be submissive, pious, and pure. Advice for women in contemporary books and journals emphasized how to be pleasing and appropriate companions to men. Books, such as those by Catharine Beecher, provided information on domestic work and reminded ladies

Ladies of the Mills
Starting in the 1830s, many unmarried farm women and immigrants flocked to the textile mills that flourished after the invention of the spinning jenny and power loom. The young recruits were eager to leave home and join with other like-minded friends, who were seeking the clubs, churches, and libraries available in these industrial communities. Yet, the dull work and twelve-hour shifts were exhausting, the factory air foul, living conditions overcrowded, and salaries wretchedly low. Employers deducted wages or fired young females for any offense. In response, women at mills such as in Lowell, Massachusetts, sometimes banded together to fight for improvements.

that their power lay in the gentle art of persuasion. In 1837, Beecher wrote in *An Essay on Slavery and Abolitionism, with Reference to the Duty of American Females*: "Woman is to win everything by peace and love; by making herself so much respected…that to yield to her opinions and to gratify her wishes, will be the free-will offering of the heart. But this is to be all accomplished in the domestic and social circle."

The Birth of Professional American Art

The Social Climate

What type of art did American females produce within this rapidly changing context? Artists of both genders created works that represented the country's distinct heritage, separate from any European antecedents, in response to people's intensely patriotic sentiments. Portraits of leaders and average citizens, landscapes of native scenery, depictions of historic events, and genre scenes of everyday American life all expressed the optimistic idealism of the times—a period marked by the ideology of "Manifest Destiny" and by westward expansion.

Education for American Females

Prior to 1800, only about half of white American women could sign their name or read. At the beginning of the nineteenth century, white girls attended public school with boys as the nation turned its energies toward cultivating better-educated citizens. Opportunities for African-American girls, even after the end of slavery, remained slim. A small number of both white and black northerners, however, did open up their schools to these children.

In the early 1800s, female literacy rose, but mostly for the wealthy. Academies generally taught young ladies only painting, singing, French, and harpsichord, because they would have no "practical" need for Latin, Greek, history, or science while performing their expected domestic duties.

A few women did establish schools of higher learning, carefully constructing the curriculum to produce better homemakers and teachers, the only acceptable occupations for proper young ladies of the day.

Women and the Arts

Despite women's general exclusion from professional careers, a larger percentage than ever before entered the arts. Aspiring female artists in America had a slightly better chance of acquiring academic training than did their European sisters. Whereas women were not admitted to the prestigious École des Beaux-Arts in Paris until the late 1890s, American female students drew from plaster casts at the Pennsylvania Academy of

Fig. 6-1 What do you think a wife wanted guests to understand about her family when they gathered in this parlor? In 1896, Mary Gay Humphreys wrote an essay, "House Decoration and Furnishings," explaining that parlors should convey a sense of elegance, good taste, recognition of the polite art, and of graceful, social amenities [comforts]."

The Wheeler Parlor Room. *Courtesy of The Barnum Museum, Bridgeport, Connecticut.*

Factory Girls
In the early 1800s, only about one female in twenty labored outside the home. By the end of the century, one in three earned a paycheck in teeming urban centers. Factories, however, contributed to the breakup of family life, as daughters regularly left rural communities to work in cities and live on their own until marriage.

From House to Home
The concept of "home" as a quiet haven removed from the harsh realities of the outside world emerged during the Victorian era. Prior to the Industrial Revolution, husbands and wives usually worked side by side at home. Now men went to work in city factories and businesses, and women primarily remained on the domestic front. They were responsible for turning their houses into substantial and impressive "homes," which reflected their family's increased income and social standing.

Fine Arts as early as 1844. By 1860, women were enrolled in anatomy classes, and eight years later were finally able to work from nude models in specially arranged life-drawing lessons.

Still, as in Europe, American academies withheld membership and recognition from all but a handful of females. Women generally received little more than conservative instruction, and society continued to perceive their creative efforts as polite, amateur accomplishments. Nonetheless, between 1840 and 1870, the proportion of females who considered themselves artists increased fourfold. Later, from 1870 to 1900, the number of women artists and art teachers in the United States rose from approximately 418 to 11,031. By the end of the century, both upper-class and less-highborn females learned drawing in school; the subject was now considered an essential element in any gentlewoman's education.

Nineteenth-Century American Female Artists

The following are descriptions of just a few nineteenth-century American female artists working within the Western vein. They were selected for inclusion both for their renown and for their ability to represent a broad range of professional activities that took place during the period.

Sarah Miriam Peale: An Early Leader At the turn of the century, before the age of photography, SARAH MIRIAM PEALE (1800–85) gained enormous notoriety for painting exquisite portraits, fully supporting herself for sixty years. (Fig. 6-2 a, b) Peale came from a large, active, artistic family. She was taught and encouraged early on by her father, an eminent Philadelphia miniaturist and still-life artist, and by her famous uncle, Charles Willson Peale, who headed his own artistic dynasty.

Sarah Peale's sisters, ANNA CLAYPOOLE PEALE (1791–1878) and MARAGRETTA ANGELICA PEALE (1795–1882), as well as her niece, MARY JANE SIMES (1807–92), and cousin, MARY JANE PEALE (1827–1902), also were practicing artists. Other painters in the family included MARIA PEALE (1787–1866), EMMA CLARA PEALE (1814–?), and HARRIET CANY PEALE (c. 1800–69).

The Art of Reproduction
By the 1870s, technological innovations in printing and manufacturing reduced the cost of wall decorations. Victorian women adorned their homes with prints, wallpaper, reproductions of academic paintings, and photographs. Italian Renaissance images of the Madonna with the Christ child were particularly popular. The subject, which glorified motherhood, appealed to nineteenth-century homemakers and reinforced culturally esteemed values.

Peale trained alongside her siblings. At age eighteen, she made an unusual move to execute full-size portraits in a vigorous style. In 1825, Peale left Philadelphia for Baltimore and became one of that city's leading artists, receiving many more commissions than other professionals, male or female. Her talents were not restricted to local personalities. She also painted such well-known Washington politicians as Secretary of State Daniel Webster, Senator Thomas Hart Benton, and Senator Henry A. Wise, portraying them in an intelligent and optimistic light. Peale also painted tightly rendered still lifes, displaying the food and goods available in the thriving markets of her hometown. (Fig. 6-3)

Peale chose to remain unmarried. At age seventy-eight, she joined her older sisters in Philadelphia and concentrated on still lifes until her mid-eighties, when her death marked the end of a three-generation family of artists.

Fig. 6-2 a, b Sarah Miriam Peale's careful draftsmanship and brilliantly crisp colors make every surface in her paintings spring to life. What objects did she include, particularly in the wife's engaging portrait, to indicate the couple's wealth? Susan Avery's finely laced clothing, weighty gold jewelry, and richly embroidered shawl, as well as the large tortoise-shell comb in her hair, were all expensive luxury items.

Isaac Avery is believed to have been a tortoise-comb maker in Philadelphia. He began expanding his business just about the time he commissioned these two canvases. What clothing and items would you want Peale to include in your portrait if she were to paint your picture today?

Sarah Miriam Peale. Susan Avery and Isaac Avery, 1821, *oil on canvas. Courtesy of the Schwarz Gallery, Philadelphia.*

Fig. 6-3 Sarah Miriam Peale paid as much attention to the exact details of her still-life subjects as to the sitters in her portraits. How is her luscious plate of fruit similar to and different from those painted by seventeenth-century Dutch artists, such as Clara Peeters (Fig. 3-4), Rachel Ruysch (Fig. 3-6), and Maria van Oosterwyck (Fig. 3-7)? While Peale's painting style recalls that of her predecessors, do her still life and the Dutch *vanitas* compositions share the same underlying meaning?

Sarah Miriam Peale. Still Life with Watermelon, *1822, oil on wood panel. Courtesy of the Schwarz Gallery, Philadelphia.*

Mother-Daughter Feminism Through the Generations
Lilly Martin Spencer devoted her energies to becoming a successful artist, largely describing the feminine domestic sphere, while her mother wished that Lilly were more politically active. In the following excerpt, Spencer's reply to her mother gently points out the differences and similarities between their efforts:

> **My time, dear mother to enable me to succeed in my painting is so entirely engrossed by it that I am not able to give my attention to anything else.... You know dear Mother that is your point of exertions and attention and study like my painting is mine and you know dear Mother as you have told me many times if we wish to become great in any one thing, we must condense our powers to one point.**

Lilly Martin Spencer: Everyday Life for Everyday People LILLY MARTIN SPENCER (1822–1902) was one of the first females to paint genre scenes before the American Civil War. Her works were widely reproduced in prints, which made the images affordable and available to a broad audience. Spencer used her own experiences as a woman to help capture the essence of daily middle-class existence. She created idealized scenes, but ones that provide a glimpse of the way nineteenth-century Americans wished to view themselves.

Spencer was born in England to French parents who immigrated to America in 1830. They were not artists, but her mother and father were liberal thinkers and active supporters of various reform movements, including women's suffrage. They encouraged Spencer to pursue her passion, which she demonstrated, much to local acclaim at seventeen, by decorating the plaster wall of their home with charcoal murals, including life-size portraits of her family. Spencer's father subsequently took his daughter to study in the thriving art capital of Cincinnati, Ohio.

As an adult, Spencer bore thirteen children, seven of whom survived, and lived in an unconventional marriage with her husband, who gave up his own career to manage her business affairs and attend to the domestic duties. Spencer supported the family with sales of her art.

The American public adored Spencer's domestic scenes, which exhibited middle-class life and values laced with a touch of sentimentality and humor. (Fig. 6-4) She deliberately honored the day-to-day experiences of ordinary females, frequently making them the central figures in her paintings.

Spencer's clean, crisp realistic style reflected middle-class tastes. Her popularity declined in later years, when the general art-buying public lost interest in genre scenes, favoring photography instead. Nonetheless, Spencer remained dedicated to her profession. When she died at age eighty, Spencer had just spent the morning at the easel, painting a family reunion that celebrated her aunt's one-hundredth birthday.

The White Marmorean Flock: American Women Sculptors in Italy

The noted American novelist Henry James disparagingly dubbed the American female sculptors living in Rome at mid-century as "that strange sisterhood who at one time settled upon the seven hills in a white Marmorean flock." The word *Marmorean* relates to marble, but these unconventional women carvers were no mere "flock" of birds, as James implied. This group of females, living outside the United States, defied Victorian norms and forged independent, productive lives without the constraints of marriage and family.

What did Italy hold for these women? They were drawn to Rome's ancient ruins, historic artifacts, the city's inexpensive marble and skilled carvers, and the low cost of living. They also enjoyed the freedom in Italy of walking unaccompanied through the city's streets, even at night, or riding out into the countryside without a male escort. The sculptors

Art for "The People"
As the young republic flourished, the growing middle class clamored for images of themselves. *Limners*—artists who traveled through the country on horseback or in light wagons—flourished in the late eighteenth and early nineteenth centuries. These individuals, many of whom lacked formal training, attempted honest likenesses of their subjects. Occasionally, limners filled in their sitters' heads on canvases they had prepainted. In addition to portraits, limners also produced inn signs and representations of farmsteads that families hung proudly over their mantels.

Fig. 6-4 Why might Lilly Martin Spencer have specialized in family scenes? Without access to training in life drawing, females usually painted images that were easily accessible to them, such as children or women at home.

Lilly Martin Spencer. Child with Toy, c. 1858–60, oil on canvas. Courtesy of the Montclair Art Museum, Montclair, NJ.

Hosmer's Hopeful Prophecy

In 1883, Harriet Hosmer stated, "I honor every woman who has strength enough to step out of the beaten path where she feels that her walk lies in another.... But in a few years it will not be thought strange that women should be preachers and sculptors and everyone who comes after us will have to bear fewer and fewer blows."

and their friends assembled a friendly artistic and intellectual community, attending joyous dinner parties, amateur theatricals, and balls. Each member of the loosely knit group deserves individual attention, but space permits the examination of only two of these indomitable nineteenth-century spirits.

Harriet Hosmer HARRIET HOSMER's (1830–1908) remarkable nature was greatly shaped by events in her youth. Her father, who had lost his wife and three other children to tuberculosis, was determined to secure his remaining daughter's well-being and happiness. To boost Harriet's health, he took her camping, hiking, horseback riding, and mountain climbing, unusual activities for a girl at the time. Hosmer's resulting "tomboy" personality did not fit with the typical school standards, so eventually she was sent off to a "refined" school in Lenox, Massachusetts. There she met such distinguished personalities as the writers Nathaniel Hawthorne and Ralph Waldo Emerson, and the famous British actress Fanny Kemble, who urged Hosmer to pursue sculpting.

As an artist, Hosmer was drawn to the popular neoclassical style of the day. Hence, Italy, the original inspiration for the movement, became a natural site for her to study. Hosmer's fondness for nighttime horseback rides shocked both middle-class Italians and Americans alike. Yet she faced far greater opposition breaking into the all-male enclave of

Fig. 6-5 Imagine standing in front of this life-size faun. In Roman mythology, these forest creatures were half man and half goat. What clues does Harriet Hosmer provide about the faun's role? Exhausted after drinking and celebrating with Bacchus, the Roman god of wine (indicated by the large bunch of grapes), the faun has dropped his musical pipe to the ground and fallen into a deep sleep. Hosmer uses the actual weight of the marble to suggest the heaviness of the creature's slumber.

Harriet Hosmer. The Sleeping Faun, c. 1864–65, Carrara white marble. The Forbes Magazine Collection, New York. All Rights Reserved.

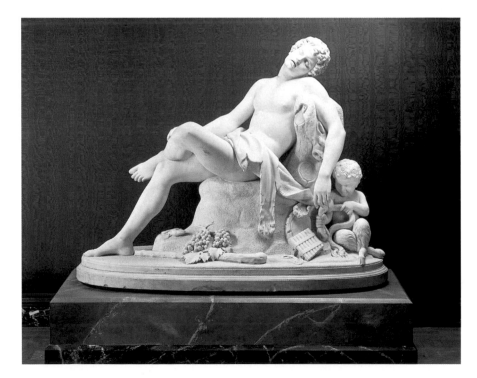

neoclassical sculpting. Hosmer did, nonetheless, make a good living from private and public commissions, and employed male stonecutters at her palatial studio. (Fig. 6-5)

Later in life, Hosmer received fewer commissions because she insisted on continuing to dress her subjects in antique dress, even though the prevailing tendency had moved toward modern fashion. Hosmer remained busy designing perpetual motion machines and other inventions, reflecting her lifelong curiosity about science.

Mary Edmonia Lewis The American women sculptors in Rome were considered unusual for their sheer tenacity in defying social customs. MARY EDMONIA LEWIS' (c. 1843–after 1911) story is even more exceptional. She faced additional challenges as the first recognized minority sculptor in the United States and as a leading female sculptor of the century.

In her adulthood, Lewis recalled how her unusual dual heritage affected her childhood: "My mother was a wild [Chippewa] Indian and was born in Albany, of copper color and with straight black hair. There she made and sold moccasins. My father, who was a Negro and a gentleman's servant, saw her and married her.... Mother often left her home and wandered with her people whose habits she could not forget and thus we, her children, were brought up in the same wild manner. Until I was twelve years old, I led this wandering life, fishing and swimming… and making moccasins."

Lewis was orphaned at age four, raised by members of her mother's Chippewa nation in New York until she was twelve, and then taken by her older brother to live in California. As a teenager, she was adopted by abolitionists who, with the help of her brother, enabled Lewis to enroll in Oberlin College in 1859, the first coeducational, interracial higher education institution in the United States. From Oberlin, Lewis went to Boston, where, dazzled by gleaming public works, she decided to pursue sculpture. There, Lewis sold medallion portraits of prominent abolitionists. She used the proceeds to travel through Europe, eventually settling in Rome with the other expatriate female neoclassical artists.

Lewis was accepted within the tightly knit Roman art colony and received extensive commissions at the height of her career, yet she always remained somewhat of an exotic outsider. Not surprisingly, many of her subjects explore themes of alienation, racial prejudice, and slavery. (Fig. 6-6) Little is known of Lewis' latter years. The last existing report of her was from 1909, and the circumstances of her death remain obscure.

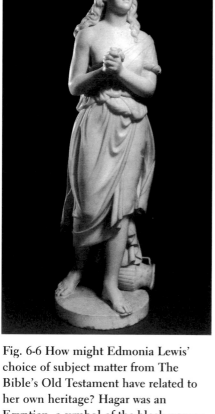

Fig. 6-6 How might Edmonia Lewis' choice of subject matter from The Bible's Old Testament have related to her own heritage? Hagar was an Egyptian, a symbol of the black woman, and a bondswoman or slave. She and her son, Ishmael, were banished to the desert. Lewis, a female artist of mixed heritage, found it easier to live in Rome than in her American homeland. Lewis once stated, "I have a strong sympathy for all women who have struggled and suffered."

Lewis became one of the first sculptors of color, male or female, to achieve international recognition.

Edmonia Lewis. Hagar, 1875, marble. National Museum of American Art, Washington, D.C./Art Resource, NY.

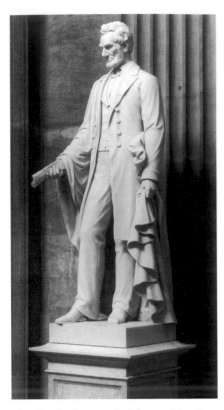

Fig. 6-7 At the age of eighteen, Vinnie Ream Hoxie won the $10,000 competition to sculpt Abraham Lincoln, although not without difficulty. Many congressmen objected to Hoxie's youth and the supposedly inappropriate behavior of women executing large-scale monuments. But Hoxie had an advantage over her nineteen competitors because she previously had modeled a bust of the president shortly before his assassination.

Vinnie Ream Hoxie. Abraham Lincoln, 1871, marble. Architect of the Capitol, United States Capitol Art Collection.

Other Nineteenth-Century American Female Sculptors

Hosmer and Lewis are but two of the substantial number of females who sought freedom in modern Roman society. Others included SARAH FISHER AMES (née CLAMPITT) (1817–1901), MARGARET FOLEY (c. 1827–77), FLORENCE FREEMAN (1825–76), VINNIE REAM HOXIE (1847–1914) (Fig. 6-7), LOUISA LANDER (1826–1923), EMMA STEBBINS (1815–82) (Fig. 6-8), and ANNE WHITNEY (1821–1915). The neoclassical artworks of these Americans might appear conservative today, but their size, subject matter, and the mere audacity of their creators to attempt such large-scale projects was remarkable in itself. These gutsy women set an important precedent for female sculptors of the twentieth century.

Toward the Future

In America, as in Europe, women worked as professional artists in greater numbers than before, despite society's pressure on them to lead traditional, domestic lives. During the course of the century, females broadened both the range of their subject matter and visual styles, regardless of their limited access to training, especially with live male nude models.

Ultimately, this generation of women artists set the stage for the subsequent modern era, when females would become active in virtually every major art movement. The professional establishment would not honestly welcome women's participation—female artists still had to combat subtle cultural conditioning and strong societal expectations that worked against their innate equality and right to full recognition.

Selected Additional Late-Nineteenth-Century Professional Women Artists

Maria Martin Bachman (1796–1863) Created bird, flower, and insect paintings and assisted John James Audubon, the ornithologist and renowned painter of birds

Herminia Borchard (?–1857) Born in Germany; successful in America with literary subjects, genre paintings, and portraits

Fidelia Bridges (1834–1923) Landscape paintings of small fragments of nature

Jennie Brownscombe (1850–1936) Many of Brownscombe's paintings were widely popular and reached thousands of American homes through calendars, commercial prints, and magazine illustrations (Fig. 6-9)

Charlotte Buell Coman (1833–1924) Coman began painting landscapes seriously at age forty

Susan Macdowell Eakins (1851–1938) Daughter of an engraver; married the famous painter and teacher Thomas Eakins; her output decreased during marriage, but she never stopped painting, continuing to work for another twenty years after her husband's death in 1916

Cornelia Adele (Strong) Fassett (1831–98) A history painter whose work
　　The Electoral Commission in Open Session (c. 1879) hangs in the United
　　States Capitol
Katherine Furbish (1834–1931) Botanist and painter known for drawing the
　　Furbish Lousewort, an endangered species named after her
Eliza Pratt Greatorex (1819–97) One of America's earliest female illustrators,
　　best known for views of old New York

Public Outcry

The notion that women should be prohibited from studying the human figure with a nude male model remained strong throughout the nineteenth century. In 1886, the eminent artist Thomas Eakins was dismissed from the Pennsylvania Academy of Fine Arts because he removed a model's loincloth in a coeducational anatomy lecture.

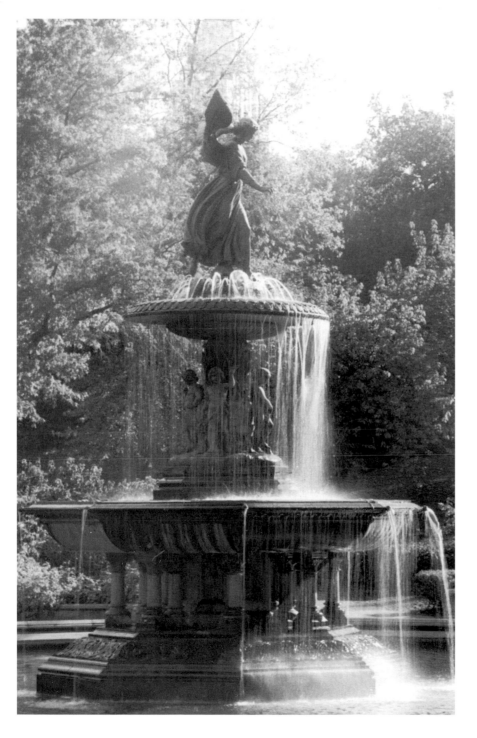

Fig. 6-8 People have admired Emma Stebbins' *Angel of the Waters*, also known as Bethesda Fountain, since its installation in New York City's Central Park in 1873. Stebbins portrays the New Testament passage in which the Angel of the Waters bestows healing powers to the Bethesda pool in Jerusalem. The four figures below her represent Temperance, Purity, Health, and Peace, and both literally and symbolically support the religious theme.

Emma Stebbins. Angel of the Waters (Bethesda Fountain), commissioned in 1863, bronze. Courtesy of Sara Cedar Miller/Central Park Conservancy.

The Birth of the American Women's Rights Movement

In 1840, Elizabeth Cady Stanton, the wife of an American abolitionist leader, and Lucretia Mott, a Quaker minister and founder of the Philadelphia Female Anti-Slavery Society, were barred from the World Anti-Slavery Convention in London, England. Outraged, the two decided to hold a convention to "discuss the social, civil, and religious rights of women," and to form an advocacy organization. In July 1848, over 300 people, including forty men, attended the first women's rights meeting in Seneca Falls, New York. Stanton read the "Declaration of Rights and Sentiments," modeled after the Declaration of Independence. The document demanded equality before the law; equal access to education, business, and the professions; and the right to vote. All the resolutions were adopted except women's suffrage, which the attendees considered too controversial and extreme.

Anna Eliza Hardy (1839–1934) Still-life artist

Frances Benjamin Johnston (1864–1952) Often called the first press photographer, commissioned to produce photo-essays; opened a portrait studio in Washington, D.C., in the early 1890s; became unofficial presidential photographer during Cleveland, Harrison, McKinley, Roosevelt, and Taft administrations. (Fig. 6-10)

Mary Nimmo Moran (1842–99) American landscape etcher; married Thomas Moran, known for his western panoramas

Imogene Robinson Morrell (?–1908) Created history paintings with patriotic themes, as well as portraits and genre scenes; also an art teacher, active in Paris and Washington, D.C., from about 1877 to 1908

Emily Sartain (1841–1927) Engraver, painter, and art educator; she and her brothers were the fourth generation of artists in the family

Fig. 6-9 In the decades following the Civil War, many Americans began to prosper. This emerging wealthy class desired images of leisure, symbolizing their ability to afford the time for relaxation and recreation. How does JENNIE BROWNSCOMBE's painting capture the idle pleasures of this genteel woman? Notice that the subject wanders in nature, set apart from the modern world. Her white dress, lovely flowers, and visible wedding ring help convey her purity. Brownscombe's harmonious colors further enhance the tranquil atmosphere.

Jennie Brownscombe. A Leisurely Summer Day, *c. 1880s, watercolor on paper. Collection Spanierman Gallery.*

Fig. 6-10 How does the self-portrait of FRANCES BENJAMIN JOHNSTON express that she was no ordinary Victorian lady, such as those seen in Jennie Brownscombe's painting (Fig. 6-9)? Would Johnston's pose, beer stein, cigarette, and exposed legs and petticoats have been typical of conventional late-nineteenth-century women? Johnston was a successful and prolific photographer in a new artistic medium that did not have a long history of male domination.

Frances Benjamin Johnston. Self-portrait, 1895, photograph. Library of Congress, Washington, D.C.

Annie Cornelia Shaw (1852–87) Painted landscapes outside in the Adirondack Mountains, along the Atlantic coast, and in the western prairies; first woman elected a full academician at the Chicago Academy of Design in 1876

Alice Barber Stephens (1858–1932) One of the best-known American illustrators of her time; studied life drawing with Thomas Eakins at the Pennsylvania Academy of Fine Arts

Maria Louisa Wagner (c. 1815–88) Itinerant painter who traveled through upstate New York in a covered wagon, eventually settling in New York City

Susan Catherine Moore Waters (1823–1900) Painter of animals

Ida Waugh (?–1919) Religious and allegorical subjects and portraits; also illustrated children's books

Chapter 7

Early Modernism in the Western European Tradition:

Making Headway in the New Age

A Radical View to Women's Freedom
In the first decades of the century, Margaret Sanger asserted, "If women are ever going to have satisfying sex lives, we have to get control over reproduction. Having a baby every time we sleep with our husbands is literally killing women before their time."

Early Western Modernism

Western Society
What ignited the blazingly original art trends of the modern age? In the early twentieth century, innovative technologies and ideas altered the texture of Western society. Airplanes and automobiles became a part of ordinary life, Sigmund Freud profoundly shaped the field of psychology, Einstein presented the theory of relativity, Emma Goldman denounced marriage as a form of prostitution, and Margaret Sanger battled furiously for women's right to control reproduction.

The Arts
Within the Western art world, social unrest inspired a wealth of exciting new styles that helped to deflate the age-old academy system. Artists gradually moved away from creating realistic depictions of the observable world to producing abstractions that focused on the qualities of line, color, and form. Both female and male creators explored different ways to express their internal thoughts and emotions. Paris was the initial hub of activity, but by the turn of the century, Russia, Germany, Italy, and America also brewed with revolutionary ideas. Prior to World War I, artists frequently crisscrossed national borders, stimulating a lively international cultural exchange.

Physical Constraints
At the turn of the century, women often fainted from wearing corsets, and they could not even bend down to tie their own shoelaces. When the United States entered World War I, in 1917, the American war office announced that if all females were released from their corsets, there would be 28,000 tons of steel available, enough to build and furnish two battleships.

Women's Place Within the New Order
Did everyone benefit equally from the advances of the modern era? Record numbers of women worked outside the home, but the majority of them were underclass females who were ruthlessly exploited by factory owners. (Fig. 7-1) These women were indeed breadwinners, yet they hardly led independent lives, because their wages frequently went directly into the hands of their husbands or fathers. African-American females largely continued to work as servants and agricultural laborers, with employment numbers in these categories twice that of native-born

whites. Immigrant European women worked primarily in service and industrial jobs, especially the laundry and needle trades.

Middle- and upper-class females also did not necessarily reap the rewards of society's technological advances. Men earned money at factories and burgeoning corporations, while many women dedicated themselves to cleaning up the resulting ills of big industry. Through volunteer work and philanthropy, they ran women's clubs, temperance societies, settlement houses, and consumer leagues that brought the values of the home into the public realm. Females fought for cleaner streets, welfare, better housing, and maternal and infant health care. They also struggled on the front lines to improve women's legal, educational, political, and economic status.

Modern Female Artists at the Turn of the Century

Most female artists of the era came from prosperous middle-class families. A career in the arts, like teaching, was one of the few acceptable means for respectable single women to earn a living, because they could pursue their passion while remaining safely within the confines of expected ladylike decorum. However, as the decades progressed, a greater proportion began to define fresh roles for themselves as autonomous, creative spirits.

Some female students trained at the official academies, whose doors finally had opened to them. Others attended women's art schools and entered the studios of established artists. Ironically, women's accep-

Women and Higher Education

Females composed nearly 37 percent of college students in 1900. Despite their access to training, few women were permitted to enter professional fields. In 1910, for example, only 1 percent of lawyers and 6 percent of doctors were female. Women with higher-education degrees tended to fill traditional feminine occupations: They made up 79 percent of all librarians, 52 percent of social workers, and the overwhelming majority of teachers.

Fig. 7-1 What do you think the photographer Lewis Hine wanted viewers to feel about this very young girl working in the cavernous, dank factory? How did he use light and shadow and a sense of scale to enhance the emotional qualities of his composition? Hine's art eventually helped lead to the passage of fairer child labor laws. Trained as a sociologist, Hine was greatly concerned with the welfare of the underprivileged and made his reputation documenting and exposing these people's hardships.

Lewis W. Hine. Joan of the Mill, 1907, gelatin silver print. The Forbes Magazine Collection, New York. All Rights Reserved.

Fig. 7-2 Built in the late nineteenth century, the famous Eiffel Tower still stands today as a symbol of modern Paris. The 300-meter-high metal structure punctuates the city's skyline.

Eiffel Tower, 1889. *Alexandre-Gustave Eiffel.*

The Nucleus of the Impressionist Group

Berthe Morisot, Claude Monet, Pierre-Auguste Renoir, Alfred Sisley, Camille Pissarro, and Edgar Degas formed the core of the group that exhibited together as the *Société Anonyme* (Anonymous Society) in 1874. Mary Cassatt joined in 1879, and MARIE BRACQUEMOND (1841–1916) in 1876. Artist Eva Gonzalès painted in a similar style but never became an official member.

tance into the establishment occurred just when numerous renegade artists were moving away from traditional styles.

Women also were linked to almost every major new art movement that swept through the period at breakneck speed, altering the appearance of art more thoroughly than at any other time since the Renaissance. It is virtually impossible to chronicle here the multitude of professional female artists. Instead, this chapter highlights several trends and a few emblematic individuals to represent the dynamic range of this vital period in art history.

The Parisian Stronghold *Impressionism* was the first stylistically innovative, avant-garde movement. The group's diverse members wished to be liberated from the rigid dictates of the salon system and its accompanying awards, medals, and jury system. Each artist's approach varied, but all the Impressionists shunned grand historical and mythological subjects. For them, the description of light and color within their compositions was more important than their subjects of everyday middle-class life. The Impressionists favored short individual brushstrokes of pure color that shimmered along the surface of the canvas, revealing the fleeting visual nuances of the moment.

Berthe Morisot: Behind the Sunny Scenes Art ran in BERTHE MORISOT's (1841–95) veins. Her granduncle was the celebrated late-eighteenth-century painter Jean Honoré Fragonard, her grandfather a renowned architect, and Morisot's father a pupil at the École des Beaux-Arts before he became a government employee.

An early teacher of Berthe and her sister Edma warned their mother: "With natures like those of your daughters, my teaching won't end with giving them pretty little drawing-room accomplishments. They will become painters. Have you really considered what that means? In your well-to-do society that would be a revolution, almost a catastrophe."

The sisters initially exhibited jointly until Edma left the profession after marrying a naval officer and moving to the provinces. Berthe continued painting following her marriage to the artist Edouard Manet's brother, Eugène, who helped to manage the logistics of her career.

Morisot joined the Impressionists from the start, much to the dismay of Edouard Manet, who counseled her to have nothing to do with such "madmen." The Impressionists' emphasis on daily life allowed her to work within the rigid norms of "expected" feminine behavior. The male Impressionists investigated Paris cafés, dance halls, and boulevards, while Morisot portrayed familiar subjects of women, mothers, and children, most of whom were close friends or relatives. (Fig. 7-3)

Fig. 7-3 How does Berthe Morisot build a sense of form and substance in her drawing? She layers strokes of finely sharpened crayons to describe each object in her composition. What are the differences in the way Morisot treats the young girl's face, her dress, the tree, and the mountainous landscape? Although Morisot was an accomplished landscape painter, her favorite subject was female relatives, whom she portrayed with loving tenderness.

Morisot exhibited with the French Impressionists from the start. Similar to them, she began to search for more structure in her art during the 1880s. As a result, she began making careful drawings, such as *Portrait of a Girl*, to help build a firmer visual foundation.

Berthe Morisot. Portrait of a Girl, *c. 1885, colored crayon. Corporate Art Collection, The Reader's Digest Association, Inc.*

Interestingly, Morisot's countless sunny depictions of domestic bliss, which she constructed with delicate brushwork and elegant colors, never disclosed her underlying anguish. In a letter to Edma, written shortly after the sister's marriage, Berthe spoke of the agony and self-doubt that plagued her during her successful career. "This painting…that you mourn for is the cause of many griefs and many troubles."

Mary Cassatt: An American in Paris MARY CASSATT (1844–1926) was the only American working with the French Impressionists. (Fig. 7-4) Although associated with these radicals, she still had to contend with the conservative ideals of the Victorian society in which she was raised. Cassatt's father strongly opposed her plans to study art abroad so that she could become a professional painter, reportedly saying, " I would almost rather see you dead." As an unmarried daughter, Cassatt also had to support her family financially and care for her seriously ill sister, mother, and father for many years until their deaths.

Nonetheless, Cassatt's fiery personality, talent, and determination helped her forge a thriving career. She had been painting for over ten years when Edgar Degas invited her to join the group in 1877. Degas

Fig. 7-4 Mary Cassatt 23-cent United States Stamp. *Stamp design © 1988 U.S. Postal Service.*

Fig. 7-5 Mary Cassatt once stated, "Nothing in art should seem to be accidental," and her countless studies, such as this fine-line drawing, demonstrates her keen observation of familiar subjects. With only limited pencil marks, Cassatt conveys the very essence of the mother-child relationship.

Mary Cassatt. The Stocking, *c. 1890, drypoint. Collection, IBM Corporation, Armonk, New York.*

exclaimed upon seeing Cassatt's work, "These are real. Most women paint pictures as though they were trimming hats." Thus began a long, but not conflict-free, relationship between the two strong-willed artists.

Cassatt, like many of the Impressionists, frequently developed striking compositions, with an elevated vantage point, asymmetrical placement, high-keyed palette, and daringly cropped figures. The Japanese woodblock prints on view in Paris in 1890 decisively influenced these visual trademarks, as did the new art form of photography. Cassatt depicted intimate images of women bathing, drinking tea, writing letters, sewing, or tenderly caring for children, but her art also extended beyond a scene's specifics to convey more universal emotions. (Figs. 7-5 and 7-6)

Cassatt spent her career in France, but in later years had to stop painting because of eye trouble. As a result, Cassatt turned increasingly to the outside world. She donated the proceeds from a New York exhibition to the cause of women's suffrage, believing that only females were capable of stopping the cruelty she was witnessing in World War I. Cassatt wrote to a friend, "Is this wholesale slaughter…necessary to make women wish an equality such as they never before had…taking active part in governing the world?"

Fig. 7-6 Mary Cassatt relied on color and form to convey the wife's rapt attention to her knitting, which suggests that a baby is on the way. While Cassatt herself never married, she illustrates how the dominant role of motherhood continued to define females within her social class.

Mary Cassatt. La Jeune Mariée, *1875, oil on canvas. Courtesy of The Montclair Art Museum, Montclair, NJ, Gift of the Max Foundation, Accession #58.1.*

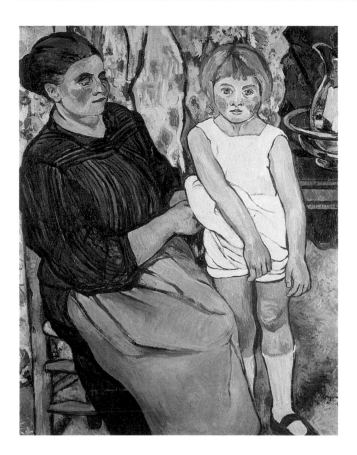

Fig. 7-7 Can you locate the areas in which Suzanne Valadon used her lively brushwork to transform three-dimensional surfaces into relatively flat fields of color? Valadon's bold marks describe not only the floor, glass bowl and pitcher, background curtains, and grandmother's apron, but also accent both the girl's and grandmother's face.

Valadon never received any formal training. However, as a model for many of the French avant-garde artists of the time, she became familiar with their works, thereby absorbing important lessons about modern art.

Suzanne Valadon. Grandmother Dressing a Little Girl, 1931, *oil on canvas. Courtesy of the Hilde Gerst Gallery, New York City.*

During her last years, Cassatt was increasingly alone, having no children and slowly losing all her relatives and peers. A group of young American artists visited her occasionally, drawing inspiration from her life and thoughts until her death at age 82, in 1926.

Additional Female Artists Associated with Impressionism

EVA GONZALÈS (1849–83) met Edouard Manet when she was twenty. Sixteen years his junior, Gonzalès was first his model and then student. Like Manet, she refused to exhibit with the Independents, despite their similar styles. Interestingly, the official salon rejected the Impressionists, but they did acknowledge Gonzalès, applauding her art for its "masculine masterliness and elegance of spirit." Unfortunately, Gonzalès died at the young age of thirty-four, shortly after giving birth. Ironically, she passed away while making a funeral wreath for Manet, who had died only the day before.

Edgar Degas said to the innovative painter SUZANNE VALADON (1867–1938), "Yes. It is true. You are indeed one of us." (Fig. 7-7) Although a colleague of Cassatt and Morisot, Valadon in fact created art that was closer stylistically to that of later French Post-Impressionists. Unlike the well-born ladies in the avant-garde, Valadon was an illegitimate

Minimal Recognition at Home
While Mary Cassatt was already well recognized in France, America paid its heroine, possibly the first Impressionist to exhibit in the United States, far less honor. A society column printed the following news about one of her trips to the States: "Mary Cassatt, sister of Mr. Cassatt, president of the Pennsylvania Railroad, returned from Europe yesterday. She has been studying painting in France and owns the smallest Pekingese dog in the world."

daughter of a laundress and grew up in the streets of Montmartre, the bohemian Paris neighborhood. Valadon literally came to art by accident. After suffering a fall from a flying trapeze as a circus performer, she began modeling in artists' studios, including those of Degas, Renoir, and Henri de Toulouse-Lautrec. She wrote, "I remember the first sitting I did…saying to myself over and over again, 'This is it! This is it!'…. I did not know why. But I knew that I was somewhere at last and that I should never leave."

Valadon did not "leave" because modeling rekindled her childhood love of art. She began to "work like mad, not to produce beautiful drawings to be framed and hung, but good drawings which capture a moment of life-in-movement in all its intensity." Without formal training, Valadon constructed a distinctive style characterized by economic lines and intense colors that depicted the earthy, working-class people with whom she was familiar. Valadon also was one of the first women to portray nude female figures extensively, fusing acute observation with her own modeling recollections.

Sadly, the more popular repetitive street scenes painted by her alcoholic son, Maurice Utrillo, whom she trained, overshadowed Valadon's unique contributions.

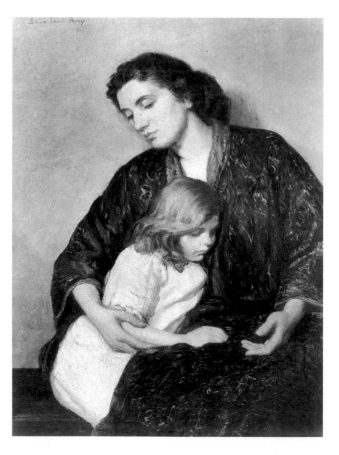

Fig. 7-8 LILLA CABOT PERRY studied art both in America and abroad. In France, she lived for over ten summers near the master Impressionist Claude Monet, and from her friendship with him and others, she gained a love for vivid colors and a lively application of paint. Where can you find flickers of Impressionism in *Mother and Child*? Despite clearly visible Impressionist-like brushwork, Perry illustrates a strong concern for draftsmanship, detail, and volume.

Lilla Cabot Perry. Mother and Child, *c. 1890s, oil on canvas, 40 1/4" x 30". Collection of Hirschl & Adler Galleries, Inc.*

Selected Additional Women Influenced by French Modernism

Cecilia Beaux (1855–1942) Leading American portrait painter who studied in both America and Europe; earned recognition for the fluid brushwork and deep psychological insight of her portraits of the social elite; singular honor of teaching painting at the Pennsylvania Academy for twenty-five years, starting in 1895

Vanessa Bell (1879–1961) Older sister of Virginia Woolf; Post-Impressionist painter who belonged to the nucleus of the Bloomsbury group, a tight-knit circle of artists, writers, and intellectuals who made an enormous impact on British culture just before and after World War I

Camille Claudel (1856–1920) Sculptor connected with Rodin; was his collaborator, model, and lover

Gwen John (1876–1939) British painter influenced by Pablo Picasso's Blue Period

Marie Laurencin (1885–1956) Colleague of the group surrounding Picasso

Mary Louise Fairchild MacMommies (Low) (1858–1946) Mary and her husband, Frederick, were both successful American sculptors who achieved distinction in Europe and the United States

Lilla Cabot Perry (1848–1933) Along with Mary Cassatt, Perry brought French Impressionism to the United States (Fig. 7-8)

Paula Modersohn-Becker: Power and Originality

To struggle for strength. It sounds so dramatic. One does as best as one can, and then one goes to bed. And that's how suddenly one day, it becomes evident that one has achieved something. — Paula Modersohn-Becker

PAULA MODERSOHN-BECKER (1876–1907) was the first German artist to generate a personal Post-Impressionist style that synthesized French and German influences. Modersohn-Becker's monumental, hardy women express the inherent strength of her sitters compared to the more passive females painted by the Impressionists.

As a youth, Modersohn-Becker defied her parents' urging to become a kindergarten teacher and instead pursued traditional art instruction. Eventually, she moved to an artists' colony located in Worpswede, a small village in northern Germany. The artists there, including Otto Modersohn, whom she married in 1901, portrayed local peasants in the bleak surrounding countryside. Although Modersohn-Becker always returned to Worpswede, she frequently made prolonged trips to Paris. French modern art inspired Modersohn-Becker to abandon her strict realism and conventional perspective for an avant-garde technique that emphasized simplified shapes, heavy outlines, and highly saturated colors. (Fig. 7-9)

As with many other females of the day, Modersohn-Becker died young. She passed away at age thirty-one, just nineteen days after giving

Fig. 7-9 Paula Modersohn-Becker had a lifelong interest in portraying females— local residents of Worpswede, peasants, and also herself. How has she achieved an impressive simplicity in her self-portrait, painted the year of her death? Notice Modersohn-Becker's simplified forms, exotic color, and strong lines. How do you think she felt about herself? It was not until years later that Modersohn-Becker became satified with her work.

Paula Modersohn-Becker. Self-portrait with Camellia Branch, 1907, oil on canvas. Folkwang Museum, Essen.

Fig. 7-10 Käthe Kollwitz expressed her ideas in prints, which, because of their relatively low cost and ability to be reproduced, could reach great numbers of people. How do you think Kollwitz felt about war? In what ways did she use line to emphasize her beliefs?

Käthe Kollwitz. Never Again War, 1924. Private collection, courtesy of the Galerie St. Etienne, New York.

birth to a daughter. Her death is a sobering reminder of the biological reality that lay behind many of the period's idealized, serene pictures of motherhood. Remarkably, in her brief career, Modersohn-Becker created some 400 paintings and more than 1,000 drawings and graphic works.

1900–40: A Multitude of Movements

Early-Twentieth-Century Modernism

Käthe Kollwitz: The Political Is Personal Was KÄTHE KOLLWITZ (1867–1945) simply concerned with making "pretty pictures"? (Fig. 7-10) For her, art was a means of expressing vital social, political, and personal concerns:

> My real motive for choosing my subjects almost exclusively from the life of the workers was that only such subjects gave me in a simple and unqualified way what I felt to be beautiful…. Middle-class people held no appeal for me at all. Bourgeois life as a whole seemed to be pedantic…. I was gripped by the full force of the proletarian's fate.

Kollwitz consistently tackled issues such as political oppression, working-class impoverishment, and other ills of modern society, as well as the joys and pains of motherhood. She used her art to address abortion, hunger, alcoholism, child care, and worker safety.

Kollwitz married a doctor who shared her convictions, and together they moved to the poorest worker's district in Berlin, where he established a medical practice. Kollwitz's own life sensitized her to the suffering of humankind. She lost her son in World War I and a grandson in World War II. In addition, she herself was persecuted by the Nazis. Kollwitz transformed her private pain into a universal statement by using the image of grieving parents in passionate antiwar artworks. Throughout her career, Kollwitz depended on black and white lines and forms to create powerful, recognizable images that radiated an emotional intensity.

The Russian Female Avant-Garde, 1910–20: Dynamic Abstraction In the late 1800s, Russia still was considered a provincial backwater. With no strong fine-art tradition, the nation was ripe for dramatic change. By the early twentieth century, avant-garde artists developed a fresh, daring visual style that replaced conventional concepts of beauty that had ruled since the Renaissance.

Modern Russian artists fostered some of the most original aesthetics of the time, but their initiatives were short-lived. After Vladimir Ilyich Lenin came to power in the early 1920s, he mandated that all art must serve the good of the state and be thoroughly understandable and useful to every worker. Many artists who objected to this policy immigrated to Germany, France, or the United States, taking their revolutionary concepts with them.

NATALIA GONTCHAROVA (1881–1962) was among the most adventurous female Russian avant-garde artists. Early in her career, Gontcharova was a leader of the Russian Neoprimitive movement, which responded to native crafts and prints as well as to contemporary French art. (Fig. 7-11) Later, along with her husband Mikhail Larionov, she devised an abstract idiom called *Rayonism*. Their style was influenced greatly by the recent invention of the electric lamp, which prompted the couple to fragment their subjects with painted "rays" of light and energy, producing startling, dynamic compositions.

Similar to her contemporaries, OLGA ROZANOVA (1886–1918) did not adhere closely to nature or tell a story in her art but instead concentrated solely on the formal elements of line, color, shape, and composition. Other women working in this abstract mode included LUIBOV POPOVA (1889–1924), ALEXANDRA EXTER (1882–1949) (Fig. 7-12), VAVARA STEPANOVA (1894–1958), and NADEZHDA UDALTSOVA (1885–1961).

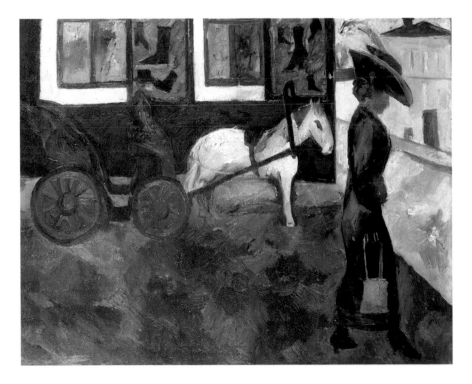

Fig. 7-11 Natalia Gontcharova reduced her composition to simplified shapes of bold, often nonrealistic colors. A few years later, Gontcharova and her husband invented Rayonism, a technique of abstracting, slicing, and rearranging scenes to create a dynamic new Russian art form.

Natalia Gontcharova. Street in Moscow, 1909, *oil on canvas. Leonard Hutton Galleries, New York.*

Manifesting Modernity
The Delaunays incorporated Modernism into their very beings, commonly wearing Sonia's fashions, which bore the same colored zones as their paintings. Robert typically would appear in a red coat with a blue collar, green jacket, sky-blue vest, black pants, red socks, and yellow-and-black shoes. Sonia would don a purple dress with a wide green-and-purple belt and an antique rose and yellow-orange corsage.

SONIA TERK-DELAUNAY (1885–1979) spent most of her career outside of her birthplace in the Ukraine, but, like her Russian compatriots, she devoted herself to using abstraction for expressive purposes. Just before World War I, Delaunay and her husband, Robert, invented a painting system of brilliantly colored disks to establish a rhythmic effect that became known as Simultanism. (Fig. 7-13) Delaunay's strident color fragments and rhythms translated the tempo of modern urban life into visual form. Her art embodied the vibrating, multicolored halos that glowed from the new electric lamps, as well as the staccato tango and fox-trot beats pouring out of the Paris dance halls, which she and Robert frequently visited.

Delaunay initially experimented with complete abstraction in 1911 while working on a blanket for her first child:

> *I had the idea of making…a blanket composed of bits of fabrics like those I had seen in the homes of Russian peasants. When it was finished the arrangement of the pieces of material seemed to me to evoke Cubist conceptions and we tried then to apply the same process to other objects and paintings.*

Delaunay and other avant-garde artists, including ANNI ALBERS (1899–1994) (Fig. 7-14) from Germany; SOPHIE TAEUBER-ARP (1889–1943), born in Switzerland but working primarily in Germany; and

Fig. 7-12 Can you identify the grapes and pear in Alexandra Exter's multi-faceted painting? Exter helped pioneer Russian modern abstraction. While on a trip to Paris, she became familiar with a style invented by Pablo Picasso and Georges Braque called Cubism, which Exter explores in this painting.

Like other artists who explored Cubism during the early twentieth century in Paris, she builds colored planes not just from paint but also with elements such as newspaper that she pasted onto her canvas. How does Exter's style affect the sense of space?

Alexandra Exter. Grapes in a Vase, 1913, collage and oil on canvas. The Rothschild Art Foundation.

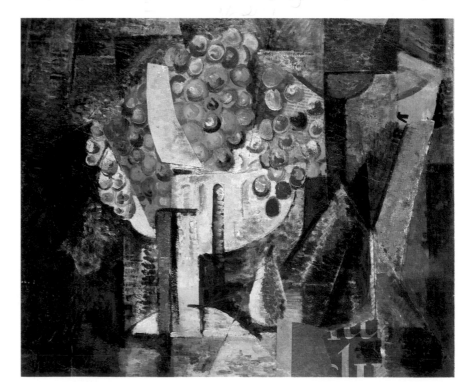

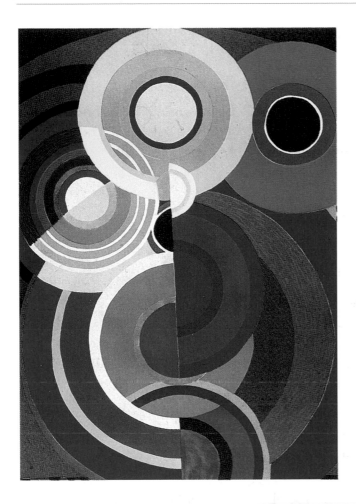

Fig. 7-13 Why does Sonia Delaunay brazenly juxtapose her colors? The composition resonates with its own internal energy. While wholly abstract, Delaunay's hues and shapes, along with the seasonal association of her title, loosely evoke rings in a pond from a tossed pebble, halos in the sky from a starry night, or the inner circles of cut trees.

Sonia Terk-Delaunay. Automne, 1965, color lithograph. Courtesy of the Andre Zarre Gallery, New York City.

Fig. 7-14 After World War II, Anni Albers founded a weaving workshop in America, and for sixteen years encouraged several generations of students to experiment with various materials and processes.

In her *Untitled* series for the AT&T Corporation, Albers' linear pattern appropriately seems to evoke circuit breakers or telephone wiring.

Anni Albers. Untitled, 1984, flat woven tapestry (one of four). Collection AT&T Corp. Permission Josef and Anni Albers Foundation.

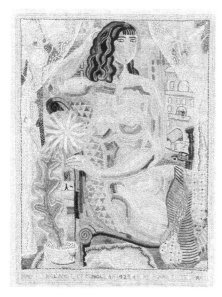

Fig. 7-15 Marguerite Zorach felt a strong connection between painting and textiles. Zorach abstracts her figure so that it carries a strong sense of shape and color. In 1936, she said, "I am first of all a painter. It was my interest in color (later in texture) and a certain spirit of adventure that led me to do a picture in wool. I became fascinated by the possibilities of the new medium and developed it more and more…. It is because I am a painter that the tapestries have the qualities they possess."

Marguerite Zorach. For Bill and Lucy L'Engle, 1924, wool on linen. Kraushaar Galleries, New York.

Questionable Distinction

Marguerite Zorach helped introduce French Modernism to America when she exhibited at the landmark New York Armory Show of 1913. Yet, a critic refused to acknowledge her in a modern-art context and instead joked, "In the 'study' by Marguerite Zorach, you see at once that the lady is feeling very, very bad. She is portraying her emotions after a day's shopping. The pale yellow eyes and the purple lips of her subject indicate that the digestive organs are not functioning properly."

the American MARGUERITE THOMPSON ZORACH (1887–1968) (Fig. 7-15), passionately believed in moving art out of the studio and into daily life. Along with Gontcharova, Exter, Popova, and Stepanova, these females were involved in textile design, weaving, tapestry, quilt making, costume and stage design, home furnishings, porcelains, book jackets, and advertisements. The women's varied endeavors demonstrated their belief in the equality of the applied and fine arts.

Women Artists Associated with Dada and Surrealism from 1920 to the Early 1940s: New Visions

In the years surrounding World War I, a group of European artists, writers, and philosophers reacted to what they felt was the decline of Western society and the chaotic arbitrariness of human existence.

Dada and later Surrealist artists of the 1920s and 1930s scorned conventional art and instead mined the unconscious for inspiration. Their images attempted to illustrate a different, or "sur-real," reality rather than that ordinarily perceived by the logical mind. They relied on dreams, chance juxtapositions, and irrationality to generate their compositions.

Surrealism's male theorists held an ironic attitude toward females that ultimately weakened women's individuality. On the one hand, they valued females as spontaneous, innocent, and uncorrupted by intellect or reason. Females were men's primary source of artistic creativity. At the same time, the artists feared women's supposed ability to be "closer to the subconscious." The male Surrealists believed that they were responsible for translating female intuitive strengths to the world. As a result of their adulation, the men relegated women into objects that were inherently limited by "feminine" characteristics.

Nevertheless, during the 1930s, a significant number of females were attracted to Surrealism's antiacademic stance and also to the movement's reliance on personal exploration, which legitimized an artistic path that many women artists had followed for ages.

The Mexican artist FRIDA KAHLO (1910–54), as with other females associated with Surrealism, avoided presenting women as objects. Unlike her male peers who depended on women as muse or erotic symbol, Kahlo relied on the Surrealist fascination with duality to express touching personal statements. Her perceptive self-portraits combine aspects of the outside world with a deep inner truth. For instance, the animals and wildly overgrown vegetation, which literally entwine Kahlo's hair in *Self-portrait with Monkey and Parrot* (Fig. 7-16), compress her body into a tight space. With no room to breathe, she forces us to confront her unflinching stare. Spirited life forms encompass her, but Kahlo's expression conveys extreme suffering. In reality, she had endured severe physi-

Fig. 7-16 How does Frida Kahlo create an alluring image with a disturbing undertone? Her acidic colors, static pose, as well as irrational space and scale intensify the underlying emotions behind her unrelenting gaze. The majority of Kahlo's paintings are self-portraits that reveal both her internal and external state.

Frida Kahlo. Self-portrait with Monkey and Parrot, *1942, oil on board. Collection, IBM Corporation, Armonk, New York.*

cal pain following a crippling bus accident that occurred in her teens and emotional turmoil as a result of a tumultuous marriage to the artist Diego Rivera, who was often unfaithful to her.

Other Modern Female Artists South of the Border

MARIA IZQUIERDO (1902–55) is less well-known than her countrywoman Frida Kahlo. Whereas Kahlo evoked aspects of Mexican folk art, Izquierdo borrowed from Spanish colonial art traditions. (Fig. 7-17) Izquierdo was familiar with modern European masters such as Gauguin, Picasso, and Matisse, but she never lost sight of her own heritage, stating, "I try to make my work reflect the true Mexico, what I feel and love. I avoid anecdotal, folklore and political themes because they do not have expression or poetic strength and I think that in the world of art, a painting is an open window to human imagination." (Fig. 7-18)

Izquierdo drew directly from her own experience, producing art that reflected her colonial upbringing. She was raised by her grandparents in a conservative, Catholic atmosphere. At fourteen, Izquierdo was wed in an arranged marriage to an army colonel and gave birth to three children in rapid succession. After six years of marriage, Izquierdo

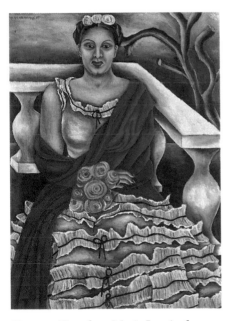

Fig. 7-17 How does Maria Izquierdo include signs of her Spanish colonial upbringing? Despite the native Mexican shawl, Izquierdo portrays herself in a European-style dress with frills and bows. Given the desolate background in which she paints herself, what do you think Izquierdo wants to communicate about her personality or emotions?

Maria Izquierdo. Autorretrato (Self-portrait), *1940, oil on masonite.* © 1993 *Sotheby's, Inc.*

Fig. 7-18 What emotions does Maria Izquierdo create in her evocative painting? Are these women happy? How does Izquierdo's title relate to the composition? Are the females praying or crying to the moons and sun that fill the sky? Izquierdo leaves it up to each viewer to interpret her work's poignant meaning. Although its unrealistic qualities relate to the Surrealist bent for incomprehensible scenes, unlike her European contemporaries, Izquierdo deliberately uses the native people of her Mexican homeland as her subjects.

Maria Izquierdo. Esclavas en Paisaje Mítico (Slaves in Mystical Landscape), *1936, watercolor on rice paper laid down on board.* © 1993 Sotheby's, Inc.

Avant-Garde Female Artists in Latin America

The concept of "machismo" in Latin American culture associated men with the outside, physical world and relegated women to the internal sphere of emotions. Thus, being an artist was considered an appropriate realm for expressing personal feelings, a "natural" activity for females.

divorced her husband in 1927 and entered the Escuela National de Bellas Artes in Mexico City. Izquierdo worked and exhibited alongside the male Mexican Modernists of the day, but the men often treated her as a mere appendage. In one painful incident, she lost the right to create a public mural. Diego Rivera, who had initially championed Izquierdo's efforts, claimed that she was too inexperienced and he successfully blocked a federal commission for her artwork at the national palace—an award she had already been promised.

The Mexican photographer LOLA ALVAREZ BRAVO (1907–93) had a long and varied career, working as a photojournalist, teaching art and photography, organizing exhibitions, and even writing a Surrealist screenplay with Frida Kahlo. (Fig. 7-19) Bravo sometimes made photographs of Mexican scenes, particularly of peasant life, or those suggesting social commentary. At other times, Bravo gave her works a Surrealist edge. She knew many of the country's cultural elite, including Kahlo, Maria Izquierdo, and Diego Rivera.

Additional Latin American artists also embraced Modernism starting around 1920. ANITA MALFATTI (1889–1964) and TARSILA DO AMARAL (1886–1973) played a prominent role in Brazil's avant-garde movement. Along with Kahlo and Izquierdo, LEONORA CARRINGTON and REMEDIOS VARO (both mentioned below) were Surrealists working in Mexico, although neither woman was native to the country.

Selected Additional Dada and Surrealist Women Artists

Gertrude Abercrombie (1908–77) American Surrealist who used primitive, personal imagery

Leonora Carrington (b. 1917) British by birth, Carrington was considered an integral part of the art scene in Mexico, where she lived from 1942 until 1985, when she moved to the United States; she incorporated elements of the occult into her work

Marie Cerminova, called Toyen (1902–80) Czech. Toyen used images from nature as metaphors for political reality

Leonor Fini (1908–96) Born in Argentina; spent her childhood in Italy with her mother's family; moved to Paris in 1932, where Surrealism had been gaining momentum since 1924; painted bizarre bone and rotting vegetation-filled compositions with scientific accuracy

Hannah Höch (1889–1978) German. Part of the Berlin Dada group; her photomontage works borrowed elements from the world of machines to create visual statements about the confusion and ironies of postwar European society

Alice Lex-Nerlinger (1893–1975) German. Created anti-Fascist art for posters and brochures; persecuted by the Nazis and forbidden to work from 1933 to 1945; after World War II she continued as a freelance commercial artist in East Berlin

Meret Oppenheim (1913–86) Born in Germany; worked and exhibited regularly with the Surrealists from 1933 to 1966; Oppenheim felt that her famous, incongruous fur-covered teacup, saucer, and spoon was a humorous symbol of her rebellious spirit

Kay Sage (1898–1963) American. Painted poetic, haunting Surrealist landscapes that suggest a lonely and empty world (Fig. 7-20)

Dorothea Tanning (b. 1913) American. Internationally recognized Surrealist painter who lived in France, where she gained more renown than on her native soil; her work explores chaos, dreams, and the imagination (Fig. 7-21)

Remedios Varo (1913–63) Born in Spain, moved to Mexico in 1940; worked with Surrealist themes, dreams, music, time, cosmology, the occult, and alchemy; close friendship with Leonora Carrington

Selected Early Modern-Artist Partnerships

Marie Bracquemond (1841–1916) and Félix Bracquemond—Marie's engraver husband initially helped her enter French artistic circles in 1869; his jealousy later inhibited her development and contributed to her lack of recognition as an Impressionist

Gwendolyn Knight (b. 1913) and Jacob Lawrence—Knight was born in Barbados and moved with her family first to St. Louis and then to Harlem, in New York City; greatly influenced by the creativity of the Harlem Renaissance, she combined her interest in art with dance and music; she met Jacob Lawrence while they were both students of the influential sculptor and teacher Augusta Savage (See page 111, "African-American Women Artists in the Early Avant-Garde")

Fig. 7-19 Can you find similarities between this photograph of the painter Frida Kahlo and the artist's self-portrait (Fig. 7-16)? Lola Alvarez Bravo portrays her friend in a manner that recalls Kahlo's own intense painting style.

Lola Alvarez Bravo. **Frida Kahlo with Ringed Hand on Chin,** *1944,* **Gelatin Silver print. Courtesy of the Throckmorton Fine Art, Inc., New York, NY.**

Fig. 7-20 Can you make sense of the title or objects in KAY SAGE's painting? Like most of her Surrealist works, Sage's words do not exactly explain her mysterious architecturelike image located in deep space. In a sense, it is a bit like a dream where things may appear real, yet not quite comprehensible.

Kay Sage. Tomorrow Mr. Silber, *1949, oil on canvas. Courtesy of the Michael Rosenfeld Gallery, New York.*

War Versus Childbirth: A Deadly Reality
Between 1910 and 1925, the "privilege" of childbirth took the lives of approximately 300,000 women, more than all the American men who had died in battle from the American Revolution to World War II.

Gabriele Münter (1877–1962) and Vasily Kandinksy—Münter exhibited with the German *Blaue Reiter* (The Blue Rider), which her companion helped found; she shared the group's notion of color as an independent expressive element, but also drew from other modern European movements of the era

Georgia O'Keeffe (1887–1986) and Alfred Stieglitz—O'Keeffe was one of the forerunners of Modernism in the United States (See "Georgia O'Keeffe: An American Original" on page 108 for more information); Stieglitz was first O'Keeffe's patron, and then husband and advocate for almost thirty years, as well as one of America's important modern photographers

Kay Sage (1898–1963) and Yves Tanguy—Surrealist compatriots who spent the war years together in New York

Sophie Taeuber (1889–1943) and Jean Arp—Taeuber's husband, Jean Arp, credits his success and their collaborations to her inspiration: "It was Sophie Taeuber who, through the example of her clear work and her clear life, showed me the right way, the way of beauty."

Dorothea Tanning (b. 1913) and Max Ernst—The two married in 1946 (Ernst's fourth and final time) and relocated to Arizona, where they painted with other Surrealists; in 1952, they relocated permanently to France where Tanning, like Cassatt, received more recognition than in her native land

Marianne von Werefkin (1860–1938) and Alexej Jawlensky—Along with Münter and Kandinsky, the companions cofounded the New Artists' Association of Munich in 1909, two years before the first *Blaue Reiter* exhibition

America: The First Half of the Twentieth Century

The Artistic Climate: An Overview

How did artists in the United States react to the avant-garde movements fermenting overseas? European abstraction dramatically influenced the American scene in the first decades of the twentieth century. The now legendary 1913 International Exhibition of Modern Art, referred to as the Armory Show, introduced the most innovative European styles to the country. By the 1920s and early 1930s, however, many American artists became disenchanted with these foreign antecedents and instead looked to their own roots to create pieces that glorified their homeland and its past.

Representational art centering on social protest flourished during the Depression. By World War II, American artists were forging dynamic, nonfigurative idioms that borrowed aspects of European abstraction, which refugee artists had brought with them when fleeing their battle-torn countries across the Atlantic.

Female Artists in America: 1900–29

At the turn of the century, the genteel, representational art of earlier decades had became irrelevant to the new technological age. Cutting-edge artists now lived in urban centers filled with towering skyscrapers, elevated trains, streetcars, flickering electric lights, and crowds of people from all walks of life. Compared to the past, more women ventured outside the home, although most filled "pink-collar" jobs such as clerical and sales help, domestic service, and elementary-school teaching. Females who competed with males for employment routinely were paid less, with the implicit understanding that men were the "true" economic providers for the family.

Society urged most women to remain at home as mothers because of the declining birthrate. Nonetheless, many females did participate significantly in the rapid succession of art movements that reflected the new social order. They also made invaluable contributions to the museum field, publishing, illustration, and industrial design, and they proved to be indispensable art patrons and sponsors.

Women in Art Vocations During the Early Twentieth Century
Prior to the Depression, females made headway in the fields of industrial and interior design, advertising, publishing, illustration, and museum work. Yet, as artists, they still received only about 20 percent of the available professional awards and commissions.

Fig. 7-21 Can you explain specifically what is happening to the "beautiful girl" DOROTHEA TANNING mentions in her title? She appears to be blossoming into womanhood. The flowerlike emblems and printed words hint at her life to be. Tanning combines dreams and fantasy to create a perplexing but engaging composition.

Dorothea Tanning. Beautiful Girl, 1945, oil on linen mounted on panel. Courtesy of the Michael Rosenfeld Gallery, New York.

Fig. 7-22 Georgia O'Keeffe stamp. *Stamp design © 1995 U.S. Postal Service. Photograph of* Red Poppy, 1927 *© Malcolm Varon, NYC.*

A Different Point of View
Georgia O'Keeffe commented on the male artists who composed Stieglitz's circle: "The men liked to put me down as the best woman painter. I think I'm one of the best painters."

Fig. 7-23 Did Georgia O'Keeffe describe every detail in her landscape? She deliberately simplified both the forms and colors, allowing us to see and feel nature in a profound way.

Georgia O'Keeffe. From the Plains I, *1953, oil on canvas. Gift of the Estate of Tom Slick, McNay Art Museum, San Antonio, Texas.*

Georgia O'Keeffe: An American Original GEORGIA O'KEEFFE (1887–1986) remains one of the most enigmatic artists to classify. Early in the century, she was associated with Alfred Stieglitz's New York gallery and its astonishing displays of European Modernism. As Stieglitz's colleague and later wife, O'Keeffe led an unconventional life in which she spent a great deal of time without Stieglitz, preferring to remain in New Mexico, pursuing her artistic path.

In 1923, O'Keeffe wrote about her particular moment of liberation:

One day seven years ago I found myself saying to myself—I can't live where I want to—I can't go where I want to go—I can't do what I want to—I can't even say what I want to…. I decided I was a very stupid fool not to at least paint as I wanted to and say what I wanted when I painted, as that seemed to be the only thing I could do that didn't concern anybody but myself…. I found that I could say things with color and shapes that I couldn't say in any other way—things I had no words for.

O'Keeffe skillfully eliminated the distinct boundaries between representation and abstraction by constructing distilled, spare forms derived from the natural world. Her large close-ups of flowers (Fig. 7-22), cityscapes, and hauntingly beautiful vistas of upstate New York and the deserts of New Mexico all embody the mystical, sensuous lyricism that became her hallmark. (Fig. 7-23)

Minnie Evans: Outside the Mainstream MINNIE EVANS (1892–1987) was a self-taught African-American artist from North Carolina. She traced her background to a maternal ancestor who came to the United States from Trinidad as a slave. Interestingly, Evans' vivid hues and floral motifs

Fig. 7-24 Minnie Evans' sumptuous painting welcomes us into a private dreamscape. Evans' intense palette helps make her internal world, inspired by dreams, come alive. She explains: "My whole life has been dreams… sometimes day visions,…they would take advantage of me."

Evans never received formal art training. However, during her visions, "something told me to draw or die. It was shown to me what I should do."

Minnie Evans. The Voice of the Fifth Angel, *c.1959, oil on cardboard. Collection Siri von Reis. Courtesy of the Luise Ross Gallery, New York.*

evoke Caribbean folk art, even though she traveled outside of her home state just once. Possibly, Evans' flower-filled compositions were inspired by Airlie Gardens, in Wilmington, North Carolina, where she worked as the gatekeeper for twenty-seven years.

Evans' art has a hallucinatory quality, stemming from unusual dreams that originally plagued her as a child and resumed in 1935. She once said, "An angel spoke to me just as loud as I'm speaking to you." Evans repeatedly drew her visions in spicy, colorful compositions, working in a variety of media until her death fifty-two years later. She frequently fixed human faces within exotic blossoms and garlands. Her pieces are essentially spiritual, representing a realm in which images of the Christian God, humans, and nature freely intermingle. (Fig. 7-24)

American Women During the Depression and War Years: The 1930s and 1940s

The 1929 stock market crash ended the jubilant Jazz and Flapper Age as well as the nation's sense of economic security. The 1930s were a peculiar period of ambivalence for females. In the movies, Hollywood cast Katharine Hepburn, Bette Davis, and Rosalind Russell as beautiful, intelligent, emancipated, wisecracking career professionals, but their characters inevitably forfeited their positions when "Mr. Right" came along. Within government, the New Deal policies paid lip service to the notion of equal opportunity, but the media pressured women to leave

Modern Cultural Matrons

Numerous consequential female art patrons emerged during the twentieth century. Mary Cassatt worked intensively with Louisine Elder Havemeyer and her husband; their celebrated, nearly 2,000-piece collection resides at the Metropolitan Museum of Art.

Lillie P. Bliss, Abby Aldrich Rockefeller, and Mary Quinn Sullivan opened the Museum of Modern Art in New York; and Gertrude Vanderbilt Whitney, an artist in her own right, founded the Whitney Museum of American Art. Baroness Hilla Rebay von Ehrenweisen, a German-American artist, became the guiding spirit behind New York's Solomon R. Guggenheim Museum.

Isabella Stewart Gardner's museum in Boston holds vast treasures, reflecting her wise collecting talent. Sisters Claribel and Etta Cone bequeathed over 3,000 twentieth-century masterpieces to the Baltimore Museum of Art.

Fig. 7-25 Is there a distinct foreground and background in Irene Rice Pereira's painting? The boundless sense of space within her nonobjective art was inspired by a trip in the early 1930s to the Sahara.

Pereira was struck by a feeling of infinity when she looked out over the endless stretches of sand in the blazing sun. Pereira used pure geometry to evoke a cosmic sense of "the reality of space and light; an ever-flowing… continuity,…infinite possibilities of change."

Irene Rice Pereira. Pillar of Fire, 1956, oil on canvas. Courtesy of the Andre Zarre Gallery, New York City.

their jobs to help ease male unemployment. Wage-earning women became targets for hostility, and the slogan of the era declared, "Don't take a job from a man."

Female wage earners often were depicted as out to steal men's jobs. In reality, the Depression made it more important than ever for women to support themselves or their families. Working wives encountered particular discrimination. For instance, thousands of married female teachers discovered that the only way to retain their positions was to file for a temporary divorce.

In 1936, 82 percent of Americans who participated in one survey said that wives should not work outside the house if their husbands had jobs. Thus, women had fewer employment opportunities and were limited sharply by the scarcity of jobs, society's misogynistic attitudes about female roles and capabilities, and widespread workplace discrimination.

When America entered World War II, these stereotypes were shelved as the nation swung into wartime production. More than six million females filled the jobs of men who went to fight overseas. By 1943, women composed about one-third of the employment force. When servicemen returned in 1945, federal agencies that once had enthusiastically recruited female workers now urged them to return home to take care of their husbands and children. Although women's work during the war proved otherwise, employers now argued that they had neither the physical strength nor the emotional or mechanical ability to perform well in high-paying, skilled factory positions. Furthermore, they claimed, women's presence distracted the men from their tasks.

Female Artists of the 1930s and 1940s

Government-Sponsored Programs Women did flourish, however, within the art world, in large part because of the Federal Art Project. A 1935 survey of government-paid jobs for artists indicated that females held approximately 40 percent of the positions. Many of America's leading women artists began their careers in these federal programs, including ISABEL BISHOP (1902–88) (see page 113, "Selected Additional American Women Artists of Early Modernism"), Lee Krasner (1908–84) (see pages 121–122, "Women Artists in the 1950s"), LOREN MACIVER (b. 1909), Alice Neel (1900–84) (see page 132, "Recovering Realism"), Louise Nevelson (1900–88) (see pages 121–122, "Women Artists in the 1950s"), and IRENE RICE PEREIRA (1907–71) (Fig. 7-25). Both women and men produced thousands of paintings, murals, sculptures, and prints and taught classes in community art centers around the country. Sadly, countless public pieces that once had adorned post offices, schools, and other official buildings have been lost, discarded, or destroyed over the years.

Stylistically, many artists in the federal programs produced uplifting, idealized images of American workers and farmers, although a small percentage did work in an abstract vein.

African-American Women Artists in the Early Avant-Garde

African-American female artists experimented with various media and early modern styles during the 1930s and 1940s. AUGUSTA SAVAGE (1892–1962) was an important sculptor and influential figure in the advancement of black art in the United States. She also helped promote younger African-American artists through the Harlem Art Center of the Federal Art Project and later at the Savage School of Arts and Crafts. She was an acclaimed artist in her own right, yet felt, "I have created nothing really beautiful, really lasting, but if I can inspire one of these youngsters to develop the talent I know they possess, then my monument will be in their work." (Fig. 7-26)

LOIS MAILOU JONES (b. 1905) had a long, distinguished career despite the discrimination she encountered as one of the initial female African-American modern artists. She originally trained in America and France. In the early 1940s, Jones abandoned her Impressionist-like Paris scenes in favor of subjects dealing directly with her personal experience. African art particularly influenced Jones' style, in which she created planar designs with contrasting colors. On her first visit to Haiti in 1954, Jones was immediately drawn to the island's warm climate, colorful scenery, and deeply spiritual people. The government honored the artist with the National Order of Honor and Merit for both her work and the painting classes that she taught. Jones and her husband, a prominent Haitian artist whom she had met at Columbia University in 1934, divided their time between Haiti, Washington, D.C., and Martha's Vineyard, Massachusetts, until his death in 1982. Jones continues to maintain an active studio in Haiti, her second spiritual home. (Fig. 7-27) Whether depicting overt discrimination and prejudice or incorporating influences from Haitian and African art, Jones, as an artist and a veteran educator, serves as a compelling model for all women.

ELIZABETH CATLETT (b. 1915) was one of Jones' students and considered by many the greatest African-American sculptor of either gender. Catlett also is renowned for creating striking prints, which, like her three-dimensional works, are often distillations of recognizable subjects. (Fig. 7-28) In 1978, Catlett remarked, "Art must be realistic for me whether sculpture or printmaking. I have always wanted my art to service black people—to reflect us, to relate to us, to stimulate us, to make us aware of our potential."

Fig. 7-26 How does it feel to face this man's penetrating stare? What words might capture his moving expression? Augusta Savage was one of the first artists to consistently explore African-American facial features in portraiture.

Augusta Savage. Portrait Head, *c. 1940, painted plaster. Courtesy of the Michael Rosenfeld Gallery, New York.*

Fig. 7-27 Unlike Augusta Savage (Fig. 7-26), Lois Mailou Jones' parents and early teachers encouraged her artistic efforts. Nonetheless, Jones encountered enough discrimination in America that she spent much of her time abroad. Jones studied painting in France, incorporated African themes into her art, and developed a strong love for Haiti.

How does Jones visually express the vitality of Haiti's crowded market place? She jams her composition full of people and also angular objects, which explode beyond the frame's boundaries.

Lois Mailou Jones. Marché, Haiti, *1963, polymer. Courtesy of the artist.*

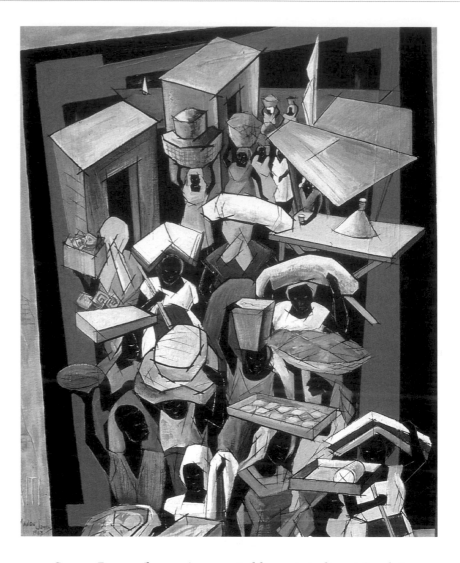

All in Relationship to Men
In the government's Works Progress Administration projects, someone said that Alice Neel was "the woman who paints like a man." She responded, "I always painted like a woman, but [not] like a woman is supposed to paint."

SELMA BURKE (b. 1900) supported her art studies at Sarah Lawrence College in the 1930s by modeling for various modern artists, including Alfred Stieglitz and Edward Steichen, and she studied with Matisse and Maillol in Paris. Burke was daringly unconventional. For example, she fled Austria when Hitler marched into the country during World War II, carrying with her a half a million dollars' worth of jewels stitched into her clothing to deliver to the Quaker refugee offices in America.

In 1944, Burke was commissioned to sculpt Franklin Roosevelt, and the resulting portrait was adopted for the new dime. At ninety-three, Burke received yet another federal commission, this one for a sculpture of the civil rights activist Rosa Parks. Burke noted, "It's surprising how many outstanding women sculptors there have been and how many of them are black." She continued, "Art didn't start black or white, it just started. There have been too many labels in this world.... Why do we still label people with everything except 'children of God'?"

Selected Additional American Women Artists of Early Modernism

Rosalind Bengelsdorf (Browne) (1916–79) Painted one of the first abstract murals for the Federal Art Project

Isabel Bishop (1902–88) Leading American humanist painter whose art portrayed the workers, shoppers, waitresses, and derelicts surrounding her downtown New York City studio

Lucienne Bloch (b. 1909) Participated in the American mural movement inspired by the Mexican artist Diego Rivera; hired by the Federal Art Project

Romaine Brooks (1874–1970) Brooks' difficult childhood experiences of caring for her mad and sexually abusive brother pervade her haunting portraits

Katherine Sophie Dreier (1887–1952) Joined the New York Dada group after viewing avant-garde abstract art from Europe in the early twentieth century; championed modern art, in 1920, when, along with Marcel Duchamp and Man Ray, she helped establish Société Anonyme, the first museum of modern art in America

Elsie Driggs (1898–1992) Painter who, in the 1920s, captured the clean, abstract beauty of the machine age with geometrically simplified compositions (Fig. 7-29)

Mary Abastenia St. Leger Eberle (1878–1942) Sculptor who portrayed immigrant life in New York City's slums; collaborated with ANNA VAUGHN HYATT (1876–1973), best known for her powerful animal sculptures

Meta Vaux Warrick Fuller (1877–1968) African-American Realist/Impressionist sculptor whose work expressed African-American aspirations and was greatly influenced by Rodin

Fig. 7-28 Elizabeth Catlett produced many prints during her lifetime, including those depicting African-American females as laborers, artists, and farmworkers. What is the woman's connection to the small boy? How does Catlett's title relate to the work?

Elizabeth Catlett. These Two Generations, 1987, *lithograph. Collection AT&T Corp. Courtesy of the artist. Photograph by Manu Sassoonian.*

Fig. 7-29 What does ELSIE DRIGGS' style suggest about her attitude toward American industrialization, which enabled structures like the mammoth Queensborough Bridge, in New York City, to be built? She illuminates her kaleidoscopic scene with a heavenly light that evokes the general optimism of the prosperous 1920s.

Elsie Driggs. Queensborough Bridge, *1927. Courtesy of The Montclair Art Museum, Montclair, NJ.*

Gertrude Glass Greene (1904–56) Pioneering geometric abstractionist in wood constructions

Marion Greenwood (1909–70) Acclaimed muralist in Mexico; painter and print-maker in the United States, working within the Social Realist manner; during World War II, Greenwood was the only female artist-correspondent

Malvina Hoffman (1887–1966) Sculpted huge group works around themes such as "The Races of Man"; studied with Rodin and was part of the early-twentieth-century movement that emphasized direct carving in stone

Helen Lundeberg (b. 1908) Cofounded one of the few independent American avant-garde movements of the 1930s, California Surrealism

Ethel Myers (1881–1960) Exhibited nine sculptures in the 1913 Armory Show, depicting the streets and people of New York City's Lower East Side (Fig. 7-30)

Elizabeth Olds (1896–1991) Known during the Depression era for her prints whose themes bitingly attacked the evils of society and sided with the plight of the worker

Jane Peterson (1876–1965) Post-Impressionist watercolorist

May Wilson Preston (1873–1949) Exhibited in the 1913 Armory Show and won prizes for her paintings in New York, London, and Paris

Concetta Scaravaglione (1900–75) Child of poor Italian immigrants, her large-scale public sculpture expressed humanist ideas

Florence Scovel Shinn (1869–1940) Recognized for her humorous pen-and-ink illustrations

Henrietta Shore (1880–1963) Born in Toronto, Canada, Shore studied in New York City and moved to Los Angeles in 1913; an early modernist of the 1920s who painted some of the finest federally sponsored murals of the 1930s; her work had a strong influence on the progressive photographer Edward Weston

Marianna Sloan (1875–1954) Exhibited landscapes and city scenes at the Pennsylvania Academy and the London Royal Academy; younger sister of the famous artist John Sloan, an exceptional teacher who also trained other successful female artists of the 1930s, among them PEGGY BACON (1895–1987), DORIS ROSENTHAL (1895–1971), and HELEN FARR SLOAN (b. 1911), later his second wife

Florine Stettheimer (1871–1944) Artist from New York City's social elite, Stettheimer's deliberately naive, whimsical compositions convey a witty view of the high society in which she circulated

Laura Wheeler Waring (1887–1948) Noted African-American Realist portrait painter whose sitters included such famous African-American figures as historian W.E.B. Du Bois and artist Alma Thomas (1892–1978) (see page 131, "Minimalist Tendencies: Post-Painterly Abstraction")

Alice Morgan Wright (1881–1975) One of the first American sculptors to use Cubist forms

Early Female Photographers: New Frontiers

Why were numerous women on the cutting edge of photography from its inception? The new art form, begun around 1839, was not burdened with a long, male-dominated history, nor did the medium require the years of training necessary in the more traditional arts. Throughout its development, female photographers greatly helped expand and legitimize the field.

One of the earliest trailblazers was the nineteenth-century British photographer JULIA MARGARET CAMERON (1815–79), best known for her soft-focused, romantic images that echoed the then prevailing British painting style. (Fig. 7-31) Cameron made stunning portraits of some of the most distinguished intellectuals of the day, from poet Robert Browning to naturalist Charles Darwin. In the early twentieth century, American GERTRUDE KÄSEBIER (1852–1934) commonly posed her sitters in artificial situations that carried symbolic meaning.

By the 1920s, photography thrived in portrait studios and in popular magazines. The public craved mechanically reproduced images, especially ones that resembled modern art. In the 1930s and 1940s, DOROTHEA LANGE (1895–1965) created acutely sensitive and memorable

Fig. 7-30 ETHEL MYERS, like Marguerite Zorach (Fig. 7-15), exhibited in the landmark modern art exhibition, the Armory Show of 1913, which introduced avant-garde art to America. How does Myers convey the woman's character in one of her nine sculptures from the exhibition? The figure's substantial form and the large awkward load that she carries, as well as her clothes and shoes, visually define a "matron"—a married woman or a widow, especially a mother of dignity, and mature age.

Ethel Myers. The Matron, c. 1910, bronze. Kraushaar Galleries, New York.

Fig. 7-31 Julia Margaret Cameron's poses and costumes indicate that her models are reenacting the sorrowful parting of the adulterous lovers Lancelot and Guinevere from the legend of King Arthur.

Julia Margaret Cameron. The Parting of Sir Lancelot and Queen Guinevere, *1874. The Forbes Magazine Collection, New York. All Rights Reserved.*

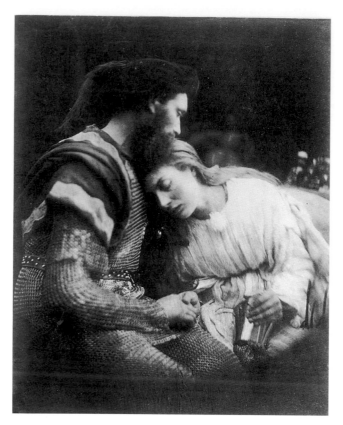

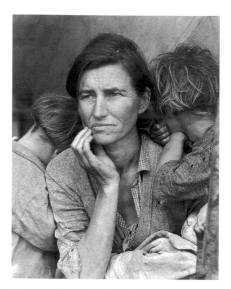

Fig. 7-32 In 1936, Dorothea Lange ventured into the pea fields of Nipomo, California, to document the plight of migrant farmworkers during the depths of America's Great Depression.

Lange wrote in her notes about the woman Florence Thompson, a thirty-two-year-old widow with seven children, "The crop froze this year and the family is destitute [penniless]. On this morning they had sold the tires from their car to pay for food."

Interestingly, Lange emphasized Thompson's role as a mother rather than as a worker.

Dorothea Lange. Migrant Mother, Nipomo, California, 1936, *vintage gelatin-silver print.*

images that captured the heart-rending plight of the American public during hard times. (Fig. 7-32) MARGARET BOURKE-WHITE (1904–71) transformed images of the machine age into austere modern abstractions. (Fig. 7-33)

Female photographers faced fewer barriers than did women painters or sculptors, but they still encountered considerable difficulty. For instance, BERENICE ABBOTT (1898–1991), in documenting New York City during the 1930s, was told bluntly that "nice" girls don't go to the Bowery. "I am not a nice girl," she responded. "I am a photographer." (Fig. 7-34)

Selected Additional Early Female Photographers

Eileen Agar (1904–91) Surrealist photographer

Jessie Tarbox Beals (1870–1942) Credited as the first American female photo-journalist; a nonconformist spirit who documented bohemian life in New York City's Greenwich Village during the early 1900s

Evelyn Cameron (n.d.) Cultivated upper-class British woman who traveled to the American frontier before the turn of the century; chronicled the country's rugged vitality in eloquent photographs

Imogen Cunningham (1883–1976) Belonged to Group f.64, the influential California photography society of the 1930s that produced simplified, sharp-focus images, often of natural phenomena

Rosalie Gwathmey (n.d.) Member of the Photo League, formed in New York City in 1936 to promote the use of photography as an instrument of social change

Florence Henri (1893–1982) American-born, Henri spent her creative life in France and Germany; she generated formalist close-up, fractured views of everyday objects and captivating portraits: "What I want above all in photography is that the volumes, lines, the shadows and light to obey my will and say what I want them to say"

Lotte Johanna Jacobi (1896–1990) Fourth-generation photographer, her great-grandfather studied with Louis Jacques Mandé Daguerre, French inventor of one of the first modern photographic processes; Jacobi was an acknowledged portrait photographer in Germany during the 1920s and 1930s and operated her own studio in New York City after fleeing the Nazis in 1935

Consuelo Kanaga (1894–1978) Photojournalist who also exhibited with the important Group f.64; Kanaga composed formalist still lifes and landscapes but is best known for vivid portraits of the struggling working class, especially African Americans: "I thought a medium like photography would change the world"

Lee Miller (1907–77) Surrealist photographer; worked as a photographer and correspondent with the Allies in Europe during World War II

Lisette Model (1906–83) Model's politically potent images are characterized by their emotional intensity: "Never photograph anything which does not passionately interest you"

Tina Modotti (1896–1942) Introduced to photography by the American master Edward Weston; an ardent anti-Fascist devoted to recording the revolution in Mexico, where she shot some of her finest images during the 1920s

Lucia Moholy (1900–1989) Recognized for her theater photography, photograms, and Bauhaus-influenced portraits

Dorothy Norman (b. 1905) Confidante, pupil, and promoter of Alfred Stieglitz; approached her cityscapes, portraits, images of flowers, and architecture as private acts of love and wonder

Ruth Orkin (1921–83) Orkin received her first camera at age ten, and two years later began printing her own film; moved from Hollywood, California, in 1943, to New York City, where she began a long career of capturing her adopted home city in black-and-white photographs; also worked for magazines

Modern American Women Architects

Historically, American female architects have received little attention, even though they succeeded in making headway in one of the most conventionally male-controlled arenas. As women advanced in architecture, they simultaneously set encouraging precedents for their sisters who were pursuing emancipation in other areas.

In 1881, JENNIE LOUISE BLANCHARD BETHUNE (1856–1913) was the first female accepted as a member of the American Institute of Architects. She entered the profession traditionally, apprenticing as a draftsman and

Fig. 7-33 How did Margaret Bourke-White mesh the technological world with modern art's tendency toward abstraction? By photographing the radio tower from below and within the scaffolding, she created an abstract composition of line and color from a real-life element.

Bourke-White photographed modern industry for magazines such as *Fortune* and *Life* just when photojournalism first began to transform the American media.

Margaret Bourke-White. Radio Transmitting Tower, c. 1935, *silver print.* © 1990 *Sotheby's, Inc.*

then moving up through the ranks. At age twenty-five, Bethune opened her own office, marking what is considered the initial entry of women into the field. Working in and around Buffalo, New York, Bethune, along with her husband and partner, Robert Armour Bethune, received a steady stream of industrial, commercial, and educational commissions.

JULIA MORGAN (1872–1957) probably is most renowned for her mammoth twenty-year undertaking of San Simeon, the Mediterranean castlelike structure along the California coast that she built for William Randolph Hearst starting in 1919. (Fig. 7-35) Morgan was the first female architect licensed in California and established her own firm in San Francisco in 1904. She demonstrated a mastery of light, space, and scale

Fig. 7-34 Why might Berenice Abbott have decided to photograph New York City's Flat Iron Building from this perspective? After experimenting with various angles, she settled on this version, which she shot from the street level. Her composition transforms viewers into pedestrians who glance up momentarily at the unusually shaped edifice. Abbott intentionally included a great deal of sky to emphasize the building's unique form.

Berenice Abbott. Flat Iron Building, *1938. Silver print. The Forbes Magazine Collection, New York. All Rights Reserved.*

in her over-800 documented projects, which include schools, universities, churches, mansions, cottages, and public institutions.

Selected Additional Early Female Architects

Ellamae Ellis League (1899–1991) and Jean League Newton (b. 1919) At twenty-two, League was divorced and left with two children to raise and educate; after only a year of college, she apprenticed in a local firm and became the first woman architect licensed in Georgia; her daughter Jean received a degree from Harvard University in 1944, and together they formed a two-generation creative team

Marion Mahony (1871–1961) First woman to receive a degree in architecture at the prestigious Massachusetts Institute of Technology, and the first female architect licensed in Illinois; worked for fourteen years in Frank Lloyd Wright's firm, contributing several of her own commissions; in 1911, Mahony married Walter Burley Griffin, a colleague in Wright's office, and subordinated herself to him in their professional partnership: "I can never aspire to be as great an architect as he, but I can best understand and help him and to a wife there is no greater recompense"

Aino Marsio (1894–1949) Marsio married Finnish architect and designer Alvar Aalto; they founded the furniture and design firm Artek, in which Marsio worked as the managing director and created many pieces with her own hands

Breaking New Artistic Ground

At the beginning of the modern era, a record number of females became professional artists. Most still were constrained by family obligations as wives, mothers, or unmarried daughters and all too frequently subjugated their own careers to those of their artist husbands or partners.

However, as the period progressed and women advanced in various other arenas, female artists took increasing liberty in selecting their own subjects, materials, and styles. They also helped forge the new medium of photography and made significant inroads into architecture. In the years ahead, women would continue to participate in, and propel, even more radical aesthetic trends. Although some female artists gained visible success, in years to come, many pioneers still would have to battle both obvious and subtle social discrimination that hindered their legitimate standing in history.

Fig. 7-35 The architect Julia Morgan executed this magnificent site for the wealthy California journalist and publisher William Randolph Hearst. What would it feel like to walk up the steps to the imposing facade of the main house, La Casa Grande?

Julia Morgan. La Casa Grande Facade, Facade begun 1922. Hearst Castle/Hearst San Simeon State Historical Monument.

Chapter 8

Mid-20th Century to the Millennium:
Out of the Shadows and into the Light

Late Modernism: Making Headway

How did women fare in America, the cultural capital of the Western world, as modernism shifted toward contemporary trends? An unprecedented number became professional artists after World War II, overcoming age-old limitations. This chapter merely hints at the numerous innovative spirits who contributed significantly to the visual arts during this dynamic era of change. The categories outlined below are designed to provide clarity, but it is important to understand that a multitude of women worked in more than one arena.

Females in America During the 1950s: The Cautious Decade

At midcentury, the conservative backlash of the postwar years essentially negated the advances women had made in the two previous decades. For instance, while the McCarthy "witch hunts" for communists and Cold War paranoia commanded public attention, hundreds of females were more immediately affected by the return of World War II veterans whose jobs they had filled when the men were overseas. Women were abruptly elbowed out of the work force and once again expected to retreat graciously to the kitchen and bedroom.

The American Art World Midcentury:
The Country's First Art Heroes

How did the nation's conservative climate affect the art world? Postwar optimism and wealth fostered the birth of Abstract Expressionism and an explosive new generation of American artists. For the first time, the United States recognized its own visual geniuses. New York City replaced Paris as the art center of Western society, and as the Great Depression lifted, America emerged as a world leader.

Vanguard artists, who had become disillusioned by the war's devastation and failed promises of earlier political reform, abandoned the socially oriented Realist and Regionalist styles of the previous era.

Females in the Workplace
In 1950, 31 percent of all women were employed. However, unlike those in the work force during World War II, they were overwhelmingly confined to a female job ghetto. Ninety-five percent held low-status, dead-end, poor-wage positions in light manufacturing, retail trade, clerical work, health, and education. Furthermore, while women had earned about two-thirds of men's salary during the war, their median income now dropped to just 53 percent of that earned by their male counterparts.

Fig. 8-1 Elaine de Kooning, one of the leading Abstract Expressionists of the late 1940s and 1950s, used intensely colored marks to create dynamic, all-over compositions. Both her bold hues and slashing brushstrokes communicate or "express" the vitality and strength of the enormous creature, taken from memories of bullfights she had seen in Mexico.

Elaine Fried de Kooning. Sunday Afternoon, 1957, oil on masonite. Published courtesy of Ciba. Permission Estate of Elaine de Kooning.

Instead, they turned inward toward their own visions and experiences, producing abstract symbols from their subconscious to express deep personal truths.

The *Abstract Expressionists*, alternatively known as Action Painters or the New York School artists, ushered in a heroic period in which physical scale, grand vision, and aggressive, visible brushwork explicitly symbolized the speed and raw energy with which they worked. Although they were partially stimulated by expatriate modern artists who had sought refuge in America during the war, this initial generation quickly outstripped their European forebears.

Women Artists in the 1950s

Did female avant-garde artists prosper in this dazzling new age? As in the past, many women had to combat both subtle exclusion and rampant sexism. Leading galleries and museums rarely displayed their work, and the artists received few awards or commissions in proportion to their actual numbers. The media acknowledged American artists for the first time, but reporters frequently overlooked females in favor of the more flamboyant, often hard-drinking, male Abstract Expressionists.

For instance, despite her talent and tenacious character, Lee Krasner (1908–84) was long overshadowed by her famous husband,

If Only She Had Been a Man
Louise Nevelson endured blatant sexism early in her career—one critic wrote after viewing her work, "We learned the artist was a woman in time to check our enthusiasm. Had it been otherwise, we might have hailed these sculptural expressions as by surely a great figure among the moderns."

Fig. 8-2 The Port Authority of New York and New Jersey commissioned Louise Nevelson to create a huge wall sculpture for the lobby of its One World Trade Center building in Manhattan.

How does Nevelson evoke a cityscape? The stacked shallow, black wood components recall a sweeping New York vista filled with skyscrapers, construction sites, and bridges.

Louise Nevelson. Skygate—New York, *1977–78, black-painted wood. Collection of the Port Authority of New York and New Jersey.*

Jackson Pollock. Yet Krasner said, "I never held him responsible for the fact that I hadn't made it…. I felt that was due to many, many things outside of him, including the misogyny of the New York School. In each case, you knew how threatened [the men] were; one could physically feel the hostility. The whole culture is that way." Although Pollock received more recognition than Krasner, the couple's artistic alliance remained symbiotic. "It wasn't a student-teacher relationship, but a relationship of equals." Krasner's sense of order and refinement influenced Pollock's painting; his approach helped free her from preconceived notions about art and nature and allowed Krasner to embrace private, internal experience as the basis for her work.

Additional invaluable "foremothers" among the early American Abstractionists include ELAINE FRIED DE KOONING (1920–89) (Fig. 8-1), and sculptors LOUISE NEVELSON (1900–88) (Fig. 8-2) and LOUISE BOURGEOIS (b. 1911) (Fig. 8-3), all of whom greatly influenced the succeeding generation.

Females of the Second Wave HELEN FRANKENTHALER (b. 1928) was the first artist to invent a formal abstract vocabulary, using diluted pigments to stain raw canvases, yet she was not given credit for the invention until Kenneth Noland, Morris Louis, and Paul Jenkins later adopted her technique. (Fig. 8-4) GRACE HARTIGAN (b. 1922) created bold expressionistic compositions that made her one of the earliest avant-garde female artists to earn an international reputation. (Fig. 8-5) JOAN MITCHELL (b. 1926) once stated, "My paintings are about a feeling that comes to me from the outside, from landscape."

Selected Women Sculptors After World War II In the late 1940s and 1950s, advanced sculptors began constructing abstract, open forms that frequently echoed the spontaneous quality of Abstract Expressionist paintings.

An Artistic Heritage
Born in France to a family of tapestry weavers, Louise Bourgeois grew up believing art was useful, not simply an elitist pastime. At just fifteen she helped her mother repair ancient tapestries, made working drawings for her parents, and observed her father's passion for sculpture. Bourgeois continued her studies in New York City after marrying an American art critic.

Fig. 8-3 Louise Bourgeois uses abstraction to suggest human sexuality. Throughout her career, Bourgeois has moved freely among various sculpture media—marble, wood, and wax.

In 1977, Yale University honored Bourgeois, saying, "You have offered us powerful symbols of our experience and of the relations between men and women. You have not been afraid to disturb our complacency."

Louise Bourgeois. Trani Episode, 1971, marble. Courtesy of the Robert Miller Gallery, New York. Photograph by Allan Finkelman © 1990.

Fig. 8-4 Is Helen Frankenthaler's gestural art completely unrelated to the observable world? She recalls that as a child in New York City, "I would spend time looking out my window in the early morning and what I saw was connected in my mind with moods or states of feeling."

The work, she says, "is born out of idea, mood, luck, imagination, risk, into what might even be ugly. The result is…a beautiful message."

Helen Frankenthaler. Under April Mood, 1974, Acrylic on canvas. Collection, IBM Corporation, Armonk, New York. © Helen Frankenthaler, 1996.

Fig. 8-5 Grace Hartigan uses lively brushwork to evoke or express emotions abstractly. Hartigan says the title is based upon a poem of that name by Barbara Guest (American, b. 1920): "The poem meant a great deal to me since I was leaving New York and all my friends in the art world to move to Baltimore and marry my late husband."

Grace Hartigan. The Hero Leaves His Ship, 1960, oil on canvas. Collection IBM Corporation, Armonk, New York.

Fig. 8-6 Dorothy Dehner's all-American girl literally carries various stages of life within her. Can you detect the tiny baby in the section right under her head? Or the plant form, possibly symbolizing budding youth, in the portion beneath?

Dorothy Dehner. The All-American Girl, 1955, bronze. Private collection. Photograph courtesy of the Kraushaar Galleries, New York, and Dorothy Dehner Foundation for the Visual Arts.

Although prominent female sculptors had been relatively rare in previous periods, quite a number began to work during the modern era.

RUTH ASAWA (b. 1926) received her earliest lessons from several Japanese artists who had worked for Disney Studios when she was interned with them as a child along with her Japanese-American parents during World War II. Asawa has received major sculptural commissions, cofounded the Alverado School Art Workshop, and helped establish the School of the Arts—both in San Francisco. DOROTHY DEHNER (1901–94) was noted for her lyrical Abstract Expressionist wood and bronze totemic forms (Fig. 8-6) and BEVERLY STOLL PEPPER (b. 1924) constructs monumental, welded metal abstract sculptures for public sites. (Fig. 8-7) Additional innovators include SUE FULLER (b. 1914) and French-born GERMAINE RICHIER (1904–59).

The End of the 1950s

As the decade drew to a close, art was no longer a remote affair—an eager public now routinely sought out the hottest male celebrities in the artists' New York City Greenwich Village hangouts. Within this new climate, women strove to achieve the same acclaim as their male counterparts.

Contemporary Art: Into Their Own

The 1960s and 1970s: Decades of Radical Change and Upheaval

The nation's dramatic race to the moon and the innovations of computers, television, and atomic power were just some of the elements that revolutionized American society in the 1960s. The assassinations of Medgar Evers, the Reverend Martin Luther King, Jr., Malcolm X, President John F. Kennedy, Senator Robert F. Kennedy, Jr., and the Kent State killings of unarmed student protesters further threatened the country's sense of stability. Within this explosive atmosphere, many people struggled to define themselves in new ways and became involved in women's liberation, civil rights, anti-Vietnam protests, gay and lesbian rights groups, the Black Panthers, and the American Indian Movement.

The Sexual Revolution

The sexual revolution of the 1960s also had a profound effect on women's lives. When the Federal Drug Administration approved the birth control pill, sexuality and reproduction suddenly were separated. Consequently, many of the so-called baby boomers, then in their twenties, cast off their parents' values and explored their sensual selves, openly questioning Western society's definition of proper feminine conduct. Sexual liberation, however, also proved a double-edged sword for women because it once

again supported the notion of their ready availability to men, and those who chose not to meet a man's desires were frequently chastised. Additionally, according to one survey about sexuality, the 1970 Hite Report, females—but not males—were judged as immoral for participating in extramarital affairs.

Mainstream Art and American Female Artists in the Turbulent Age: Invisible No Longer

In the 1960s and early 1970s, only a handful of women participated in the dominant movements of *Pop Art*, which borrowed recognizable, media-derived imagery, or turned to *Minimalism*, with its "cool," unemotional geometric abstractions. The majority of female artists instead drew on their own roots and experiences as a basis for their work and, in so doing, played a meaningful role in shaping emerging styles.

At the same time, female artists, critics, and historians were shedding light on women's current and past creative accomplishments through exhibitions, catalogs, scholarly books, and feminist art history courses. They rallied against women's meager representation in galleries, museums, and survey books, many of which—after covering 50,000 years of art—rarely mentioned female creators.

New Styles for a New Era: A Feminist Slant

Feminist art directly addressed women's suppression and marginalization throughout Western history. The artists mentioned below reflect diverse styles, but shared the wish to raise political and social consciousness while validating their own experience.

The Body as Political Tool Women helped end Abstraction's reign by reintroducing the figure as legitimate subject matter. However, their

Birth of the Women's Liberation Movement
In 1969, a band of militant females picketed the Miss America Pageant and tossed bras, girdles, and other "girlie" items into the trash, rallying the cry of "women's liberation," a phrase that quickly entered the English language. On August 26, 1970, the fiftieth anniversary of woman suffrage, 50,000 females marched down New York City's Fifth Avenue. Eleanor Holms Norton, chair of the New York City Commission on Civil Rights, declared that women's rights would be the social movement of the 1970s, as civil rights was in the 1960s.

Fig. 8-7 Beverly Stoll Pepper's site-specific sculpture allows viewers literally to experience both the landscape and her artwork at once. Pepper reflects that she created this corporate commission "to bring people out of their offices and into an involvement with the site. It allows them to enter into it. To sit down or to walk, to be alone or in groups… to withdraw in silence."

Beverly Stoll Pepper. Amphitheater, 1976, concrete, 200 feet in length. Collection AT&T Corp. Courtesy of the André Emmerich Gallery.

Fig. 8-8 Which is the most important seat in Judy Chicago's *The Dinner Party?* There are thirteen places on each 48-foot arm of the equilateral triangle, an early symbol of female power and the sign of the goddess. The settings for the thirty-nine women, along with 999 additional names inscribed on the hand-cast tile floor below, commemorate ancient goddesses to twentieth-century heroines. Every porcelain plate reflects the specific achievements of the historical figure and is based on female sexual anatomy.

Judy Chicago. The Dinner Party, 1979, mixed media, 48' x 48' x 48'. © Judy Chicago, 1979. Photograph © Donald Woodman.

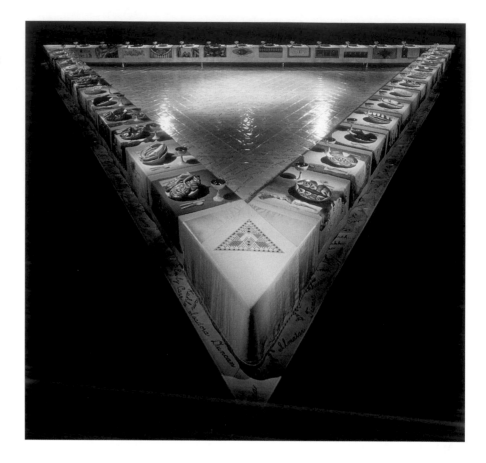

Women's Long Legal Battles
In 1973, the Supreme Court legalized women's access to abortion with its historic seven-to-two decision. However, the crucial Equal Rights Amendment, which first had been introduced to the United States Senate in 1923, never passed, dying in Congress in 1982.

decidedly female vantage point intentionally countered the traditional use of women's bodies as objectified sexual symbols. Artists called upon both their individual lives and feminine mythology to celebrate the dignity and power of female sexuality and fertility. As they began to integrate the private realm into the public artmaking arena, women embodied the feminist dictum that "the personal is political."

JUDY CHICAGO (b. 1934) used female sexual anatomy as the central imagery for each place setting in *The Dinner Party*, 1974–75, a monumental testament to women's cultural histories. (Fig. 8-8) The installation was constructed by a workshop of over 100 women. In addition, Chicago's incorporation of typically female "crafts" of china painting, ceramics, and needlework also promoted respect for female history and artistic production. Chicago explained the impetus for *The Dinner Party:* "And as long as women's achievements were excluded from our understanding of the past, we would continue to feel as if we had never done anything worthwhile."

Parisian-born NIKI DE SAINT PHALLE (b. 1930) constructed huge, exaggerated female figures that were some of the earliest pieces to joyously, and sometimes menacingly, contradict historical sexual stereotypes.

Sylvia Sleigh (n.d.), born in North Wales, overturned conventional gender roles when she depicted women artists painting passive male nude models. Cuban-born Ana Mendieta (1948–85) used her own body within the natural environment to create arresting images that represented how violence, ritual, and spirituality relate to women. (Fig. 8-9)

Political and Social Agendas By the late 1960s and early 1970s, unrecognized minorities, including African Americans, Native Americans, lesbians, gays, and senior citizens, began demanding a voice in mainstream society. Both female and male artists reflected the cultural conflicts that divided the United States, such as racism, sexism, and the military presence in Southeast Asia. Nancy Spero (b. 1926), for instance, dealt with the devastation and violence of war by using female figures to represent all victims, because "woman has had the status of victim 'par excellence' from time immemorial." (Fig. 8-10)

Explorations of Heritage Betye Saar (b. 1926) (Fig. 8-11) and her daughter Alison Saar (b. 1956), Faith Ringgold (b. 1930), Emma Amos (b. 1938), and May Stevens (b. 1924) were some of the first artists to articulate visually the rift between the white, male "American dream" and the daily reality for doubly oppressed women of color. These artists, as well as those foremothers mentioned in chapter seven (see "African-American Women Artists in the Early Avant-Garde," page 111), examined gender issues as they relate to class, economics, race, and history.

Fig. 8-9 What shape has Ana Mendieta dug into the earth? From 1973 to 80, Mendieta developed approximately 200 works that established "a dialogue between the landscape and the female body (based on my own silhouette)." She carved these solitary images into sand hillsides and modeled them out of mud and clay.

Ana Mendieta. Silueta (Silhouette) series in Mexico, 1973–78. *Color photograph documenting earth/body work with sand, water, and pigment, Salina Cruz, Mexico. © The Estate of Ana Mendieta. Courtesy of the Estate of Ana Mendieta and Galerie Lelong, New York.*

Fig. 8-10 How does Nancy Spero visually celebrate the ancient goddess of love and beauty as a strong, modern-day female? Her bold marks quickly draw our eye to the figure's leaps through the air. Spero often repeats an image throughout her work to suggest a continuous presence.

She wants "the past reverberating in the present.... I'm recovering the past through all kinds of images by women, from goddesses to victims."

Nancy Spero. Rebirth of Venus, detail, *1984, collage, handprinting on paper. Courtesy of the artist. Photograph by David Reynolds.*

Uncommon Materials: Three-dimensional Dialogues Many female sculptors avoided Minimalism's uninflected surfaces and clean, hard-edged geometric forms and instead turned to unusual materials. Sculptor LEE BONTECOU (b. 1931) employs industrial goods, fabricating large, rugged constructions from worn-out commercial-laundry conveyor belts sewn onto steel frames, which critics have compared to everything from airplane engines to female sexual anatomy. Canadian-born JACKIE WINSOR (b. 1941) and JACKIE FERRARA (b. 1929) rely largely on textured materials such as metal, cement, brick, saplings, plywood, rope, and nails to build powerful floor sculptures that remain economically abstract despite their recognizable material. EVA HESSE (1936–70) infused a disturbing sensuality into her limping, tangled artworks, which she made from an iconoclastic mix of industrial rope, latex, rubberized cheesecloth, clay, metal, and wire. Sadly, after having survived the horrors of Nazi Germany as a child, Hesse died as a result of a brain tumor as a young adult. (Fig. 8-12)

Fig. 8-11 How does Betye Saar undercut a single interpretation of African-American culture in her multimedia artwork? While the woman's picture and handkerchief seem to evoke the blood and sweat of African-American laborers, she also includes a piece of elegant black lace in the lower right to suggest the varied racial mixture and class diversity within African-American society. Throughout her long career, Saar has assembled found objects that speak of the pain and richness of African-American experience.

Betye Saar. Creole Lace, 1977, *collage on handkerchief. Collection of AT&T Corp. Courtesy of the artist.*

BARBARA CHASE-RIBOUD (b. 1936) incorporates influences from her own African heritage as well as those of Egyptian, Asian, and American cultures. Some of her best-known works are cast metal masks adorned with flowing natural fibers that hang down and suggest a supernatural presence. Chase-Riboud believes her sculpture demonstrates "the continuous relationship between the male and female elements" as the soft "feminine" fibers support the hard "masculine" metal forms above.

Born in Paris to Venezuelan parents, the artist MARISOL (Escobar) (b. 1930) moved to New York in 1950. Her large, painted-wood figurative works are sometimes linked to Pop Art, but she also is influenced by pre-Columbian art and early-American folk carving. NANCY GRAVES (1940–95) scoured science, nature, and industry to create impressive sculptures of metal, burlap, plastic, wax, and animal skins.

MAYA YING LIN (b. 1959) uses scale and geometric simplicity to establish the immediate impact of her *Vietnam Veterans Memorial*, 1982. Lin was still an undergraduate at Yale University when she won the national design competition, beating out more than 1,400 other entries. Her V-shaped black granite wall, set like a giant tomb or gravestone in the earth, carries the carefully incised name of each of the more than 56,000 Americans who lost their lives in Southeast Asia. Lin believes that her piece serves as a means of healing, as people search for and often physically touch the name of a loved one listed on the wall.

A Generation of Women Dealers
During the 1950s and 1960s, a large number of female art dealers emerged, including Terry Dintenfass, Ileana Sonnabend, Betty Parsons, Rose Fried, Joan Washburn, Bertha Schaffer, Grace Borgenicht, Antoinette Kraushaar, and Edith Gregor Halpert. In 1995, Dintenfass reflected on the early decades, saying, "I am not a feminist really, but in those days it was all right for a woman to be a dealer. It was ladylike, people thought. It's probably much less ladylike than anything you could think of." Still, this period was a gentler era, before poaching artists from rival galleries, complex legal contracts, or protracted lawsuits became the norm.

Fig. 8-13 Why would Deborah Butterfield title her work "Wickiup," the popular name for a domed or pointed bush shelter traditionally constructed by some Native American tribes in Nevada and Arizona?

She wrote about her art, "Many young children confuse the word 'horse' and 'house,' so I was playing with that idea. Also, as a former potter, I think all animate [living] beings are vessels for their spirits. With this piece I invite the viewer to figuratively crawl inside the horse to see what the world is like from another point of view."

Deborah Butterfield. Wickiup, 1991, *bronze sculpture. Collection AT&T Corp. Permission of the artist.*

Varying Perspectives
Deborah Butterfield states, "I think the purpose of figurative art is to help us develop empathy for others, and to step outside of our own, limited perceptions of reality."

No Longer Alone
Miriam Schapiro was delighted in the 1970s to find other females with whom to work and share ideas after the isolation she had encountered in the 1960s:

> **There were several interested and dedicated women artists in New York, but with them I had only "girl talk." The men would get together in studios to talk about their work. The women really didn't respect one another [or] care about my opinion.... [They only] wanted a man's opinion.**

DEBORAH BUTTERFIELD (b. 1949) is best known for her skeletonlike horses made from scrap metal, wire, tree branches, twigs, and clay. (Fig. 8-13) Sculpted war-horses usually carry esteemed generals. Instead, Butterfield constructed images of mares expecting foals, hoping that "in my own quiet way, I was making art against war—about the issue of procreation and nurturing rather than destruction."

Craft as Art: The Fabric Revolution In the 1970s, women wove magnificent textiles, challenging the art establishment's typical dismissal of the medium as "merely" craft or "low art" and its limited association to female cultural traditions.

Some women fiber artists abandoned the loom to knot, braid, twine, wrap, and crotchet, thus transforming their two-dimensional works into three-dimensional sculptures. LENORE TAWNEY (b. 1925) contributed technical innovations to construct monumental off-the-loom "woven forms" that raised the status of the art of weaving. (Fig. 8-14) CLAIRE ZEISLER (1903–91), SHEILA HICKS (b. 1934), and Polish artist MAGDALENA ABAKANOWICZ (b. 1930) also reject the division between craft and fine art.

Alternative Spaces: New Outlets for Exposure Women fought against their token representation in museums and galleries by establishing alternative exhibition spaces and collaboratives, activities that also challenged the increasing commercialization of the art world.

Artists such as ALICE AYCOCK (b. 1946), NANCY HOLT (b. 1938), MARY MISS (b. 1944), MICHELLE STUART (b. 1940), and Greek-born ATHENA TACHA (b. 1936) (Fig. 8-15) withdrew their work from the gallery

context. They literally expanded the boundaries of their exhibition sites by constructing earthworks and environmental pieces that incorporated outdoor landscapes into new, tactile experiences that required the viewer's physical participation.

Minimalist Tendencies: Post-Painterly Abstraction Some female artists in the late 1960s and early 1970s worked within Minimalism's clean-edged, geometric style, which eliminated Abstract Expressionism's intimate touch of the image maker and private, emotional subject matter.

AGNES MARTIN (b. 1912) foreshadowed the Minimalist movement with her exquisitely sensuous penciled grids that balance the individuality of her mark with the impersonality of a formal structure. One member of the first generation of Minimalists, JO BAER (b. 1929) explores a reduced vocabulary of forms, often pushing shapes to the outermost edges of her canvases. Canadian-born DOROTHEA ROCKBURNE (b. 1934) folds and bends colored paper into elegant constructions, while the British Op artist BRIDGET RILEY (b. 1931) devises hypnotic patterns solely with line, color, and shape. ALMA THOMAS (1892–1978) applied pure, unarticulated hues as a means of exploring the expressive quality of colors. (Fig. 8-16)

Revisiting Decorative Traditions Females inserted a political undertone to their abstract compositions when they turned to various decorative traditions for inspiration. By contradicting the negative association of these practices as "only women's work," they also honored centuries of anonymous, mostly female creators who had long been ignored by the art establishment.

Fig. 8-14 Are the spiritual qualities of Lenore Tawney's textile immediately understandable? She borrows the large warm-colored circle from Eastern religious traditions, which use the form to represent the integration of past and present. The tiny central black-and-white circle symbolizes the universal opposites of yin and yang, and the hanging linen threads throughout suggest spiritual lightness.

Lenore Tawney. Rose of Fire, *1980, canvas collage and linen strands. Philip Morris Companies Inc.*

Fig. 8-15 How does Athena Tacha tie her site-specific sculpture to its surroundings? She uses water, rocks, and concrete—all materials that exist in the Riverfront Park. Tacha stimulates a physical response in viewers by combining the strict geometry of her stacked concentric circles with the sensuous flow of the spouting water and scattered, roughly textured rocks.

Athena Tacha. Blair Fountain, *1982–83, concrete and rocks plus water jets. Riverfront Park, Tulsa, Oklahoma. Photograph by Athena Tacha.*

Fig. 8-16 Alma Thomas once said, "A world without color would seem dead. Color is life." How does Thomas' title relate to her abstract composition? The luminous patches spiral in concentric circles, conveying a sense of movement in space. In fact, Thomas was inspired to create this piece after watching the astronauts land on the moon in 1969.

Alma Thomas. Splashdown of Apollo Thirteen, n.d., acrylic on canvas. Collection AT&T Corp. Photograph by Manu Sassoonian.

A Renegade from the Start
Alice Neel once said, "I was born believing in feminism. I was born believing in art. My mother used to say, 'I don't know what you expect to do in the world, you're only a girl.' But if anything, that made me more anxious to do something."

MIRIAM SCHAPIRO (b. 1923) was a key instigator in this new movement. As early as the 1960s, she incorporated lace, fabric, sequins, and buttons into her abstract compositions, creating what she called *femmages*, sumptuous compositions that fused form and content. (Fig. 8-17) JOAN SNYDER (b. 1940) also added an intimate voice to her Abstract Expressionist paintings in the late 1960s. She sometimes cut, stuffed, or sewed portions of her canvas and attached wallpaper, textiles, wooden dowels, children's drawings, glitter, or newspaper photographs. In recalling the 1970s, Snyder reflected, "I believe that women artists pumped the blood back into the art movement.... At the height of the Pop and Minimal movements, we were making other art—art that was subjective, autobiographical, expressionist, narrative, and political—using words and photographs and as many other materials as we could get our hands on."

When a critic exclaimed to the Pattern and Design artist JOYCE KOZLOFF (b. 1942), "It looks just like embroidery," she instantly replied, "Good, that's just what it's supposed to look like." (Fig. 8-18) CYNTHIA CARLSON (b. 1942), LIA COOK (b. 1942), and VALERIE JAUDON (b. 1945) also have called upon American, European, Islamic, Celtic, Asian, and African decorative practices as their creative impetus.

Recovering Realism Some American artists in the 1970s returned to the representational world with a sharper eye than that of others before them. Women typically brought a heightened female sensitivity to the movement, alternately labeled Super-Realism, Photo-Realism, New Realism, or Hyper-Realism. ALICE NEEL (1900–84) painted unflinchingly honest portrayals of pregnant nudes and women of many races at various ages, whose unidealized, commonly naked bodies reveal their true inner qualities. (See page 110, "Government-Sponsored Programs.") (Fig. 8-19) AUDREY FLACK (b. 1931) fills her canvases to the brim with heavily laden vanity tables, displaying her delight in the minute beauty of the feminine world. (Fig. 8-20)

IDELLE WEBER (b. 1932) began as one of the few women Pop artists of the 1960s. She later became a leading Photo-Realist and sometimes made the refuse of New York City pavements her subject. Weber's ornate, decaying urban environments force viewers to contemplate the effects of modern industrial civilization. JANET FISH (b. 1938) shifts from realism to abstraction by moving in so closely to her still-life subjects that they dissolve into mesmerizing patterns. (Fig. 8-21) CAROLYN BRADY (b. 1937) also captures the subtle nuances of the observable, particularly feminine domain. In contrast, YVONNE JACQUETTE (b. 1934) creates overall abstract designs by portraying both urban and rural landscapes from distant, aerial perspectives.

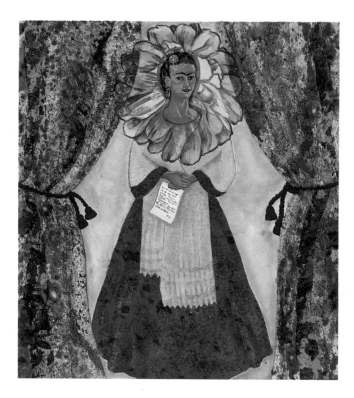

Fig. 8-17 Miriam Schapiro celebrates the Mexican painter Frida Kahlo. But how is her work different from Kahlo's *Self-portrait with Monkey and Parrot* (Fig. 7-16), painted in 1942? Schapiro created a "femmage"—a word she invented to describe a female version of collage. Can you detect where Schapiro incorporated fabric into her painting?

Miriam Schapiro. Presentation 1990, 1990, acrylic and fabric on canvas. © Miriam Schapiro. Collection Sarah Steinbaum. Courtesy of the Steinbaum Krauss Gallery, NYC.

Fig. 8-18 Why does Joyce Kozloff pose the question in her title and how does it relate to the print? Kozloff was one of the first artists to celebrate lush decorative patterns and designs, which the art establishment had historically considered of lesser value than figurative painting and sculpture.

Kozloff obtains her inspiration from architectural details, textiles, and other ornamentation frequently made by anonymous female creators.

Joyce Kozloff. Is It Still High Art?, 1979, lithograph. Collection AT&T Corp. Courtesy of the artist.

Fig. 8-19 How does Alice Neel's nude differ from traditional pictures of naked females? Neel focuses without embarrassment on a woman in the late stages of pregnancy and the transformation of her body. Neel's unidealized painting celebrates, but does not romanticize, this important event in a woman's life.

Alice Neel. Pregnant Woman, 1971, oil on canvas. © The Estate of Alice Neel. Courtesy of the Robert Miller Gallery.

Fig. 8-20 Audrey Flack paints each item in such detail that it seems as if we are looking through the eye of a camera. Flack was one of the first artists to use photography openly as a direct source of inspiration.

Although Flack works with a subject historically painted by females (see Figs. 3-6 and 3-7), she updates her still life by using a photorealistic technique and includes a plastic parrot which represents mass-produced objects that are popular in contemporary American society.

Audrey Flack. Parrots Live Forever, *1978, oil over acrylic on canvas. Courtesy of the Louis K. Meisel Gallery, New York.*

Fig. 8-21 What does it feel like to stare at Janet Fish's close-up view of everyday objects? Do you experience any sense of agitation? Fish once compared her painting to meditation. "You sit there with something very quiet. You are looking at it all day and you are constantly pushing through the thing you are looking at."

Janet Fish. Vinegar Bottles, *1972, oil on linen. Courtesy of The Collection of The Port Authority of New York and New Jersey, with permission by the artist. © Janet Fish.*

Street Art Starting in the 1970s, women painted huge, public murals that called attention to feminist themes, racial equality, and other potent issues. Artist collectives such as CITY-ARTS GROUP and MUJERES MURALISTAS were just a few precursors to the activist, New York City-based GUERRILLA GIRLS, whose members have made public appearances since 1985 wearing ape masks and costumes, marching outside of institutions that practice unjust policies toward all women and toward artists of color.

Performance and Video Art: Images in Motion Many females abandoned painting in the 1970s because of its associations with patriarchal values. Instead, they investigated how their bodies could be both the medium and subject matter in new forms referred to as Performance and Video Art. They culled autobiographical sources, ancient feminine spirituality, and political content to produce impressive pieces that combined visual art, theater, dance, music, poetry, and ritual. In 1977, SUZANNE LACY (b. 1945) and LESLIE LABOWITZ (b. 1946) staged a costumed event called *In Mourning and in Rage* on the steps of Los Angeles City Hall. The performance brought attention to the media's sensationalization of the city's wave of rapes and murders. Narrative and autobiography also infiltrate the multifaceted work of LAURIE ANDERSON (b. 1947) (Fig. 8-22) and ADRIAN PIPER (b. 1948). (Fig. 8-23)

Fig. 8-22 Laurie Anderson mixes together computer-generated music, human voice, dance movements, and mesmerizing background visuals to relate compelling, poetic, and often humorous stories. As a multimedia artist, Anderson produces videotapes, CD-ROMS, fine-art works, and audio recordings.

Laurie Anderson. The Nerve Bible Tour, 1995. *Photograph of Laurie Anderson performing. Courtesy of the artist.*

Fig. 8-23 What kind of mood do Adrian Piper's words and pose inspire? In the early 1970s, Piper walked through New York City streets dressed as an African-American man, outfitted in a huge Afro wig, bell-bottom pants, and dark sunglasses.

From her experiences, Piper created confrontational performances that expressed the anger or indifference she encountered when playing a stereotyped African-American male. Afterwards, Piper frequently created drawings about

her public performances, such as *It Doesn't Matter.*

Adrian Piper. It Doesn't Matter, 1975, *three oil crayon drawings on photographs. Courtesy of the John Weber Gallery, New York.*

Speeding Toward the Millennium

Art, Women, and Society in the 1980s and 1990s

A frightening backlash hit female artists and all artists of color in the
1980s, after the expansive pluralism of the preceding decade. Although
their earlier achievements had contributed to the founding of many new
styles for artists of both genders, ultimately it was the men who gained
substantial fame and fortune.

According to a mid-1980s economic report of the National
Endowment for the Arts, while 38 percent of practicing artists were
women, they made an average annual income less than half that of their
male peers. This downward trend has remained unchanged, regardless
of the fact that women represent nearly half the artistic community.
Despite ongoing barriers, female artists have made headway with museum
retrospectives, major gallery representation, widening critical attention,
and auction sales.

Art Boom and Bust

The art market boom of the 1980s reflected the period's general economic
prosperity. Waves of aggressive, upwardly mobile collectors—many more
concerned with investments than aesthetics—helped propel a small
number of young, primarily male artists to superstar status. Art was viewed
as money and a way of measuring power and wealth. However, astro-
nomic prices and skyrocketing careers came to an abrupt halt when the
stock market crashed in 1987.

Fig. 8-24 The deep-red hue of Jaune
Quick-to-See Smith's canvas alludes to
a special gift—that of traditional Native
people's attitude toward the planet.
"The earth does not belong to human-
kind; humankind belongs to the earth.
I grew up within this belief system and
was made aware of my surroundings as
though I were an environmentalist....
My paintings begin with a compressed
view of the land.... Over this...I paint
outlines, picto-forms of plant, animal,
and humans.... I include vessels—
traditionally used to store or save life-
giving things—as a plea to save the
environment."

Jaune Quick-to-See Smith. Gifts of Red
Cloth, 1989, oil on canvas. © Jaune
Quick-to-See Smith. Collection AT&T
Corp. Courtesy of the Steinbaum Krauss
Gallery, NYC.

The Female Vanguard:
Women Artists in the Late Twentieth Century

As the century draws to a close, females are active in all contemporary movements, which encompass photography, painting, collage, drawing, sculpture, installation, public art, performance pieces, and the brave new world of electronic online computer imaging. Some women address purely formal visual concerns while others express individual philosophical, political, or social interests. The sampling discussed below, along with the artists mentioned previously, have forged ahead at the end of the millennium.

Women of Color: Probing Cultural Identity Whereas female artists in earlier decades had explored their commonalities, women from diverse ethnic backgrounds now are examining the lasting influences of their unique cultural heritage and complex relationship to mainstream society. By celebrating their differences, these females have expanded their roles as leaders and healers while nurturing a broader dialogue for intercultural understanding and respect.

JAUNE QUICK-TO-SEE SMITH (b. 1940) is a North American Indian of Salish, Shoshone, and French Cree descent. She uses humor and political commentary to address issues of racism, sexism, government affairs, tribal politics, and the environment. Smith often juxtaposes traditional Native American imagery with insensitive mass-media advertising to develop eerie and poignantly beautiful paintings and prints. (Fig. 8-24) KAY WALKINGSTICK (b. 1935), of Cherokee and Winnebago heritage, uses expressionistic brushwork and abstract landscapes to create emotionally evocative artwork that makes Native American concerns about the land relevant to the population at large.

CARRIE MAE WEEMS (b. 1953) uses photography to investigate the spiritual, political, and family aspects of African-American culture. Her series often present intensely personal stories, sometimes accompanied by handwritten texts that capture the subtle emotional nuances of daily life. LORNA SIMPSON (b. 1960) commonly adds terse poetic phrases to her close-up, segmented photographs of African-American women. (Fig. 8-25)

HOWARDENA DOREEN PINDELL (b. 1943) has been an activist antiracist artist, writer, speaker, and organizer since 1979. Her tactile, mixed-media works, composed of pieces of unstretched canvas stitched together and decorated with bits of colored paper, hair, string, glitter, talcum powder, and the like, are as richly intricate as is her African, Seminole, French, British, German, Christian, and Jewish background. PHILEMONA WILLIAMSON (b. 1951) paints perplexing compositions of African-American children involved in undefinable, provocative activities. (Fig. 8-26)

Fig. 8-25 How does Lorna Simpson use this nonfigurative piece to explore issues of sexuality and race?

The wall text reads: "It is late, decided to have a quick nightcap at the hotel having checked in earlier that morning. Hotel security is curious and knocks on the door to inquire as to what's going on, given our surroundings we suspect that maybe we have broken 'the too many dark people in the room code.' More privacy is attained depending on what floor you are on, if you are in the penthouse suite you could be pretty much assured of your privacy, if you were on the 6th or 10th floor there would be a knock on the door."

Lorna Simpson. The Bed, 1995, serigraph on four felt panels with felt text panel. Courtesy of Sean Kelly, New York.

Fig. 8-26 Can you make out exactly what is occurring here despite Philemona Williamson's recognizable objects? Aren't these children a bit old to be playing under a table? They seem to be looking out at us with a somewhat guilty stare. And what do the oddly colored, lively fish on top of the table have to do with the work's meaning?

Williamson intentionally raises more questions than she answers, paralleling the awkward transition from childhood to adolescence.

Philemona Williamson. First Flush of Fish, *1990, oil on linen. Collection AT&T. Courtesy of the artist, represented by the June Kelly Gallery, New York City.*

Fig. 8-27 How would you describe the mood of this rather high-class woman? Hung Liu literally boxes her in with real gold-leaf tables and ceramic bowls. She is perched passively on a seat as an object for men's pleasure and unable to do much for herself. She must hold the fan carefully because of her long, manicured nails. Her tiny bound feet make it nearly impossible to walk. The woman's complacent expression further communicates her physical, psychological, and spiritual enslavement.

Hung Liu. Sepia 1900, *1990, oil on canvas, wood, gold leaf, ceramic bowls. © Hung Liu. Collection AT&T. Courtesy of the Steinbaum Krauss Gallery, NYC.*

DEVELOPMENT OF SUBURBIA

In 1968, HUNG LIU (b. 1948) and thousands of Chinese students, intellectuals, and artists were forced by the Maoist government to work as farm laborers during the Cultural Revolution. Liu has lived in the United States since 1984, and in her work she continues to mine historical depictions of Chinese females as a means of expressing her rage and pain at both the distant and more recent oppressions perpetrated within her native land. (Fig. 8-27)

The Latina artist and activist JUDITH BACA (b. 1949) has organized local residents, especially city youth, to help paint socially conscious public murals that refer to the various cultures that have forged California's history. Baca believes that art is a means of healing: "For me the process of making art is the transforming of pain. First there's rage, below that rage is indignation, below that indignation is shame, below that hope and at its corniest base, love." (Fig. 8-28)

The Abstract-Realist Link: Neo-Expressionism and New Image Painting

After the mid-1970s, scores of young artists discarded Minimalism's pared-down abstraction and returned to the world around them for inspiration. Unlike the immediately recognizable subjects of earlier Realists, this younger generation painted distinctive images in heavily worked canvases that reflected their strong interest in the process of making art itself. The

Fig. 8-28 In 1976, Judith Baca began teaming up with high-school students from the Summer Program for Disadvantaged Youth and the Juvenile Justice Program to create the *Great Wall of Los Angeles*. The mural depicts the histories of the city's diverse populations on the cement wall lining the Tujunga Wash. It was the students, rather than Baca, who made decisions about the imagery, giving them a sense of power and identity as they helped shape the enormous project, which took years to complete.

Judith F. Baca and a crew of thirty youths, seven artist supervisors, and muralists. Development of Suburbia, section of the Great Wall of Los Angeles, 1976–83. © SPARC.

Fig. 8-29 What is Susan Rothenberg's true subject matter if it isn't the horse itself? Rothenberg is fascinated with mark making. In fact, although she began painting horses in 1973, the inspiration came from abstraction. "I drew a line down the middle [of the canvas] and before I knew it, there was half a horse on either side."

Susan Rothenberg. Untitled (Horse Embryo), 1979, *acrylic, gesso and graphite on paper. Collection PaineWebber Group Inc. Permission of the artist.*

resulting pieces frequently walk a fine line between realism and abstraction. SUSAN ROTHENBERG (b. 1945) typically floats an unanchored image in a mysterious, agitated, single-toned background. (Fig. 8-29) ELIZABETH MURRAY (b. 1940), KATHERINE PORTER (b. 1941), and PAT STEIR (b. 1938) (Fig. 8-30) also paint in a similar expressive, semiabstract manner.

Narrative For centuries, Western women have fashioned art that tells stories. Recently, their tales have become both more intimate and elusive. LAURIE SIMMONS (b. 1949) photographs perplexing, surreal, dreamlike images of object-and-doll-leg figures topped with miniature items, such as homes, hourglasses, and watches, that offer multiple meanings about female roles and the mind-body relationship. BEVERLY BUCHANAN (b. 1940) paints and constructs unusual shacks, which evoke the poverty of her home state's rural poor as well as their spirited dignity. GLADYS NILSSON (b. 1940) was a leading member of the Chicago Imagist school, whose artists typically created funky, agressive, sometimes sexual imagery. CANDIDA ALVAREZ (b. 1955) obtains inspiration from her own Puerto Rican heritage as well as her knowledge of pre-Columbian, African, and modern Western art to create enigmatic often allusive works. (Fig. 8-31)

Persistence of the Natural World SYLVIA MANGOLD (b. 1938), PATRICIA TOBACCO FORRESTER (b. 1940), and SUSAN SHATTER (b. 1943) (Fig. 8-32) are artists working in the Realist mode who bring a sensitive eye to nature and provide an indispensable respite from the modern urban environment.

The Nineties Art Market

In 1996, women and minority artists continued to grow in number as younger dealers, who had grown up with the women's and black liberation movements, entered the field. Yet, according to an informal *New York Times* poll of sixty-two galleries, only nine dealers represent at least one black female, and merely three represent more than one.

Fig. 8-30 Pat Steir establishes direct communication with three very different artists from the past by roughly quoting their painting styles in her successive rows of cresting waves. From top to bottom is the late-fifteenth-century Italian Renaissance artist Leonardo da Vinci, the early-nineteenth-century Japanese printmaker Katsushika Hokusai, and the late-nineteenth-century French painter Gustave Courbet. Although Steir bases her print on a recognizable subject, the wave's repetition and Steir's gestural marks simultaneously push the boundaries of realism toward abstraction.

Pat Steir. The Wave—From the Sea—After Leonardo, Hokusai, and Courbet, *1985, color etching. Collection AT&T Corp.*

Fig. 8-31 What title would you give this work? Candida Alvarez's words and composition are a jumping-off point for each viewer's imagination. However, she feels that it is most important "to try and make honest pictures and be truthful." Alvarez continues, "My work comes out of reality and personal experience. It is not a dreamscape."

Candida Alvarez. Three Girls Dancing in the Woods, *1986, acrylic on paper. Collection AT&T Corp. Courtesy of the June Kelly Gallery.*

The Continuing Three-dimensional Dialogue: Sculpture Women, like their male peers, are expanding the media, scale, and content of traditional sculpture. JUDY PFAFF (b. 1946) assembles miscellaneous urban debris and manufactured objects and turns them into rowdy, often eloquent three-dimensional works. By painting many of her forms, Pfaff develops the illusion of weightlessness that counters the materials' true weight. (Fig. 8-33) LYNDA BENGLIS (b. 1941) expresses emotional states through abstract, oozing, polyurethane amoebalike forms and oversized painted "knots," "folds," and "blobs." KIKI SMITH (b. 1954) works with forms of the human body as a political battleground to address racial and sexual discrimination, abortion, and AIDS.

Fig. 8-32 What sensation do you feel looking at Susan Shatter's canvas? She intensifies the feeling of "vertigo," or dizziness, by placing us right at the canyon's edge, peering far down to the scene below. The streaming veins of violet, red, and yellow paint that flow down the cliff's surface further heighten the drama.

Susan Shatter. Vertigo Black Canyon, *1983, oil on canvas. Collection AT&T Corp. Permission of the artist.*

Fig. 8-33 How does Judy Pfaff evoke the underwater world? Her glass, tar, and metal ooze and swirl in front of us in space as though we are encountering this wet botanical scene on a scuba-diving trip. Yet, ultimately, she wants her art not to imitate the natural world exactly, but "to shake people up…. Life isn't soothing—it's disquieting…. I am interested in opening up the language of sculpture as far and as wide as I can in terms of materials, colors, and references and in trying to include all things that are permissible in painting but absent in sculpture."

Judy Pfaff. Hydroza, 1994. *Mixed media (tar, resin, fiberglass, steel). Courtesy of the André Emmerich Gallery. Photograph by Kevin Ryan.*

Installation and Multiple-Media Art Jennifer Bartlett (b. 1941) produces virtuoso room-size installations that distill immense quantities of visual information into small, manageable, bite-size chunks of marks, dots, and strokes. In her first major installation, the 153-foot *Rhapsody*, 1975–76, Bartlett completely engulfed the gallery walls with 988 one-foot-square variations of the same house, tree, mountain, and ocean. She silkscreened each enamel twelve-inch plate with a grid that contained 2,304 tiny cells of information. (Fig. 8-34)

Sandy Skoglund (b. 1946) collapses fact and fiction in large, lushly colored photographs that document her elaborate handmade, idiosyncratic tableau installations. Skoglund's sculpted and painted environments are both the subjects of her photographs and discrete artworks themselves.

Critiquing Mass Culture: Manipulation and Appropriation Art in the Information Age Numerous artists have responded to the constant bombardment of visual media infiltrating contemporary society by incorporating it into their work.

Sarah Charlesworth (b. 1947), Louise Lawler (n.d.), Sherrie Levine (b. 1947), and Cindy Sherman (b. 1954) (Fig. 8-35) are second-generation feminists who directly quote or refer to existing fine-art and mass-culture images to expose the rampant societal reinforcement of

Fig. 8-34 How do you think Jennifer Bartlett's statement relates to one of her earliest installations? "I always told everyone I wanted to be an artist. And I kept doing repetitive things. When I saw Disney's [movie] *Cinderella* I made about five hundred drawings of Cinderella with a different trim on every one of her dresses. Or I'd buy lots of those fuzzy chickens you get on Easter and divide them up by color and put them in pens according to color.... Anything to do with organization."

Jennifer Bartlett. Rhapsody, 1975–76, enamel, silkscreen, baked enamel on steel plates. 988 12" x 12" plates. Installation: Paula Cooper Gallery 1976. Private Collection. Courtesy of the Paula Cooper Gallery. Photograph by Geoffrey Clements.

Fig. 8-35 Cindy Sherman uses a variety of props and costumes to transform her own body. Her resulting images expose the artificiality of the way women have been depicted throughout history.

What are the major differences between Sherman's color photograph and Artemisia Gentileschi's oil painting *Judith and Holofernes* (Fig. 2-19)? Gentileschi's earlier Baroque piece is far more graphic, but Sherman's deliberately artificial work alerts us to the limited ways in which females have been portrayed in the past.

Cindy Sherman. Untitled, 1990, color photograph. Courtesy of the artist and Metro Pictures.

female stereotypes. JENNY HOLZER (b. 1950) and BARBARA KRUGER (b. 1945) (Fig. 8-36) apply slogans to "found" or fabricated commercial images. Their superimposition of words over media images reveals advertising's hidden messages. By closely imitating and yet altering advertisements, these women expose the presumably benign, anonymous voice behind such imagery and its underlying statements about gender, sex, violence, and capitalism. Furthermore, by deliberately appropriating pre-existing motifs, many of these artists are confronting the all too frequently unchallenged value of originality held dear by the art establishment.

Creative Heroines: Past, Present, and Future

Females have been inventive artists since the beginning of human history. They have made significant gains in numerous areas, even in the face of ongoing societal, institutional, educational, and economic discrimination. Today, countless feisty, pioneering spirits still pursue their passion and shine a light on earlier cultural heroines. Ultimately, their combined efforts ensure that future generations will increasingly honor women's unique and richly varied creative expressions.

Fig. 8-36 How do Barbara Kruger's words affect her image? Although the woman's picture evokes earlier, pre-feminist advertising, Kruger's sentence converts the piece into a biting contemporary commentary that rejects conventional female roles and obligations. Kruger uses text to illustrate how language expresses a culture's ideas and values.

Barbara Kruger. "Untitled" It's a small world but not if you have to clean it, 1990, photographic silkscreen and vinyl. Collection Museum of Contemporary Art, Los Angeles. Courtesy of the Mary Boone Gallery, New York.

Selected Bibliography

Titles with * are particularly appropriate for young readers.

General References

Albers, Anni. *On Weaving.* Middletown, CT: Wesleyan University Press, 1965.

Anonymous Was a Woman: A Documentation of the Women's Art Festival, with Letters to Young Women Artists. Valencia, CA: Feminist Art Program, California Institute of the Arts, 1974.

ARTnews 69 (January 1971). Entire issue devoted to women artists.

Bachmann, Donna G., and Sherry Piland. *Women Artists: An Historical, Contemporary and Feminist Bibliography.* Metuchen, NJ: Scarecrow Press, Inc., 1978.

Bank, Mirra. *Anonymous Was a Woman: A Celebration in Words and Images of Traditional American Art and the Women Who Made It.* New York: St. Martin's Press, 1979.

Berkeley, Ellen Perry, and Matilda McQuaid, eds. *Architecture: A Place for Women.* Smithsonian Institution, Washington, DC, 1989.

Bishop, Robert, William Secord, and Judith Reiter Weissman. *Quilts, Coverlets, Rugs and Samplers.* New York: Alfred A. Knopf, 1982.

Brouder, Norma, and Mary D. Gerrard, eds. *Feminism and Art History—Questioning the Litany.* New York: Harper and Row, 1982.

Chadwick, Whitney. *Women, Art, and Society.* London: Thames and Hudson, 1990.

Chiarmonte, Paula L., ed. *Women Artists in the United States: A Selective Bibliography and Resource Guide on the Fine and Decorative Arts, 1750–1986.* Boston: G. K. Hall, 1990.

Collins, Georgia, and Renee Sandell. *Women, Art, and Education.* Reston, VA: National Art Education Association, 1984.

Collins, Jim L. *Women Artists in America: Eighteenth Century to the Present.* 2 vols. Chattanooga, TN: University of Tennessee, 1973 and 1975.

Dewhurst, C. Kurt, et al. *Artists in Aprons: Folk Art by American Women.* New York: E. P. Dutton and the Museum of American Folk Art, 1979.

Epstein, Vivian Shedson. *History of Women Artists for Children.* Denver: VSE Publisher, 1987.*

Fine, Elesa Honig. *Women and Art: A History of Women Painters and Sculptors from the Renaissance to the Twentieth Century.* Montclair, NJ: Allanheld, Osmun and Co. Publishers, Inc., 1978.

Gerdts, William H. *Women Artists of America, 1701–1964.* Newark, NJ: The Newark Museum, 1965.

Greer, Germaine. *The Obstacle Race: The Fortunes of Women Painters and Their Work.* New York: Farrar Straus Giroux, 1979.

Harris, Ann S., and Linda Nochlin. *Women Artists, 1550–1950.* New York: Alfred A. Knopf, 1976.

Hedges, Elaine, and Ingrid Wendt, eds. *In Her Own Image, Women Working in the Arts.* Old Westbury, NY: Feminist Press; New York: McGraw Hill, 1980.

Heller, Nancy G. *Women Artists: An Illustrated History.* New York: Abbeville Press Publishers, 1987.

Hess, Thomas B., and Elizabeth Baker. *Art and Sexual Politics: Women's Liberation, Women Artists and Art History.* New York: Macmillan, 1973.

Kiracofe, Roderick, with Mary Elizabeth Johnson. *The American Quilt: A History of Cloth and Comfort, 1750–1950.* New York: Clarkson Potter Publishers, 1993.

Kirkland, Winifred Margaretta, and Frances. *Girls Who Became Artists.* Freeport, NY: Books for Libraries Press, 1967.

La Duke, Betty. *Compañeras: Women, Art, and Social Change in Latin America.* San Francisco: City Lights Books, 1985.

———. *Africa: Through the Eyes of Women Artists.* Trenton, NJ: Africa World Press, Inc., 1991.

———. *Women Artists: Multicultural Visions.* Trenton, NJ: Red Sea Press, Inc., 1992.

Lerner, Gerda. *The Majority Finds Its Past: Placing Women in History.* New York: Oxford University Press, 1979.

Lewis, Samella. *African American Art and Artists.* Berkeley: University of California Press, 1990.

Lippard, Lucy R. *From the Center: Feminist Essays on Women's Art.* New York: E. P. Dutton, 1976.

———. *Overlay: Contemporary Art and the Art of Prehistory.* New York: Pantheon Press, 1983.

Lyle, Cindy, Sylvia Moore, and Cynthia Navaretta, eds. *Women Artists of the World.* New York: Midmarch Associates, 1984.

Munro, Eleanor. *Originals: American Women Artists.* New York: Simon and Schuster, 1979.

Muntersterberg, Hugo. *A History of Women Artists.* New York: Clarkson N. Potter, 1975.

National Museum of Women in the Arts. Collection catalog. New York: Harry N. Abrams, 1987.

Nesmer, Cindy. "Art Criticism and Women Artists." *The Journal of Aesthetic Education* 73 (July 1973): 73–83.

Nochlin, Linda. "Why Are There No Great Women Artists?" in *Women in Sexist Society: Studies in Power and Power Lessons.* Edited by Vivian Gornick and Barbara Moran. New York: Basic Books, 1971.

———. *Women, Art, and Power and Other Essays.* New York: Harper and Row Publishers, 1988.

Old Mistresses, Women Artists of the Past. Exhibition catalog. Baltimore: Walters Art Gallery, 1972. Also *The Walters Art Gallery Bulletin* 24 (April 1972).

Orlofsky, Patsy and Myron. *Quilts in America.* New York: McGraw Hill, 1974.

Parker, Rozsika, and Griselda Pollock. *Old Mistresses: Women, Art and Ideology.* New York: Pantheon Books, 1981.

Petersen, Karen, and J. J. Wilson. *Women Artists: Recognition and Reappraisal from the Early Middle Ages to the Twentieth Century.* New York: Harper Colophon Books, 1976.

Petteys, Chris. *Dictionary of Women Artists: An International Dictionary of Women Artists Born Before 1900.* Boston: G. K. Hall, 1985.

Raven, Arlene, Cassandra L. Langer, and Joanna Frueh. *Feminist Art Criticism: An Anthology.* Ann Arbor, MI: UMI Research Press, 1988.

Rosenblum, Naomi. *A History of Women Photographers.* New York: Abbeville Press Publishers, 1994.

Rubinstein, Charlotte Streifer. *American Women Artists: From Early Indian Times to the Present.* New York: Avon Books, 1982.

———. *American Women Sculptors: A History of Women Working in Three Dimensions.* Boston: G. K. Hall, 1990.

Slatkin, Wendy. *Women Artists in History: From Antiquity to the Twentieth Century*. Englewood Cliffs, NJ: Prentice Hall, 1990.

Sullivan, Constance. *Women Photographers*. New York: Harry N. Abrams, 1990.

Torre, Susana, ed. *Women in American Architecture: A Historic and Contemporary Perspective*. New York: Whitney Library of Design and Watson-Guptill Publications, 1977.

Tufts, Eleanor. *American Women Artists: Past and Present, Volume II: A Selected Bibliographical Guide*. New York and London: Garland Publishers, Inc. 1989.

———. *American Women Artists: A Selected Bibliographic Guide, Volume I*. New York and London: Garland Publishers, Inc. 1984.

———. *Our Hidden Heritage: Five Centuries of Women Artists*. New York: Paddington Press, Ltd, 1974.

Weissman, Judith, and Wendy Lavitt. *Labors of Love: America's Textiles and Needlework, 1650–1930*. New York: Alfred A. Knopf, 1987.

Women of Photography: A Historical Survey. San Francisco: Museum of Art, 1975.

Zimmerman, E. "Women Also Created Art." *Art Education* 34, no. 3 (1981): 5.

Prehistoric Through Seventeenth Century

Carr, Annemaire Weyl. "Women Artists in the Middle Ages." *Feminist Art Journal* 5, no. 1 (Spring 1976): 5–9, 126.

Garrard, Mary D. *Artemisia Gentileschi: The Image of the Female Hero in Italian Baroque Art*. Princeton, NJ: Princeton University Press, 1989.

Lesko, Barbara. *The Remarkable Women of Ancient Egypt*. Berkeley: BC Scribe Publications, 1978.

Miner, Dorothy. *Anastaise and Her Sisters: Women Artists of the Middle Ages*. Baltimore: Walters Art Gallery, 1974.

Perlingieri, Ilya Sandra. *Sofonisba Anguissola: The First Great Woman Artist of the Renaissance*. New York: Rizzoli International Publications, Inc., 1992.

Ragg, Laura M. *The Women Artists of Bologna*. London: Methuen and Co., 1907.

Robbins, Gay. *Women in Ancient Egypt*. Cambridge, MA: Harvard University Press, 1993.

Tolnay, Charles de. "Sophonisba Anguissola and Her Relations with Michelangelo." *Journal of the Walters Art Gallery* 4 (1941): 115–19.

Turner, Jonathan. "Artemisia's Hour." *ARTnews* 90, no. 9 (November, 1991): 24.

Eighteenth and Nineteenth Centuries

American Women Artists, 1830–1930. Exhibition catalog. Washington, DC: The National Museum of Women in the Arts, 1987.

Ashton, Dore, and Denise Brown Hare. *Rosa Bonheur: A Life and a Legend*. New York: Viking Press, 1981.

Bontemps, Arna, et al. *Forever Free: Art by African-American Women, 1867–1980*. Normal, IL: Beacon Press, 1980.

Callen, Athena. *Women Artists: Arts and Crafts Movement, 1870–1917*. New York: Pantheon Books, 1979.

Dunford, Penny. *A Biographical Dictionary of Women Artists in Europe and America Since 1850*. Philadelphia: University of Philadelphia Press, 1989.

Fry, Gladys-Marie. *Stitched from the Soul: Slave Quilts from the Antebellum South*. New York: Dutton Studio Book and Museum of American Folk Art, 1990.

Garb, Tamar. *Women Impressionists*. New York: Rizzoli International Publications, Inc., 1986.

Gerard, Frances A. *Angelica Kauffmann: A Biography*. London: Ward and Downey, 1893. New edition, Macmillan.

Higonnet, Anne. *Berthe Morisot's Images of Women*. Cambridge, MA: Harvard University Press, 1992.

———. *Berthe Morisot*. New York: Rizzoli International Publications, Inc., 1993.

Hunter, Wilbur H., and John Mahey. *Miss Sarah Miriam Peale, 1800–1950*. Baltimore: Peale Museum, 1967.

Marsh, Jan, and Pamela Gerrish Nunn. *Women Artists and the Pre-Raphaelite Movement*. London: Virago Press, 1989.

Mayer, Dorothy Moutlon. *Angelica Kauffmann, R.A., 1741–1807*. Gerards Cross, England: Colin Smythe, 1972.

Meyer Susan E. *Mary Cassatt*. New York: Harry N. Abrams, 1991.*

National Collection of Fine Arts. *Lilly Martin Spencer, 1822–1902: The Joys of Sentiment*. Exhibition catalog. Washington, DC: Smithsonian Institution Press, 1973.

Sheriff, Mary D. *The Exceptional Woman: Elisabeth Vigée-Lebrun and the Cultural Politics of Art*. Chicago: The University of Chicago Press, 1995.

Strachey, Lionel, trans. *Memoirs of Madame Vigée-Lebrun*. New York: George Brazille, Inc., Publishers, 1989. (Originally published 1903 by Doubleday, Page and Company.)

Turner, Robyn Montana. *Rosa Bonheur*. Boston: Little, Brown and Company, 1991.*

The White Marmorean Flock, Nineteenth Century American Women Neoclassical Sculptors. Exhibition catalog. Poughkeepsie, NY: Vassar College Art Gallery, 1972.

Twentieth Century

Albers, Anni. *On Weaving*. Middletown, CT: Wesleyan University Press, 1965.

Alma Thomas: Retrospective Exhibition. Washington, DC: Corcoran Gallery of Art, 1972.

American Women Artists, 1830–1930. Exhibition catalog. Washington, DC: The National Museum of Women in the Arts, 1987.

Ball, Jacqueline A., and Catherine Conant. *Georgia O'Keeffe: Painter of the Desert*. New York: Blackbirch Press, 1991.*

Baruch College Gallery and Fine Arts Center. *Women Artists of the Surrealist Movement*. Stony Brook: State University of New York, 1987.

"Becker: A Short, Creative Life." *American Artist* 37 (June 1973): 16–23.

Berman, Avis. "Women Artists 1980: A Decade of Progress, But Could a Female Chardin Make a Living Today?" *ARTnews* 79 (October 1980): 73–79.

Bishop, Isabel. *Isabel Bishop*. New York: Harry N. Abrams, 1975.

Bober, Natalie S. *Breaking Tradition: The Story of Louise Nevelson*. New York: Atheneum, 1984.*

Bontemps, Arna, et al. *Forever Free: Art by African-American Women, 1867–1980*. Normal, IL: Beacon Press, 1980.

Broude, Norma, and Mary D. Garrard. *The Power of Feminist Art: The American Movement of the 1970s*. New York: Harry N. Abrams, 1994.

Brown, Betty Ann, and Arlene Raven. *Exposures: Women and Their Art*. Pasadena, CA: New Sage Press, 1989.

Castro, Jan Garden. *The Art and Life of Georgia O'Keeffe.* New York: Crown Publishers, 1985.

——. *Women Artists and the Surrealist Movement.* Boston: Little, Brown and Company, 1985.

Chadwick, Whitney, and Isabelle de Courtivron, eds. *Significant Others: Creativity and Intimate Partnership.* London: Thames and Hudson, 1993.

Chicago, Judy. *The Dinner Party: A Symbol of Our Heritage.* Garden City, NY: Anchor Press/Doubleday, 1979.

——. *Through the Flower: My Struggle as a Woman Artist.* New York: Doubleday, 1975.

Collischan van Wagner, Judy K. *Women Shaping Art: Profiles of Power.* New York: Praeger, 1984.

Contemporary American Women Artists: Featuring the Work and Words of Twenty-four Prominent Artists. San Rafael, CA: Cedco, 1991.

Daffron, Carolyn. *Margaret Bourke-White.* New York: Chelsea House, 1988.*

Dunford, Penny. *A Biographical Dictionary of Women Artists in Europe and America Since 1850.* Philadelphia: University of Philadelphia Press, 1989.

Fowler, Carol. *Contributions of Women: Art.* Minneapolis: Dillon Press, Inc., 1976.*

Gherman, Beverly. *Georgia O'Keeffe: The "Wideness and Wonder" of Her World.* New York: Antheneum Publishers, 1986.*

Glueck, Grace. "At the Whitney It's Guerilla Warfare." *New York Times,* December 12, 1970: 22.

Goldberg, Vicki. *Margaret Bourke-White: A Biography.* New York: Harper and Row, 1986.

Guerrilla Girls (Whoever They Really Are). *Confessions of the Guerrilla Girls.* New York: HarperPerennial, 1995.

Hall, Robert L. *Gathered Visions: Selected Works by African American Women Artists.* Washington, DC: Smithsonian Institution, 1992.

Henkes, Robert. *The Art of Black American Women: Works of Twenty-four Artists of the Twentieth Century.* Jefferson, NC and London: McFarland and Company, Inc., Publishers, 1993.

Jones, Virginia Watson. *Contemporary American Women Sculptors.* Phoenix: Oryx, 1986.

Klein, Mina C., and H. Arthur. *Käthe Kollowitz: Life in Art.* New York: Holt, Rinehart and Winston, 1972.

La Duke, Betty. *Compañeras: Women, Art, and Social Change in Latin America.* San Francisco: City Lights Books, 1985.

——. *Africa: Through the Eyes of Women Artists.* Preface by Elizabeth Catlett. Trenton, NJ: Africa World Press, Inc., 1991.

——. *Women Artists: Multicultural Visions.* Trenton, NJ: Red Sea Press, Inc., 1992.

Larson, Kay. "For the First Time Women Are Leading Not Following." *ARTnews* 79 (October 1980): 64–72.

Lauter, Estella. *Women as Mythmakers: Poetry and Visual Art by Twentieth Century Women.* Bloomington: Indiana University Press, 1984.

Miller, Donald. "The Timeless Landscapes of I. Rice Pereira." *Arts Magazine* (October, 1978).

Miller, Lynn F., and Sally S. Swenson. *Lives and Works: Talks with Women Artists.* Metuchen, NJ: Scarecrow Press, Inc., 1981.

Moses, Anna Mary Robertson. *My Life's History.* Edited by Otto Kallir. New York: Harper and Row, 1952.

Nagel, Otto. *Käthe Kollwitz.* Greenwich, CT: New York Graphic Society, 1971.

Nemser, Cindy. *Art Talk: Conversations with Twelve Women Artists.* New York: Charles Scribner's Sons, 1975.

O'Keeffe, Georgia. *Georgia O'Keeffe.* New York: Viking Press, 1976.

O'Kelley, Mattie Lou. *From the Hills of Georgia: An Autobiography in Paintings.* Boston: Little, Brown and Company, 1983.*

Perry, Regenia. *Free Within Ourselves: African-American Artists in the Collection of the National Museum of American Art.* Washington, DC: National Museum of American Art, Smithsonian Institution, 1992.

Prelinger, Elizabeth. *Käthe Kollwitz.* Washington, DC: National Gallery of Art, 1992.

Reflective Moments: Lois Mailou Jones. Exhibition catalog. Essay by Edmund Barry Gaither. Boston: Museum of Fine Arts, 1973.

Rose, Barbara. *Frankenthaler.* rev. ed. New York: Harry N. Abrams, 1974.

Rosen, Randy, and Catherine C. Brawer. *Making Their Mark: Women Artists Move into the Mainstream, 1970–85.* New York: Abbeville Press Publishers, 1989.

Roth, Moira. *The Amazing Decade: Women and Performance Art in America, 1970–1980.* Los Angeles: Astro Artz, 1983.

Russian Women Artists of the Avant-Garde, 1910–1930. Cologne, Germany: Galerie Gmurzynska, 1979.

Russo, Alexander. *Profiles on Women Artists.* Frederick, MD: University Publications of America, Inc. 1985.

Sill, Leslie. *Inspirations: Stories About Women Artists.* Morton Grove, IL: Albert Whitman and Company, 1989.*

——. *Visions: Stories About Women Artists.* Morton Grove, IL: Albert Whitman and Company, 1993.*

Waller, Susan. *Women Artists in the Modern Era: A Documentary History.* Metuchen, NJ: Scarecrow Press, Inc., 1991.

Watson-Jones, Virginia. *Contemporary American Women Sculptors.* Phoenix: Oryx, 1986.

Yablonskia, M. *Women Artists of Russia's New Age, 1900–1935.* New York: Rizzoli International Publications, Inc., 1990.

Yglesias, Helen. *Isabel Bishop.* New York: Rizzoli International Publications, Inc., 1989.

Young, Louis, ed. *The Decade Show.* New York: Museum of Contemporary Hispanic Art, The New Museum of Contemporary Art, The Studio Museum in Harlem, 1990.

Media Resources

Film/Videotape

Anonymous Was a Woman. Chicago Films, Inc. 1977, 30 min., videotape. Survey of artwork and handicraft by American women in the eighteenth and nineteenth centuries.

The Artist Was a Woman. 1981, 58 min., 16 mm. Four hundred years of paintings by women from the early Renaissance to 1950.

Betye and Alison Saar Conjure the Women of the Arts. 28 min. Available from L&S Video Enterprises, 45 Stornowaye, Chappaqua, NY 10514, (914) 238-9366; fax (914) 238-6324; E-mail: VideoPaint@aol-com.

Dorothea Lange: Closer for Me. 30 min. Available through Museum Modern Art, Department of Education, Teaching Information Center, 11 West 53rd St., New York, NY 10019, (212) 708-9864.

Eighteenth Century Woman. ABC Video Enterprises/NVC Arts/The Metropolitan Museum of Art, 1982, 60 min., videotape. The culture and fashions of the Age of Enlightenment based on an exhibition

from the Metropolitan Museum's Costume Institute. Available from ArtsAmerica Inc, Art on Video, 9 Benedict Pl., Greenwich, CT 06830, (800) 553-5278 or (203) 869-3075.

Faith Ringgold: The Last Story Quilt. L & S Video Enterprises, 28 min., videotape. This winner of the 1992 Cine Gold Eagle Award provides an inside look at how Faith Ringgold has fulfilled her dream of becoming an artist. Available from ArtsAmerica Inc, Art on Video, 9 Benedict Pl., Greenwich, CT 06830, (800) 553-5278 or (203) 869-3075.

Faith Ringgold Paints Crown Heights. 1995, 28 min., videotape. Documentary presenting Faith Ringgold as an urban diva working in her studio, discussing the mulitple flavors and colors of her neighborhood, and painting the library at Public School 22. Panels of her mural-size quilt describe America's extraordinary mix of English, French, Spanish, Scandinavian, German, Native American, Caribbean, African, and Asian cultures. Available from ArtsAmerica Inc, Art on Video, 9 Benedict Pl., Greenwich, CT 06830, (800) 553-5278 or (203) 869-3075.

Frida Kahlo. Arts/Hershon/Guerra/WDR. 62 min., videotape. Profile of the artist's work and life, including her interest in politics and tempestuous relationship with her husband, Diego Rivera. Available from ArtsAmerica Inc, Art on Video, 9 Benedict Pl., Greenwich, CT 06830, (800) 553-5278 or (203) 869-3075.

Georgia O'Keeffe. WNET/THIRTEEN, 1977, 60 min., videotape. Georgia O'Keeffe and others discuss her life and work. Available from ArtsAmerica Inc, Art on Video, 9 Benedict Pl., Greenwich, CT 06830, (800) 553-5278 or (203) 869-3075; Home Vision, 5547 N. Ravenswood Ave., Chicago, IL 60640–1199, (800) 826-3456 or (312) 878-2600, or through Museum of Modern Art, Department of Education, Teaching Information Center, 11 West 53rd St., New York, NY 10019, (212) 708-9864.

Isabel Bishop: Portrait of an Artist. Beymer/Depew, 1977, 30 min., videotape. Explores Bishop's work of ordinary people, including shopgirls, hoboes, and the students she observed in New York City over the course of half a century. Available from ArtsAmerica Inc., Art on Video, 9 Benedict Pl., Greenwich, CT 06830, (800) 553-5278 or (203) 869-3075.

Louise Nevelson in Process. WNET/THIRTEEN, 29 min., videotape. Louise Nevelson creates two new sculptures on-camera, providing a rare opportunity for viewers to share in the unfolding of her unique artistic process. Available from ArtsAmerica Inc, Art on Video, 9 Benedict Pl., Greenwich, CT 06830, (800) 553-5278 or (203) 869-3075.

Marisol. Pantin, 1984, 13 min., videotape. Detailed examination of one of the Venezuelan artist's wood sculptures. Available from ArtsAmerica Inc, Art on Video, 9 Benedict Pl., Greenwich, CT 06830, (800) 553-5278 or (203) 869-3075.

Mary Cassatt: Impressionist in Philadelphia. WNET/THIRTEEN, Chicago Films, Inc., 1977, 30 min., videotape. Available from ArtsAmerica Inc, Art on Video, 9 Benedict Pl., Greenwich, CT 06830, (800) 553-5278 or (203) 869-3075; Home Vision, 5547 N. Ravenswood Ave., Chicago, IL 60640 -1199, (800) 826-3456 or (312) 878-2600.

Maya Lin: A Strong Clear Vision. Feature-length film on the architect-artist who designed the Vietnam Veterans Memorial in Washington, DC. Lin beat out more than 1,400 other national entries while still an undergraduate at Yale University.

Portrait of Imogen. Meg Patridge, 28 min., videotape. More than 250 photographs and commentary by Imogen Cunningham about her 75-year career. Available from ArtsAmerica Inc, Art on Video, 9 Benedict Pl., Greenwich, CT 06830, (800) 553-5278 or (203) 869-3075 or New Day Films.

Reclaiming the Body: Feminist Art in America. 58 min. Three generations of artists, from the 1960s to the present, including Louise Bourgeois, Faith Ringgold, Lynda Benglis, Nancy Spero, and Eva Hesse. Narrated by Linda Nochlin. Available from Michael Blackwood Productions, Inc., suite 415, 251 West 57th St., New York, NY 10019, (212) 247-4710; fax: (212) 247-4713; WWW: http://www.panix.com/-blackwoo.

Similar Differences: Betye and Alison Saar. Fellows of Contemporary Art, 10 min., videotape. Exploration of how mother and daughter artists work with multicultural, racial, generational, and religious issues in their work. Available from ArtsAmerica Inc, Art on Video, 9 Benedict Pl., Greenwich, CT 06830, (800) 553-5278 or (203) 869-3075.

Women of Color Media Arts Database, available at Women Make Movies, 462 Broadway, fifth floor, New York, NY 10013, (212) 925-0606. Rental and purchase in videotape and some film formats. This recently compiled database lists biographical data, video and filmographies, and bibliographical information of African-American females who make films and videotapes.

Women Make Movies, 462 Broadway, fifth floor, New York, NY 10013, (212) 925-0606. Rental and purchase in videotape and some film formats. The nation's largest distributor of videotapes and films by women. Selections include: *Joan Mitchell: Portrait of an Abstract Painter; Ana Mendieta: Fuego de Tierra; Guerrillas in Our Midst; Sphinx's Without Secrets* (various performing artists, including Laurie Anderson and Annie Sprinkle); *Womanhouse* (about the large-scale installation by Judy Chicago and Miriam Shapiro); *Alice Neel, Women Who Made the Movies* (about early female filmmakers); and *Women Filmmakers in Russia.*

Slides, Fine-Art Posters, Teacher Kits, and Recordings

The following organizations have a selection of materials on women artists from different periods in Western history.

American Library Color Slides Company, Inc., P.O. Box 4414, Grand Central Station, New York, NY 10163–4414, (800) 633-3307; (212) 255-5356; fax: (212) 691-8592; E-mail: Info@artslides.com; or WWW: http://www.artslides.com. A substantial selection of slides for sale by modern and contemporary women artists.

Art Institute of Chicago, Michigan Ave. and Adams St., Chicago, IL 60603, (312) 443-3600.

Boston Museum of Fine Arts, 465 Huntington Ave., Boston, MA 02115, (617) 267-9300.

Hildegard of Bingen: The Harmony of Heaven. Performed by Ellen Oak. Available from Bison Tales Publishing, 175 High Street, Belfast, ME 04915.

Media for the Arts, 73 Pelham St., Newport, RI 02840, (401)846-6580.

Metropolitan Museum of Art, 1000 Fifth Ave., New York, NY 10028–0198, (212) 879-5500; fax: (212) 570-3879.

Museum of Modern Art, Department of
Education, Teaching Information
Center, 11 West 53rd St., New York, NY
10019, (212) 708-9864. Loans slides, films,
videotapes, and curriculum materials to
schools.

National Gallery of Art, Department of
Extension Programs, Washington, DC
20565, (202) 842-6246. Offers slide pro-
grams, curriculum guides, films, and
videocassettes to educators free of charge
throughout the country.

National Museum of Women in the Arts,
801 13th St., NW, Washington, DC
20005, (202) 783-5000.

Rosenthal Art Slides, 50 Portland St.,
Worcester, MA 01608, (800) 533–2847.
More than 36,000 art slides, including
those of female artists throughout
history. Over thirty sets of slides devoted
specifically to women.

Sandak, 180 Harvard Ave., Stamford, CT
06902, (800) 343–2806 or (203) 969-0442;
fax: (203) 967-2745. Sets of particular
interest are "Women Artists, Eighteenth
to Twentieth Century"; Judy Chicago:
"Birth Project" and "The Dinner Party";
"Women's Work: American Art 1974";
and "Women Artists: Nature as Image
and Metaphor."

Saskia Ltd., 2721 N.W. Cannon Way,
Portland, OR 97229, (503) 520-8855; fax:
(503) 626-1162.

Shorewood Fine Art Reproductions, Inc., 27
Glen Road, Sandy Hook, CT 06482,
(203) 426-8100. Fine-art print sets with
teacher guides.

Universal Color Slide Co., Inc., 65A
Mathewson Dr., Weymouth, MA 02189,
(617) 337-5411.

Selected Glossary

abstract An art style that suggests or por-
trays something without exactly imitating its
appearance. The subject matter may be rec-
ognizable or completely expressed in line,
color, and form.

Abstract Expressionism Style of visible,
emotional, all-over brushwork that originat-
ed in America during the late 1940s and
1950s. Artists generally worked without
preparatory drawings and instead made
highly personal marks inspired by their sub-
conscious or intuition.

academies Societies of higher learning.

acropolis The highest point of a Greek city,
containing temples and public buildings.

amphitheater A circular or elliptical space
surrounded by rising tiers of seats.

appliqué Cut-out decorations fastened to a
larger piece of material.

Anasazi The ancient ancestors of certain
Southwest cultures.

avant-garde Art that is the furthest away
from the prevailing traditions of a given era.

Baroque A period and style of art, approxi-
mately 1600–1750, primarily in western
Europe, characterized by large-scale, ornate
decoration and a bold use of color and light.

Bauhaus A multidisciplinary German
design workshop and art school founded in
1919. Until its forced closure by the Nazis,
influential teachers from many countries,
including Anni Albers and her husband,
Josef, stressed industrial and mechanical art
processes that related to painting, sculpture,
architecture, crafts, printmaking, and other
art forms.

breviary Book of daily prayers and readings.

collage From the French word *coller*,
meaning "to paste." A composition made by
pasting various natural or synthetic materi-
als (such as photographs, newspapers, sand,
cloth, and so forth) onto a two-dimensional
surface.

composition The arrangement of ele-
ments in a work of art. The word stems
from a Latin term meaning "putting togeth-
er." Usually, composition refers to the rela-
tionship of line, shape, and color on a flat
surface, although it can be applied to three-
dimensional art as well.

crafts Works of art that generally have a
functional purpose, including ceramics,
textiles, jewelry, basketry, and so forth.

Cubism Style of art developed by Pablo
Picasso and Georges Braque at the turn of
the twentieth century in which a subject is
broken up into sharp abstract planes.

dowry Money or property a bride brings to
her husband at marriage; or a sum of
money required to join a religious order.

earthwork Work of art in which earth is an
important medium. Frequently the art is
made out of or within a natural, outdoor site.

embroidery Decorative designs sewn on
cloth with a needle and thread or yarn.

featherwork Textiles made with feathers
to form flowers, birds, and other decorations.

femmage A female version of collage
invented by the artist Miriam Schapiro.

folk art Objects made by untrained artists.

genre paintings Compositions describing
everyday life.

gilding Covering objects with thin coats of
gold.

guilds Independent unions or associations
of people specializing in a specific trade.
The Italian word for guild is *arti*, from
which the word *art* derives.

history paintings Large figurative com-
positions depicting important events based
on ancient and modern history, myths, or
legends.

homily A moralizing lecture or written
work regarding a specific topic.

horizon line The place at which the sky
and earth appear to meet.

Hours, Book of A book for private reli-
gious devotion, containing prayers for the
seven official hours of the Roman Catholic
Church. Often executed as an illuminated
manuscript.

illumination Colored illustrations that
decorate manuscripts, especially in medieval
Europe.

Impressionism A style of painting that
flourished in France in the last quarter of
the nineteenth century. It stresses the fleet-
ing, transitory quality of a subject by por-
traying the effects of light and color at a
particular moment.

lekythos A nearly cylindrical ancient Greek oil flask, tapered at the bottom, with a long, narrow neck and a small mouth.

limners Early American artists who traveled through the country on horseback or in light wagons. They frequently filled in a patron's portrait on a canvas they had prepainted.

linear perspective A principal geometric system used to generate the illusion of depth. In this technique, objects are drawn progressively smaller and closer together as they move back toward a horizon line.

Mimbres Ancient Mogollon culture in what is now southwestern New Mexico, from approximately 900 AD to 1100 AD.

miniature Very small portrait intended as a keepsake.

miniaturists Artists who create very small paintings, usually portraits.

Minimalism Uninflected, geometric abstract art style that flourished in America from the mid-1960s through the first half of the 1970s.

Neoclassicism Conservative western European art style from approximately 1750 to 1850. Neoclassicism was in part a reaction against the frivolous and ornate Rococo style that coexisted from about 1700 to 1800. Neoclassic artists were strongly influenced by ancient Greek and Roman art, artifacts, and architecture.

New Image Painting Term coined in 1978 when the Whitney Museum of American Art mounted an exhibition of this title, thus providing a label for the emerging artists whose divergent works shared recognizable but distinctly idiosyncratic imagery, largely presented in nonillusionistic contexts.

Op Art Style beginning around 1950, based on optical (visual) illusions.

opus Anglicanum Latin term that refers to the supreme examples of English needlework made during the Middle Ages.

papyrotamia Ancient art of cutting paper pictures.

Performance Art Art form pioneered largely by women, using a combination of theater and the visual arts to express the feminist dictum: "The personal is political."

Pop Art Style of art reigning in the 1960s that primarily used popular, mass-media images as its subject matter.

portal Entranceway of a church.

Post-Impressionism Late-nineteenth-century art style in France, following immediately after Impressionism, whose artists gave their subjects more substantial form and infused a sense of surface design into their compositions.

psalter Written collection of Psalms (sacred songs or poems) used in worship.

quatrefoil Stylized image of a flower with four petals.

quilted clothing Item made of a top and backing fabric and stitched together with padding between.

Rayonism Abstract idiom devised by Natalia Gontcharova and, later, husband Mikhail Larionov. Their style was greatly influenced by the recent invention of the electric lamp, which prompted the couple to fragment their subjects with painted "rays" of light and energy, thus producing startling, dynamic compositions.

realism Portrayal of a recognizable subject in a manner that imitates the way it appears in life.

Renaissance French term meaning "rebirth." In the visual arts, the term refers to the revival or rebirth of culture and learning that dominated western Europe from about 1400 to 1600. Prevailing Renaissance philosophies emphasized an interest in human beings and their relationship to the environment and were derived largely from the values and great thinkers of ancient Greek and Roman times.

representational Any work of art in which the objects or figures are easily identified.

salon An elaborate gathering during the Age of Reason in which guests discussed fashion, philosophy, science, and the arts.

samplers Stitchery paintings. Typically, young girls first practiced various sewing stitches as well as their letters and numbers on such works.

scriptorium Latin word for a manuscript-copying workshop.

sibyl Female prophet.

Souzani Persian word for needle and a type of embroidery style from Uzbekistan, an area bordering Turkey and Afghanistan, in Central Asia.

still life Depiction of an arrangement of inanimate objects.

Surrealism Artistic movement that evolved around 1924 in Paris. The artists created fantastic imagery derived from dreams, fears, absurd combinations, or chance.

symbol An image or sign, such as a person or an animal, that represents something else.

tambourwork Decorative designs that are darned into material and resemble paintings.

tapestry Wall hanging of painted, embroidered, or woven fabric with colorful ornamental designs or scenes.

textiles Woven or knit cloth.

Turkeywork Textile designs that imitate Turkish carpets made with knotted colored yarn on heavy cloth.

vanitas paintings Still-life compositions, typically made in Holland during the seventeenth century. They carry complicated symbolic meanings celebrating the beauty of the physical world while simultaneously warning viewers about the transience of earthly existence and about human mortality.

Index

Note: *Italics* refer to illustrations.